LANDSCAPE
PHOTOGRAPHY

HEATHER ANGEL

The Oxford Illustrated Press

The Oxford Illustrated Press

© Heather Angel, 1989

Reprinted 1989

ISBN 0 946609 65 9

Published by:
The Oxford Illustrated Press
Limited, Haynes Publishing Group,
Sparkford, Nr Yeovil, Somerset
BA22 7JJ, England.

Haynes Publications Inc., 861
Lawrence Drive, Newbury Park,
California 91320, USA.

Printed in England by:
J. H. Haynes & Co Limited,
Sparkford, Nr Yeovil, Somerset.

**British Library Cataloguing in
Publication Data**
Angel, Heather, *1941–*
 Landscape photography
 1. Landscape photography.
 Manuals
 I. Title
 778.9.'36
 ISBN 0–946609–65–9

**Library of Congress Catalog
Card Number**
88–83483

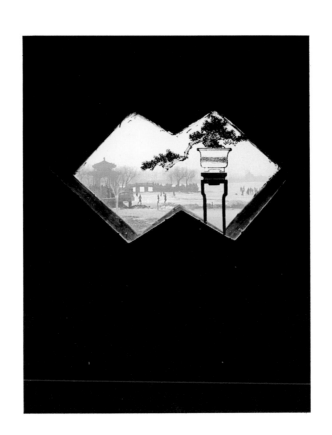

Acknowledgements

A great many people helped not only in the writing of this book but also by assisting me in my travels all over the world. I thank you all for smoothing the wrinkles both in my copy and in my movements overseas. In particular, special thanks go to:

Argentum
A.V. Distributors Ltd
Baja Expeditions
Dr Bill Ballantine
British School of Ballooning
Camera Care Systems Ltd
City of Bristol Museum
Gina Corrigan
The Forestry Commission
Kennett Engineering Ltd
Kodak Ltd
Ryan Gainey
Gardenia magazine
The Great Britain China Centre
Hasselblad (UK) Ltd
Mr and Mrs John Hignett
Michael Lear
Leeds Camera Centre
Leeds Castle
Robin Loder

Robin MacDonald of Iain MacDonald
 Safaris Ltd
Jennie and John Makepeace
Major James More-Molyneux
Mid-Wales Development Board
Tony Morrison of South American
 Pictures
Mylefoto Accessories Ltd
Desmond Napier
The National Trust
The National Trust for Scotland
The Nature Conservancy Council
Nikon UK Ltd
Occidor Travel
Dennis Orchard Duplicates
Painshill Park Trust
Reids of Guildford
Remote Sensing Unit, Aston University,
 Birmingham
The Royal Greenwich Observatory
The Royal Horticultural Society
The Royal Photographic Society
Safari Consultants
Ed Slater
Soames Summerhays
TV Man Union (Tokyo)
Twickers World
Richard White

Pat Wolseley
Susan and Graeme Woodhatch
Kenneth Woodley
The World Wide Fund for Nature
Zambian Photographic Society

The monochrome Emerson print reproduced on page 8 is from The Royal Photographic Society's Collection; the colour pictures of St Paul's Cathedral, the Thames Barrier and my son Giles Angel pages 77, 28 and 39 originally appeared in the 1987 Kodak calendar and are reproduced by kind permission of Marketing Publications, Kodak Ltd.

I should especially like to thank Colour Processing Laboratories for their film processing service, Penny Bantin for undertaking most of the word processing with able assistance from both Rona Tiller and Susie Briars.

Finally, I am as always, greatly indebted to my husband, Martin Angel, for accompanying me on a few trips and for his constant forbearance when I depart on yet another trip on my own.

Contents

Introduction

Landscape photography knows no geographical or political boundaries, in the sense that you do not need to understand the culture or know the language of a country in order to appreciate an exquisite landscape picture. Very often, it is the simplest compositions which produce haunting images that entice the eye to look again—images such as reeds projecting above water repeated as a shadow pattern in calm water, or a pine looming out of the mist on the side of a Chinese mountain.

Amateur photographers expose almost as many landscape photographs as they do portraits; yet only a small proportion of the millions of frames exposed annually on landscapes are particularly striking. What is the reason for this anomaly? The answer may well be that landscapes *appear* deceptively easy to take; for after all the terrain is static, so there is no sense of urgency as with candid photographs of people. But successful landscape photographs—perhaps more than any other branch of photography—stand or fall on the direction and quality of light.

Landscape photography is often a very leisurely occupation, involving setting up the camera on a tripod and waiting until the sun moves into the desired position. Occasionally, it may involve frenzied activity·as the weather suddenly breaks—a shaft of sunlight pierces the cloud cover or dark storm clouds race across the sky. Either way, you know instinctively when you have taken a striking landscape picture, one which will have instant appeal.

What are the ingredients needed to achieve a successful landscape photograph? Unquestionably, it is having a perceptive eye and the ability to see where to put the rectangular (or square) frame in relation to the horizon or, indeed, whether to exclude the horizon. Like landscape painting, only the basic elements of photography can be taught and even then I, like many

other photographers, would argue that the rules are there to be broken. Studying other people's work is useful, if only to evoke ideas for subjects or to arouse a reaction to the composition or lighting.

Unlike early landscape photographers such as William H. Jackson, working in the Rocky Mountains and Yellowstone over a century ago, with 8 x 10 inch wet plates giving extremely slow speed emulsions, we have a rich assortment of film speeds and types available today. I have assumed it will therefore be useful for readers to know if a very long or a short exposure was used to achieve a particular effect. The vast choice of film stocks may, in fact, hinder rather than help the amateur, for unless money is no object, a fast film put in the camera on a dull day or for taking an action shot, may prove to be unsuitable for taking landscapes on a bright day. This is where interchangeable film backs or more than one camera body can be such an asset.

No landscape photographer should ever denigrate a location by saying: 'There is no picture to be taken'. Going out with a predetermined blinkered vision of 'the picture' will make it difficult, if not impossible, to 'see' an unexpected picture. Even on a well-worn patch near my home, each time I return is like a voyage of discovery, for the light and weather constantly change. Whenever I work abroad I invariably have no conception of what I shall take each day; although if I am in a wetland habitat, I will be on the look out for reflections or patterns of water flowing over rocks, while it is more than likely that colour will arrest my eye in a deciduous forest in autumn.

The potential for taking a notable landscape picture is available to anyone with the most basic of cameras; for equipment is secondary to seeing a picture and grasping a fleeting moment of perfect light. More sophisticated cameras with a whole gamut of lenses merely allow a photographer to take a much wider range of pictures under

variable lighting conditions, or, in other words, to guarantee a much higher success rate.

Returning to my opening comments, the universality of landscape photography was brought home to me most vividly when I lectured to the Chinese Photographers' Association in 1985. Although no-one in the Beijing audience of several thousand knew any of the localities I showed on the screen, they asked many questions about specific pictures—what time of day it was taken or what lens did I use?

Whenever Chinese photographers escorted me into the field, they knew exactly the best time of day for taking spectacular views. The scenery around Guilin in southern China is a landscape photographer's and painter's paradise, with the dramatic karst scenery of limestone peaks thrusting skywards. However, without local knowledge, I would never have achieved one of my favourite landscapes from among all the pictures taken during five trips to China. Reproduced on page 127. It shows dawn breaking over the Lijiang.

Compiling this book has allowed me to relive working in quite varied habitats all over the world—ranging from the lush and humid tropics to glacial scenery in Iceland; from sea level to dizzy heights on the Mountains of the Moon in Uganda, and from the sculpted rocks of Utah to fresh lava flows in Hawaii. Although photography has taken me to so many places abroad, I do not neglect British landscapes; indeed, it was my landscape pictures for the book *The Natural History of Britain and Ireland*, which initiated the idea for this one. Whenever I am working on a project, I find it increases my perception and approach to the particular aspect of photography. For example, this book has made me look anew not only at natural landscapes, but at the ways in which man has shaped the land—both centuries ago and in recent years.

Because it is unlikely anyone else will

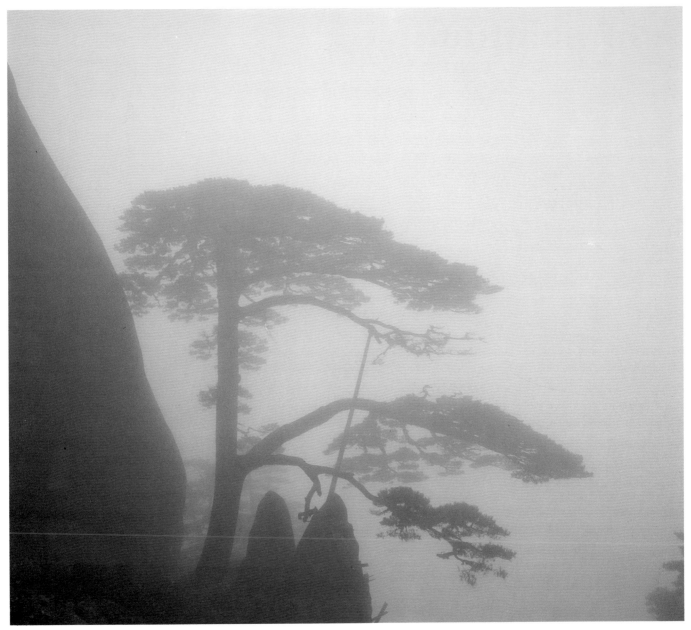

experience precisely the same lighting conditions at the same time of day, with the identical camera, lens and film as I chose to use, I do not believe that giving full and precise exposure details in a photograph is particularly helpful. In any case, I never write down my exposure! Whenever I look at photographs taken by other people I am often curious to know the place and the date when they were taken; yet so often this information is lacking. The hurricane which swept across south-east Britain on 15/16 October 1987 vividly proved how familiar landscapes can change literally overnight. Since a dated photograph records a landscape as it

appeared at that moment in time, I have included the year, and the month, when I took each photograph. Whenever the focal length of a lens is mentioned in the text, it refers to a 35mm format unless otherwise stated.

I do hope the pictures we have selected and my descriptions of how they were taken, will add to the pleasure and enjoyment in recording landscapes—wherever you may be.

Heather Angel

Farnham, August 1988

My main objective for climbing thousands of steps up Huangshan—one of the five sacred mountains in China—was to photograph the autumn colours. The low mist meant I saw virtually nothing, but adjacent to the first guest house, I found this Guest-receiving pine looming out of the mist, reminiscent of typical Chinese mountain landscapes depicted on scrolls.

Huangshan (Yellow Mountain), Anhui Province, China, October 1986. Ektachrome Professional 64, 80mm lens on Hasselblad. Thick mist.

Appreciation

What is a Landscape?

When reference is made to landscape photography (or painting) this invariably conjures up visions of an idyllic countryside vista complete with scattered mature trees, possibly a picturesque building and maybe a person or two with an attractive sky as a backcloth. The sort of picture which is typified by Joseph Gale's rural landscapes and Peter H Emerson's platinum plates in *Life and Landscape on the Norfolk Broads* (London 1886).

Emerson's plates are not only of great historic value from a photographic point of view, they are also important as an historic ecological record of the lush floating vegetation. Within the last few decades, many water plants including the attractive—and photogenic—lily pads have disappeared from most of the broads.

There are many factors which have contributed to this loss, including grazing on emergent plants by coypu (which escaped from local nutria farms in the 1960s), high nitrogen levels in the water, grazing by geese and waterfowl and where motor boat access is permitted, by propellers. Water lilies as well as

Gathering water-lilies **is one of forty platinum prints made by Peter Henry Emerson and published in his book** *Life and Landscape on the Norfolk Broads* **in 1887. This print is proof of the lush aquatic vegetation that flourished in the Broads a century ago.**

(The Royal Photographic Society's Collection, Bath.)

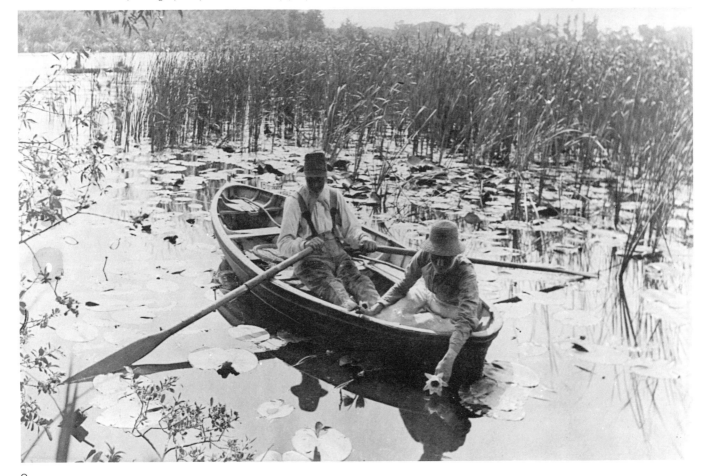

other water weeds still survive in parts of the broads which are off-river and they are making a comeback in broads where the sediment has been removed by suction dredgers.

My colour picture was taken in 1980 in a reserve managed by the Norfolk Naturalists' Trust. Like the people depicted in Emerson's picture, I was taken out to the water lilies in a rowing boat where I was able to use a low camera position and a wide-angle lens to accentuate the floating lily pads.

Static landscapes attracted early photographers since they could be easily recorded with the obligatory long exposures, unlike wildlife which moved. This was why some early wildlife photographers working in Africa resorted to photographing the game they shot.

Anyone with a specialist knowledge or a keen interest in a particular aspect of the landscape will automatically tend to adopt a somewhat blinkered approach to seeing and taking landscape photographs. This selective attitude towards seeing pictures is no bad thing; on the contrary, a trained eye will almost certainly see subjects which a general eye will pass over. For example, the archaeologist will automatically seek out an archaeological feature; while the historian will focus on buildings in the landscape; the landscape architect on landscaped gardens; the pilot on aerial vistas and the naturalist on the habitat in which a particular plant or animal lives.

The majority of landscapes are inevitably taken during daylight hours, when the choice of subjects far exceeds nocturnal scenes and the actual mechanics of taking a picture are so much easier than at night. In temperate regions, there is also a very brief period—the twilight zone—often referred to as the 'magic hour', when the sun has disappeared below the horizon, and a clear sky becomes suffused with a uniform dark blue or pale pink, giving a wonderful natural coloured backcloth to buildings or trees.

The changing quality of light through a 24-hour period and the most popular subjects seen through the eyes of amateur photographers, was graphically recorded in the most ambitious photographic project ever staged on a single day. On 16 August 1987, the British nation was encouraged to record on film some aspect of that day which encapsulated 'real' Britain in their own eyes. The most striking photographs were published in a book *One Day for Life* published in aid of a cancer trust, thereby providing a permanent record—

a time capsule—of one day in the life of a nation. People featured much more strongly than landscapes, supporting the surveys carried out by amateur photographic magazines that family and friends head the league of most popular subjects, but with landscapes coming a close second.

By freezing a moment of time, any still photograph allows that moment to be re-lived—at a later date—maybe in a completely different season. Action pictures—especially those taken by high speed flash—which reveal a moment imperceptible to the human eye, may be impressive but the equipment involved in achieving these pictures is complex. The shutter is triggered not when the picture is seen through the viewfinder, but by the subject breaking a light beam or setting off a vibration or sound trigger—whether the photographer is present or not. Landscape photographs, on the other hand, record a scene at a particular time which the eye perceives. We therefore tend to be more critical of the lighting and composition of a landscape than an action picture.

Some people, and I fall into this category, prefer *not* to include people in their wilderness landscapes. But there are occasions when people add interest, scale and maybe colour to a photograph. Several pictures will be found in this book with people—many of them taken in China—where the sheer size of the population makes it difficult to take a picture without a person in the field of view somewhere.

One of the few areas of the Norfolk Broads where emergent plants—both reeds and floating water-lilies—flourish in a nature reserve where motor boats are prohibited. I was rowed out to this site early on a mid-summer's morning where I used a wide-angle lens and a polarising filter to increase the colour saturation of the lily pads.

Norfolk Broads, July 1980. Kodachrome 25, 24mm lens on Nikon. Direct sunlight.

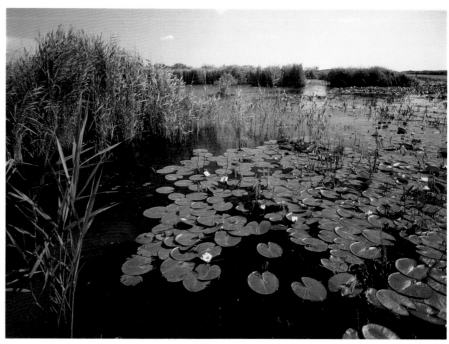

9

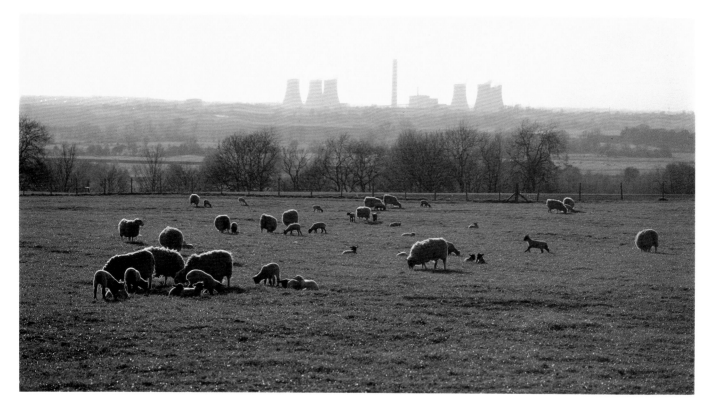

The most appealing landscapes are the simple scenes—especially if they convey a moody atmosphere. This does not have to be a sunrise or a sunset, although they are often extremely evocative. Landscape photography is by no means always synonymous with beauty. Depending on the subject matter, the way in which it is lit, the time of day it was taken, a landscape photograph can be picturesque, dramatic or moody. The moods may vary from atmospheric or peaceful, to tempestuous.

A sylvan landscape will have more universal appeal than rows of caravans in a park, but both subjects are quite legitimate landscapes. The former is acceptable because it is uncontroversial, whereas the latter immediately stimulates queries such as 'Why are there so many caravans parked?' 'Are they a temporary or permanent blot on the landscape?'. Both approaches to subject selection are equally valid, but I believe the most lasting landscapes are the ones that depict locations not obviously spoilt by the hand of man, although it is becoming increasingly difficult to find completely virgin landscapes.

One of the most stimulating aspects of landscape photography is that since the light on the landscape constantly changes, it is always possible to re-take a favourite view in new light. It does not matter how many times a view has been photographed, it will still present infinite possibilities—it is up to the photographer to seek these out

Seeing the Picture

Landscapes are the easiest and most approachable of all subjects for anyone of any age to attempt to photograph with any type of camera. I use the word 'attempt' deliberately, since so often landscapes are disappointing. Among the recurring reasons for disappointment (apart from incorrect exposure) are lack of attention to detail—especially to distractions such as unsightly telegraph wires or vapour trails; too large an area of dull sky or too much uninteresting foreground. Shapes or colours that intrude and conflict with the main scene should be avoided, for they cannot be removed after the picture is taken. All these factors can be assimilated before the shutter is released by quickly scanning the scene. I am not sure whether I scan vertically or horizontally, but I do know that I very quickly home-in on any problem area and either adjust the camera position or select a different focal length lens.

Some people find it impossible to visualise the view unless they look through a rectangular frame made by the thumb and forefinger of each hand, or even through a cardboard cut-out. I have not found this necessary and, in

At first glance, backlit sheep with their lambs is a romantic enough picture. A second look shows the lighting may be idyllic but looming on the background horizon is a power station. Depending on how it is cropped and captioned, this is a picture which can be used to make quite different editorial points.

Sheep and lambs grazing, Didcot power station behind, March 1985 Ektachrome 64, 150mm lens on Hasselblad. Backlighting in evening.

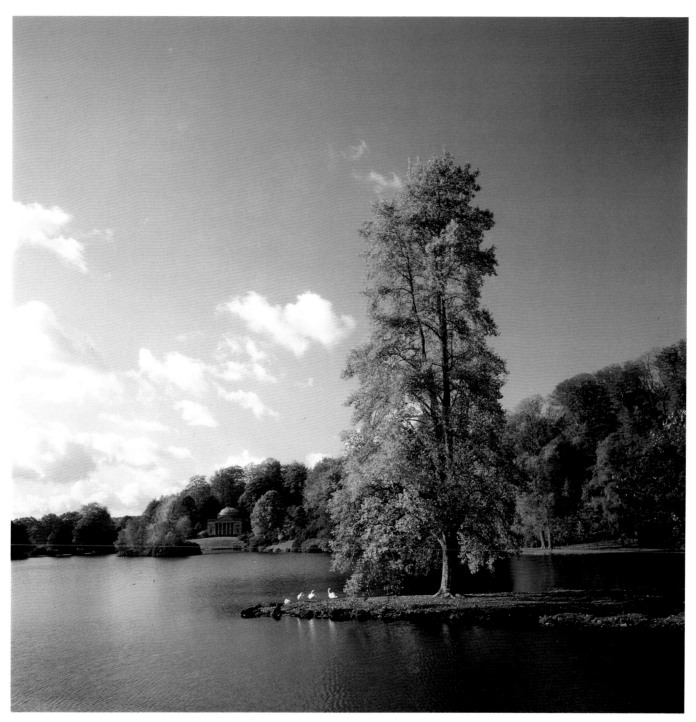

The timing was crucial for this picture, for I wanted as much colour in the tulip tree as possible, but once leaves turn, they soon fall. The National Trust botanist based at Stourhead, telephoned me early one morning to say the colour was perfect, the sun was shining and there was little wind. Soon after I set up my camera four swans obliged by getting out of the water and standing on the island beside the tree. This picture, reproduced here as the entire square frame, illustrates how, providing the subject does not fIll this square format, it offers plenty of scope for designers to crop in a variety of ways; it has been used as a horizontal wrap-around for a leaflet and as a vertical full page book illustration.

Tulip tree *Liriodendron tulipifera,* Stourhead, Wiltshire, October 1985 Ektachrome 64, 60mm lens on Hasselblad. Direct side lighting with a polarising filter

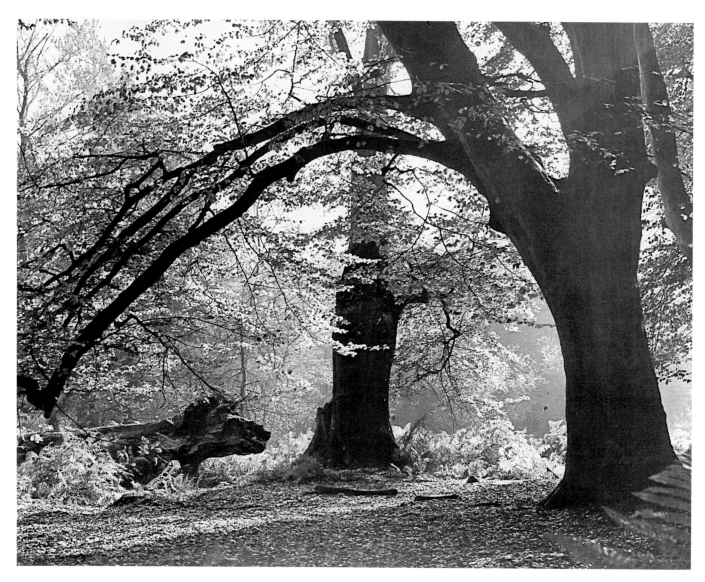

any case, it takes no time at all to pan a camera round on a tripod.

Landscape photography can be as simple or as complex as you wish to make it. The most telling aspect of any landscape picture however, is not the cost of the camera on which it was taken, but how the photographer saw the picture and why he framed it the way he did. The answer from many people taking holiday snapshots would probably be 'Because the coach/car stopped there' but it may be 'Because we saw a professional with a tripod and we knew he would have selected the best view'! The latter comment may be very flattering to the photographer, but it accentuates the point that not everyone is able to select a potential picture from a broad panorama. The 'helpful' tutor who steps out of a coach quoting the film type and the exposure for a given view is inhibit-

ing the development of any individual thought or creation.

The same argument could apply to fully automated cameras; although they do not tell you where to stand and if they produce a higher proportion of correct exposures than can be achieved with a manual camera, then it should help to concentrate all the thought and attention on the composition. Sadly, invariably very little thought is devoted to consideration of how to frame up a picture.

When we look out onto a landscape, our eyes assimilate the whole scene as we quickly scan across it. We savour it as a three-dimensional scene, perhaps with gradually changing light; whereas the camera records a brief moment of time as a two-dimensional picture. Since the two ways of seeing a landscape are so different, it is hardly

The curving branches of an old beech tree in Hampshire's New Forest, make a natural frame to this picture. The early morning back lighting helps to emphasise the solid trunks in contrast to the thinly leafed branches which had already shed many leaves. Since this picture was taken almost two decades ago, strong winds—including the October 1987 hurricane—have changed this scene.

Old beech trees in the New Forest, Hampshire, October 1976. Plus-X Pan, 80mm lens on Hasselblad. Backlighting, early morning.

surprising that sometimes the pictures we take do not capture the atmosphere and mood as we remember it. The skill lies in selecting a portion of the landscape which will come over most convincingly on film. Appreciating how to get the best image on film out of a scene comes only with experience and critical appraisal of both your own and other people's pictures.

If a picture is worth taking, it is worth spending some thought on how to compose it. Landscape photography—arguably more than any other branch of photography—is all about using your eyes and deciding where to place the frame (be it rectangular or square) around the scene. Moving the camera up or down, left or right immediately changes the composition; only you, the photographer, can decide whether it is better or worse than the original picture seen in the viewfinder. The objective should always be to strive to find a picture where no-one else has seen one.

Even the landscape pictures resulting from a grab shot taken in a fleeting moment by being in the right place at the right time, still have to be seen before they can be taken.

A momentary shaft of light on water can help to transform a dull scene into a dramatic view. When I was swimming from a Seychelles beach early one afternoon, I noticed the sun was far too high in the sky to make it worth taking a picture, so I went off overland in search of wild flowers. Returning to the beach at the end of the day, I saw the sun bathing the sea in a pool of light adjacent to a fishing boat. These two components, together with the coconut palm fronds, made a picture where there had been nothing a few hours before. I had just enough time to take three frames before the light vanished as quickly as it had come. Local fishing boats often provide the essential focal point to an otherwise lifeless expanse of seawater.

The silhouetted coconut palm fronds make an effective foreground frame for the offshore fishing boat spotlit by the sun. This, the best composed frame from a sequence of three, was damaged by a processing scratch on the right of the frame, so the original horizontal picture had to be cropped on the right hand side into virtually a square shape. I checked the final effect by laying the slide on a light box and using a strip of black (unexposed) film to mask off the right side.

Coconut palms, Mahé, Seychelles, May 1973. Kodachrome 25, 50mm lens on Nikon. Localised backlighting.

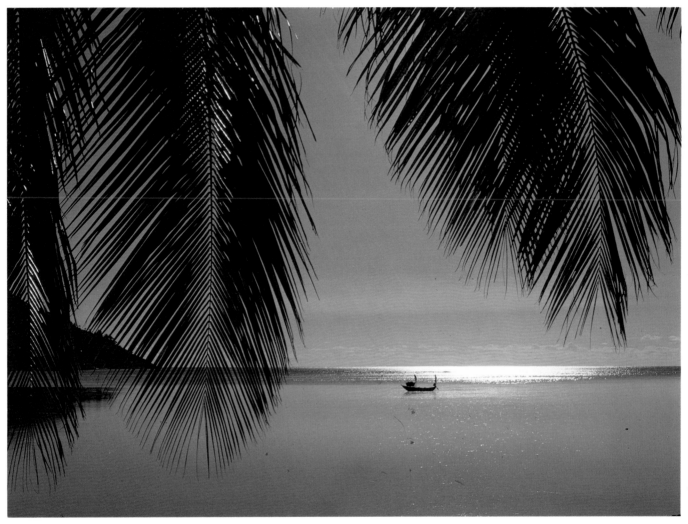

While I was being driven from Chengdu in Sichuan Province, China, *en route* to Juizhaigou we stopped on top of a twisting road to look down onto a huge lake linked to rivers where felled trees were floating downstream. My initial instinct was to select a 50mm lens to show the huge quantity of floating logs, but I quickly realised that the most striking picture would be one taken with a long focus lens. I had no prior knowledge about the route we would take; and knowing the paucity of wildlife in China, I had come without my own 300mm lens. Fortunately, someone else in the group was also a Nikon user and he very kindly lent me his 300mm lens. The moral of this story is that you can never be sure when a long lens will prove to be essential for getting the framing exactly as you want it. This sort of picture would not be difficult to pre-empt once a logging site had been located. Without any scale, such as a person, it is difficult to visualise the size of the logs

Waiting for the Moment

Sometimes waiting just a few moments can pay dividends, although true dedication involves waiting for not just hours, but days, for optimum lighting conditions before taking a picture. A major advantage a static landscape has over a fast-moving animal is that if the light is not quite right, the subject will not go away. Time can therefore be spent waiting to capture the moment when the scene is best lit. When minutes stretch into hours, this can be frustrating at the time, but if the end result is the picture you treasure, it is well worth the effort.

When I was working on the book *The Natural History of Britain and Ireland*, I had already spent two abortive days with overcast skies casting light as flat as a pancake on the snow-dusted Cairngorms up in Scotland. On the third day, I was thrilled to have been given access to drive through normally closed roads into Glen Feshie. Ever since I had seen a black and white print of red deer crossing the River Feshie in the (British) National Collection of Nature Photographs, taken by Gordon Seton some half century ago, I had longed to see this part of the Cairngorms for myself.

The day was just as overcast as the previous two, but I set off in high spirits alternatively driving and walking. I ended up in a potentially exciting location with low clouds down on all the surrounding hills, so I left the car and

This was an opportunist picture taken from the roadside shortly after stepping out of a coach. The abstract pattern of logs on a lake looked for all the world like matchsticks on a puddle—some light, some dark, depending on their orientation to the sun and the amount of light they reflected.

Logs on lake, Sichuan Province, China, October 1985. Kodachrome 64, 300mm lens on Nikon Overcast

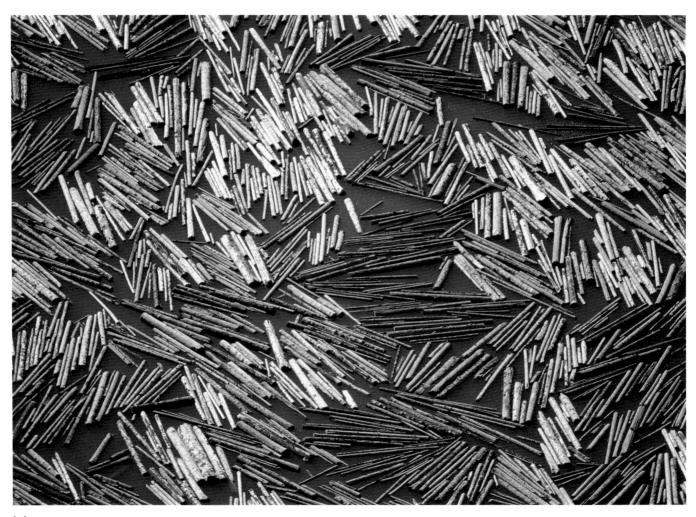

As a brief flash of sun broke through the clouds, it partially painted the river with a patch of light. With the brightly lit water, the sun-covered ground and dark pines, I knew the exposure was tricky, so I decided to go for the mid-tones. This inevitably meant that the pines on the left came out looking very solid and unexposed, but since they occupy only a small part of the picture, I argued this would be acceptable.

Glen Feshie, The Cairngorms, Scotland, January 1980. Kodachrome 25, 24mm lens on Nikon. Overcast with brief burst of sunlight.

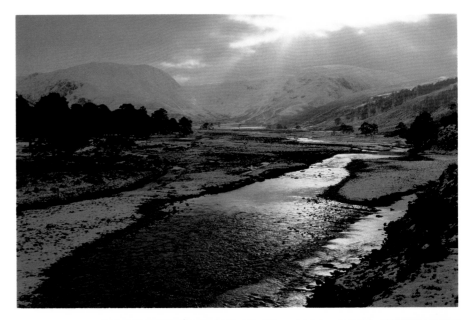

walked down to the river. There I pottered for some hours until a chink of light began to break through the clouds. Racing back to the car and my cameras, I just managed to take a few frames of the sun bathing the river before the clouds closed in again. Without the sun the picture was nothing, with it the scene came to life. The exposure was tricky, so I decided to go for the mid-tones, knowing this would make the dark pines on the left appear very solid and under-exposed.

Light and shadow can be a most effective way of focusing attention on a particular subject in a landscape. Light from a low angled sun illuminates the landscape obliquely so that where a subject is backed by a hill or a mountain, it is possible for the subject to be spotlit by sun while the background is in shadow. Waimea Canyon on the island of Kauai in Hawaii has been formed as the result of land created by volcanic action being gradually destroyed by erosion, with the result that the upper part of the canyon plunges to a depth of

As soon as I saw this koa tree growing on a precipitous slope I knew I had to portray the location. This meant waiting most of the day for the mist to clear and the sun to emerge. The oblique lighting from behind brings out the rich green leaves of the tree, while the far wall of the canyon appears as an intense blue backdrop with the diagonal ridges defined by the rim lighting.

Koa tree *Acacia koa* in Waimea Canyon, Kauai, Hawaii, January 1977. Ektachrome 64, 150mm lens on Hasselblad. Backlighting.

15

over 800 metres. The high rainfall on Kauai encourages growth on all but the steepest slopes, so that much of the canyon walls are clothed in a green mantle, but trees occur only spasmodically. When I found an endemic tree growing on a spur beneath a lookout, I knew I needed sun to emphasise the green leaves against the sombre backdrop.

Waimea is a wide canyon, but a narrow high-walled canyon will be lit by direct light for only a short time each day. To utilise the sun as a natural spotlight may therefore involve a day of observation before any photography can be contemplated. A point of interest at the base of a rocky overhang will also be lit for only a limited time.

Ruins of prehistoric Indian villages in Canyon de Chelly National Monument, Arizona, nestle at the base of towering red cliffs and in canyon wall caves. There are some fine views of these villages from the canyon rim, but the time of day has to be carefully selected to ensure the sheer wall does not appear in deep shadow.

When the sun's disc is partially blocked by a solid object, such as branches of a tree, the rays appear in the form of a natural starburst. I have used this technique several times to provide a focal point to a picture in a woodland, in a garden (p69) and in a desert. The size of the starburst can be varied by altering the size of the lens aperture.

Days when the sky is dark and stormy, but the sun occasionally breaks through, can produce some very dramatic effects. I find the best way to work is to set up the camera on a tripod, compose the picture and wait for the short burst of light. A landscaped garden full of tulip flowers may seem colourful enough, but with a stormy sky backcloth lit by direct sun, the scene becomes even stronger and more eye-catching (p68).

If a picture of an attractive honeypot area is required without people, it is a waste of time attempting it after mid-morning. What I may do though, is to make a recce as soon as I arrive at the location, noting the direction of the sun at that particular time of day. Then I return at first light well before the tourists begin to arrive on the scene.

Another instance when it is well worth waiting to take a picture is where a large area of uni-toned grass, sand or concrete would look better with a human figure or two or maybe animals moving across the frame. The line of reindeer trekking across thick snow in the Cairngorms (p19) made the picture,

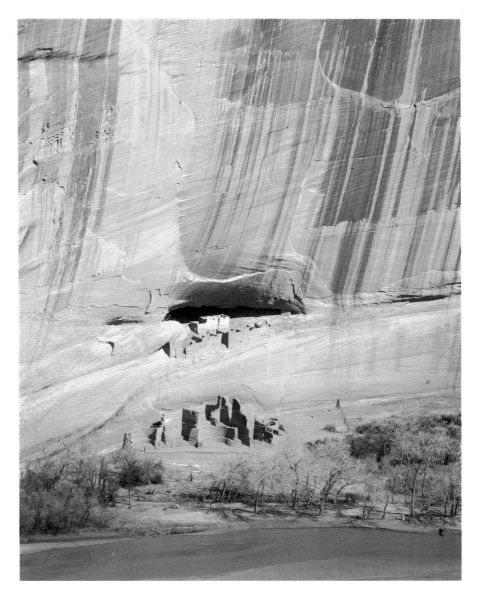

as indeed can a camel in a sandy desert expanse. Similarly, a large sheet of calm water can be broken up by a boat moving into the shot (p61).

Intermittent motion such as a breaking wave, needs to be anticipated so that it is recorded precisely at the moment it breaks on rocks, a pier or a shipwreck. Exploding fireworks are somewhat easier to photograph in that providing a slow speed film is used, a fairly long exposure can be made to show them off to the best advantage.

Composition

Many books have been written about how to compose a painting or a photograph. Some offer very specific guidelines to follow. However, by slavishly following the conventional Rule of Thirds whereby the main subject

Canyon de Chelly, is a high-walled labyrinthine canyon in north-east Arizona where the Navajo live and farm on the floor. Archaeological findings show that the canyon has been occupied virtually continuously for nearly twenty centuries. This picture is one of a series I took from a lookout on one rim looking across to the opposite side of the canyon showing the remains of a rockhouse pueblo nestling at the base of a sheer cliff. Although longer lenses enlarged the size of the ruins, they failed to give a feeling of the magnitude of the rock wall.

Rockhouse pueblo, Canyon de Chelly, Arizona, February 1982. Kodachrome 25, 200mm lens on Nikon. Front lighting.

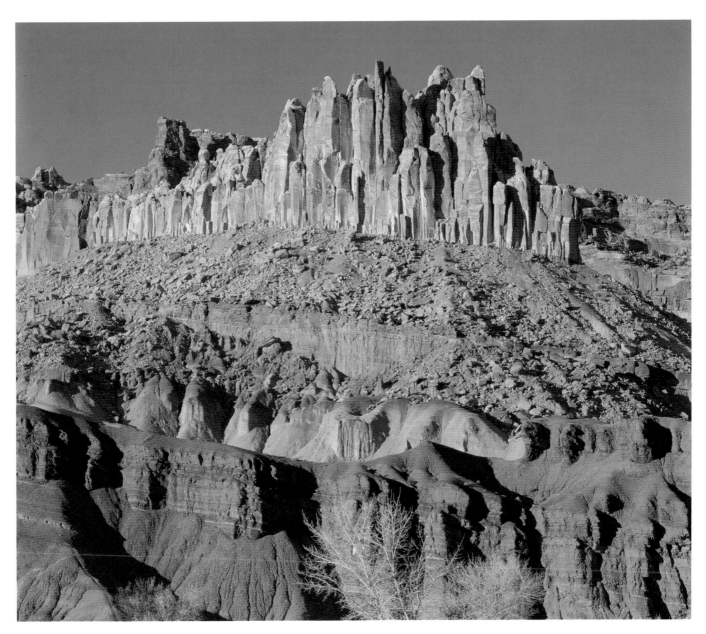

is placed at the intersection where one third of the horizontal and one third of the vertical plane intersect, will not necessarily guarantee a winning picture. Anyone who has to sit down and calculate the 'best' composition for a landscape is very unlikely to produce a winner. For a picture to succeed it must be completely instinctive—there is no stereotyped foolproof formula. Landscapes do not, in fact, have to be hurried, but rapid reflexes and familiar use of the camera are bound to stimulate an intuitive approach to seeing the best composition at the same time as the focal length of the lens is selected.

Looking at the pictures in this book you will see the horizon at the top, in the centre and at the bottom of the frame, and you can read my reasoning for positioning it where I did on each occasion.

From the large number of photographs that I look at when judging competitions, it is a sad fact that relatively few people 'see' a picture before they bring out a camera or even critically appraise what they first see in their viewfinder. Other sections in this chapter cover aspects such as camera viewpoint and perspective, both of which are essential criteria in composing the picture. Before each frame is exposed, questions such as 'Is this the best viewpoint?' 'Is the lighting direction or type doing the scene justice?'

This was the first picture I took when we arrived in Capitol Reef National Park on a winter's afternoon. Since it is a landform close to the Visitor's Centre, it is much photographed, but I found the low-angled light was ideal for showing up the form and colour of the different rocks and their erosion patterns. The intense blue sky was also a perfect backdrop for this view which involved standing in the middle of the road and dodging the infrequent passing vehicles.

The Castle, Capitol Reef National Park, Utah, January 1988. Ektachrome 64, 150mm lens on Hasselblad. Low-angled side lighting.

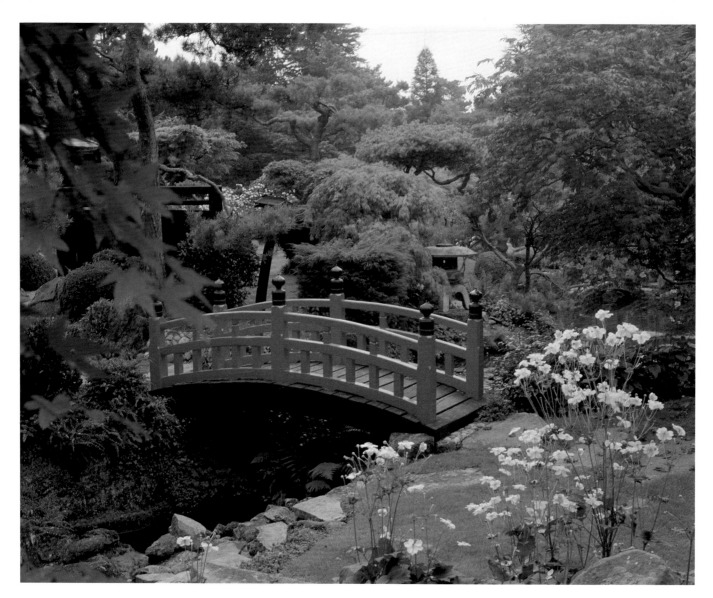

'Where should I place the horizon in the frame?' should be completely automatic.

In composing a picture, individual components such as colour, shape, form, tone, pattern and texture—as well as depth and perspective—all have to be appraised. This may sound very complicated, but in reality not all these components need be considered each time, for invariably it is only a few which are significant in any one particular picture.

Studying both contemporary and historic landscape photographs (and paintings) is an excellent way of appreciating which elements of composition and design contribute towards a successful picture and which do not. For example, automatically placing the subject bang centre in the frame every time is not only completely unimagin-

ative but is also unsettling to the eye, for it does not know which way to move—to the left or to the right? But deliberately choosing to put the subject in the centre of the frame is a bold decision when it is done specifically to give stronger emphasis.

Landscapes, above all pictures, need to be harmonious to the eye. Anything which confuses or jars the eye should be avoided. Sinuous curves—such as crests of sand dunes or walls of terraced rice fields—flow through a picture; while linear shapes that repeat themselves help to reinforce the design.

Even when you find a successful formula for composition, it is very monotonous to compose pictures in a stereotyped way. The aim should be to constantly vary the approach, to experiment with lighting as well as framing.

The newly painted bridge was such a strong focal point in a Japanese garden (in Britain) that I decided to place it in the centre of the frame, since no matter where positioned, it automatically attracted the eye. I was not happy with the view of the bridge from the other side, but as soon as I walked across it and found the clump of white Japanese anemones in the foreground and the autumn foliage—repeating the colour of the bridge—behind, I saw a composition that clicked.

The Japanese Garden, Cottered, Hertfordshire, October 1986. Ektachrome 64, 80mm lens on Hasselblad. Overcast.

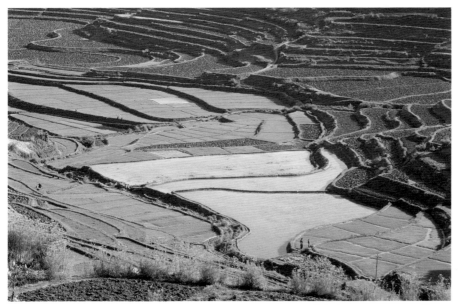

To get the composition I wanted for this picture, I had to sprint down a steep bank weaving my way round the edge of the fields, because everyone else in my party decided to stay on the road. The mixture of fields with bare earth, some flooded ready for planting out the rice seedlings and others already green with young rice plants, makes a more interesting story than if the whole picture was of uniformly coloured fields.
Because I was in such a hurry to take the picture, I did not notice the man and boy near the mid-bottom, but they do help to provide scale.

Terraced rice fields, Yunnan, China, May 1984. Kodachrome 25, 85mm lens on Nikon. Direct cross lighting.

For instance, remember that a rectangular format offers the option between taking a horizontal and a vertical picture; therefore try not to take the easy option and *always* bring the camera up to the eye in a horizontal position, it does not require much more effort to turn a camera through 90°!

Some photographers argue they take pictures solely to please themselves. I also follow this maxim, but I would add that if a freelance professional is to survive, it is no use shooting pictures which will not appeal to art editors, art buyers and designers—otherwise no sales will result! My aim is to produce pictures that arrest the eye, that make people look again *and* hopefully read the caption so that they can begin to interpret why the picture was taken in a particular way.

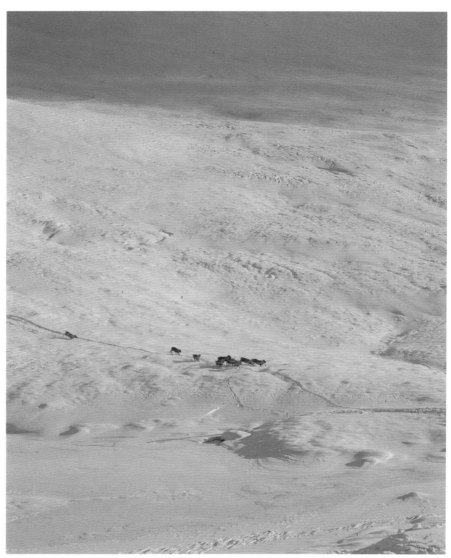

High up on the Scottish Cairngorms I spotted a line of reindeer running through deep snow. Instead of reaching for my longest lens, I decided to keep the animals as small dots traversing the huge snowy expanse so as to emphasise their diminutive size in the vast snowscape.

Cairngorms National Nature Reserve, Scotland, January 1980. Ektachrome 64, 150mm lens on Hasselblad. Direct side lighting.

19

Camera Viewpoint

The easiest way to take a landscape is by standing on a lookout beside the road, where thousands of others have stood before and hold the camera up to the eye. With a bit of luck and dramatic lighting, this may produce a striking picture, but a more original approach is to look for a new camera angle which is not so familiar.

Changing the viewpoint even just a few degrees to left or right, up or down, can dramatically alter the final composition. This may involve climbing onto a seat, a wall or a stile to gain a slightly higher viewpoint or simply kneeling or crouching to get a lower camera angle.

The perspective (p24) of a tall object changes dramatically when the viewpoint is altered. Seen from a low viewpoint, it appears to taper at the top (furthest from the camera) in a similar way to parallel rows in a field viewed end-on (p25). Conversely, seen from a high viewpoint, the top of a tall object (nearest to the camera) appears enlarged and it is the base that seems to taper.

Sometimes, it may be necessary to climb a hill so as to look into the floor of a canyon, or down onto a beach or a valley. Climbing up on to the first (or even higher) floor of a building can give an overview of the layout of a city, town or garden which is impossible to appreciate from ground level. This I discovered when I climbed on to the roofs of high-rise hotels in China. Firstly, at Chengdu I noticed the most obvious feature from this elevated viewpoint was the green ribbons of tree-lined avenues. Secondly, when I ended up in Shanghai on May Day, I wanted to get some pictures of the classic view overlooking the Bund. I entered the lift of my hotel and asked the lady to take me to the top floor. At first she denied it existed, then she said the lift did not go that far! When it was apparent she had had strict instructions not to allow anyone up there, I descended and presented my card to the Manager, who granted me two minutes on the roof top and wrote out instructions in Chinese. I beamed at the lift lady as I presented my 'pass', who clearly looked most put out, but she obliged and in the end nobody appeared after two minutes to remove me from the roof top.

Once again, it was the trees which brought colour to the drab buildings on a slightly hazy day. In addition, as far as the eye could see red flags fluttered atop almost every flag-pole giving welcome colour to the somewhat dull scene.

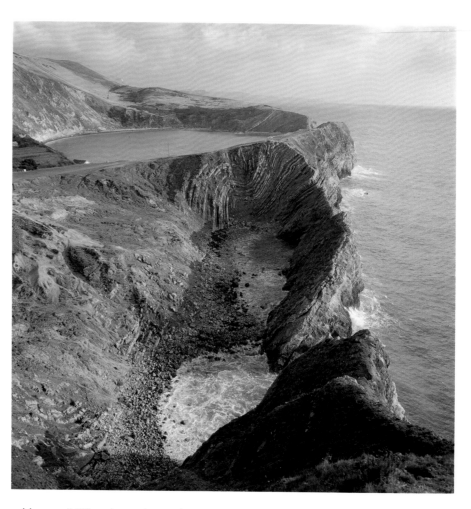

Many wildlife refuges have elevated look-outs for viewing the scenery and the wildlife. Mammals such as deer have a keen sense of smell and can be viewed from a high hide without risk of them detecting your presence when the wind direction suddenly changes. One of the most spectacular elevated look-outs I know is constructed at the end of a boardwalk in Okefenokee Swamp Park in Georgia. From the top of the high tower there is a marvellous overview of the open and closed waterways of the swamp. Early in April when the deciduous swamp cypress trees leaf out a delicate green, parts of the swamp appear as a green haze and yet it is still possible to glimpse the water through the branches.

Probably because we are used to seeing views from elevated positions such as roads or railways which span bridges, high-rise buildings and also from the air (p158), it is pictures taken from a low camera angle which are often especially eye-catching.

A more dramatic picture may be gained by descending into a valley or a

Long before I arrived at Dorset to photograph geological coastline features, I had studied a detailed Ordnance Survey map, so as soon as I stepped out of the car I climbed a hill to gain an overview. Using a wide-angled lens and putting the horizon high in the frame, I was able to get the Stair Hole, the ramparts and the sea with Lulworth Cove behind all within the square format. I chose to visit the coast in mid-winter when the odds of a tourist wearing a red anorak appearing in the field of view would be remote.

Stair Hole with Lulworth Cove, Dorset, January 1980. Ektachrome 64, 50mm lens on Hasselblad. Cross lighting.

canyon to show the profile of the cross section. The shape of the span of a natural bridge or arch can be distinguished more clearly when it it seen from a low viewpoint against a sky instead of against similar coloured rocks

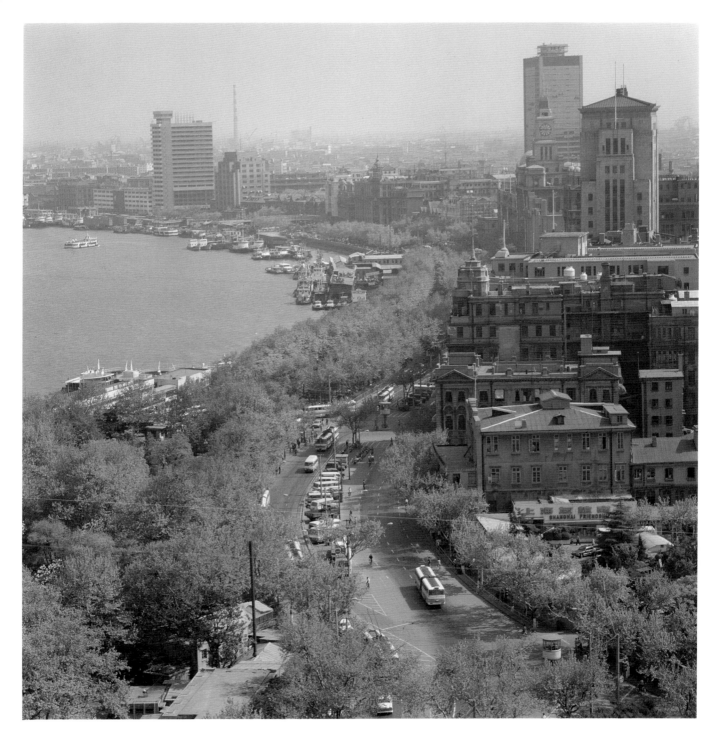

The high density of both buildings and trees, makes it impossible to get a vista from the ground along Shanghai's waterfront street known as the Bund, so I found a high viewpoint from the top of a hotel. The paucity of bicycles in the street can be explained by the array of red flags flying on May Day—a national holiday.

The Bund, Shanghai, China, 1 May 1985. Ektachrome 64, 80mm lens on Hasselblad. Hazy light.

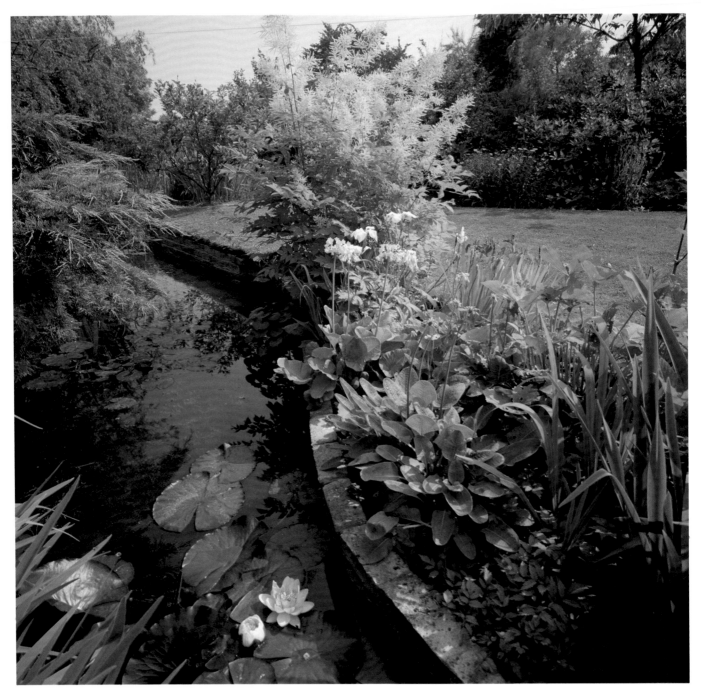

To show the water-lily flowers
and the bog bed beside the
elongated garden pond, I used
an extremely low camera angle
and a wide-angle lens. Time of
day was also important, since
water-lily flowers open only
when the sun is shining.

Private garden in Hartpury,
Gloucestershire, June 1986.
Ektachrome 64, Super-wide
Hasselblad (fixed 38mm lens). Direct
sunlight obliquely from behind.

I often use a low camera angle coupled with a wide-angle lens, to illustrate a plant in its natural habitat. Both flowering plants and fungi can be photographed using this technique. The plant does not have to occupy a large area of the frame, but it does need to be brightly coloured or a bold shape, otherwise it will tend to blend in with the landscape.

When using a wide-angle lens, dramatic changes can be made to the foreground by altering the camera viewpoint a small amount; whereas the position of distant objects changes by only a small degree. Walking a cliff-top path overlooking the coast in one direction and then walking it in the opposite direction, can present new pictures simply because the position of stacks or offshore islands relative to the coast will be first seen from quite different angles.

A useful exercise illustrating how even a slight alteration of viewpoint can change the picture, is to find an open landscape with varied features in it, such as water, a clump of trees and a building or maybe boats. Firstly take a picture of the entire scene, then concentrate on individual facets within it. A change of viewpoint may make it necessary to change the focal length of the lens. For example, the initial shot may be best taken with a wide-angle lens and then longer focal length lenses used for the cameos.

If using a 35mm system, try varying the format by taking some frames vertically and some horizontally. Also vary the viewpoint in relation to the light and the camera angle. After the film has been processed, either lay out the prints on a table or the slides on a light box to compare the images. Some will be more striking than others and, if nothing else, it will demonstrate how to make the most of a single location on the same day, or putting it another way, how to use your eyes to find pictures which do not obviously present themselves.

A photograph will often appear to be more arresting as well as having a feeling of depth, if a single fixed object is featured at one side of the foreground. Once a view has been chosen, it is worth spending a little time searching the immediate vicinity for some foreground interest. In the countryside, a clump of flowers or a flowering shrub can bring a splash of colour to the foreground (p38), while a rock or a striking tree can at any time of year. Near habitation, a seat or a statue may fit the bill.

An open gateway leading into a field (p95) is a well-used technique to entice

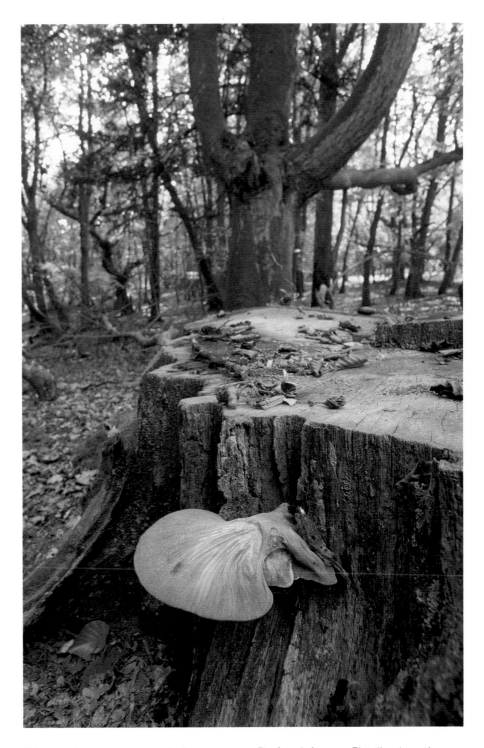

When a low camera angle is used with a wide-angle lens, the type of habitat where a wild plant grows can be depicted in the distant part of the picture. I have many close-up portraits of the beefsteak fungus, so when I found this specimen, I decided it would work well shown small in the frame with the habitat behind.

Beefsteak fungus *Fistulina hepatica* in New Forest, Hampshire, October 1982. Kodachrome 25, 24mm lens on Nikon. Overcast day.

the eye to look beyond the boundary. Depending on the height of the gate and the camera angle, it can also be used to frame a view. If a closed gate is opened for the picture, be sure to remember to close it again afterwards.

Any foreground object featured in a landscape should be sharply focused, for the eye naturally moves from the front of the picture to the back. The rest of the scene behind should also appear in focus, otherwise it will simply be a picture of a gate or a seat with an out-of-focus background. This means stopping down the lens to a small aperture, often necessitating a long exposure and a solid tripod.

There are occasions when the viewpoint may have to be hurriedly changed for safety reasons; for example, an incoming tide fast approaching up the beach; hot lava or volcanic ash erupting from an active volcano.

Perspective

A straightforward landscape picture taken by holding a camera with a standard lens up to the eye, comprises three elements—a foreground, a middle zone and a distant expanse. The area covered by each part depends on how the view is framed and the position of the horizon in that frame. The angle of view we see equates most closely to a 50mm lens, so that if an ultra wide lens or a long focus lens is used, the perspective that we normally experience will change.

A wide-angle lens can be used to emphasise foreground shapes, whether they be man-made or natural landscapes. For example, the size and significance of boulders or concrete tetragons on the beach can be accentuated by using a 20mm or even a 16mm lens. Likewise, the natural convolutions of the grykes and fissures created in limestone pavement by natural erosion, take on an almost sinister connotation when seen through a wide-angle lens. By filling half or more of the frame with a powerful exaggerated foreground, it will then dominate the picture. This exaggerated perspective of the foreground tends to be a technique much favoured by photo-journalists since it gives additional emphasis to the news story. On the other hand, a long focus lens by increasing the image size of a long range subject, puts greater emphasis on the distant part of the landscape. It can even serve to highlight a feature which was not immediately apparent to the naked eye.

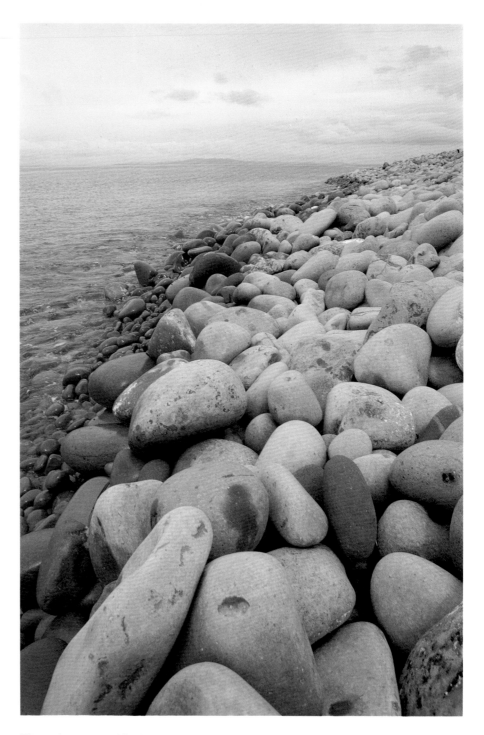

There is no specific landing place on Little Barrier Island—a nature reserve lying off the east coast of New Zealand north of Auckland—you simply step out onto the boulders. Having made repeated trips across the boulders from the boat to the land with my camping gear, I decided to exaggerate their size by using a low camera angle and a very wide-angle lens.

Boulder beach, Little Barrier Island, New Zealand, January 1979. Kodachrome 25, 20mm lens on Nikon. Overcast day.

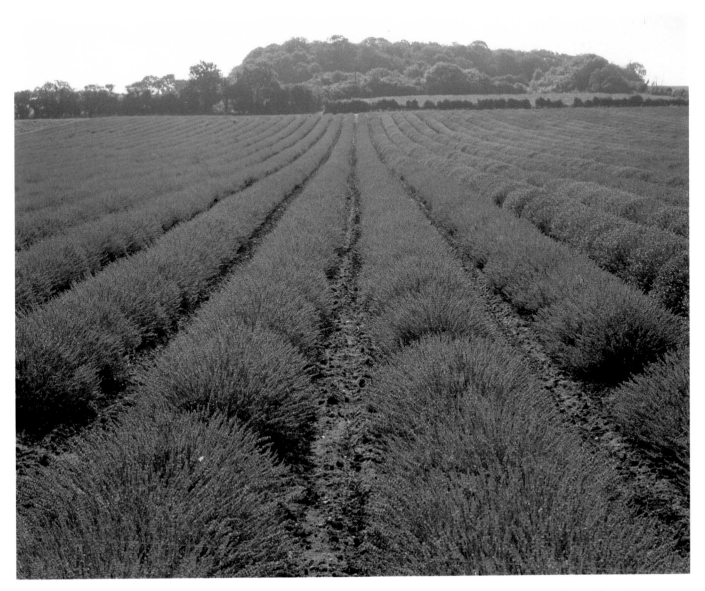

The greater the distance between an object and the camera, the smaller the object will appear. This is most apparent when a line or an avenue of straight-boled trees is photographed. The trees furthest away from the camera appear very small compared to the foreground trees. Another graphic example of diminished scale can be seen by standing at the ends of parallel furrows or broad rows of a crop in a field.

Deliberate perspective distortion of vertical lines can also be achieved by tilting the camera away from the horizontal: an upward tilt produces converging verticals, while a downward one produces diverging lines. Once again, this distorted image can be used to emphasise a point, but if it is not deliberately sought and framed, it can distract from the composition. Perspec-

tive distortion can be corrected by changing the viewpoint so as to avoid tilting the camera or by using either a perspective correcting (PC) lens (p50) or a view camera with shift movements (p47). I have found a Nikon 35mm PC lens particularly useful when photographing small gardens looking down from an elevated viewpoint, or plantations of straight-boled conifers where I had to use a low camera angle and tilt the camera upwards.

As soon as I planned a visit to East Anglia in July to photograph some gardens for a book, I looked in my diary notebook listing subjects to take month by month, where I noted 'Lavender fields, Norfolk'. In this way I could economise on both time and petrol. The timing was perfect, for the lavender bushes were in full flower just prior to harvesting. At the bottom of the picture two rows fill the frame, but diminished scale and strongly converging lines result in dozens of rows appearing in the top of the picture.

Lavender field, Norfolk, July 1986. Ektachrome 100, 80mm lens on Hasselblad. Against the light early morning.

Framing the View

In one sense every photograph is physically framed, whether it be as a mounted print within a picture frame, or as a reproduction on a page where its borders contrast with the colour of the paper on which it is printed. But pictures can also be composed so they have an aesthetically pleasing frame inside the edges of the film. The frame can completely surround the picture or it can be on one or more sides.

A true fish-eye lens will produce a circular frame to every picture, but since this is not the way we view a scene it can look extremely artificial and rather gimmicky. I have, however, used an 8mm fish-eye lens (which has a 180° coverage) to photograph white clouds against a blue sky from inside a high-walled canyon in Zion National Park, Utah (p49). The irregular outline of the canyon walls produced the silhouetted frame and made the picture, for the clouds would not have been worth taking on their own. A fish-eye lens such as this is used in science and industry for weather and cloud observation as well as astronomical studies.

When an image is completely enclosed within a natural, or a man-made frame, it automatically focuses attention on the vista beyond by making the eye look through the surround. Exposure should be made for the brighter area through the frame rather than the frame itself, otherwise the vista will appear over-exposed. Natural frames exist as overhanging boughs; holes in trunks of ancient rotting trees, as well as rock arches and bridges. I have used natural rock to frame views in China's Stone Forest in Yunnan and in Arches National Park in Utah. The grey limestone peaks of the Stone Forest were formed beneath the sea by the accumulation of the skeletons of marine organisms. After the area was uplifted, it became eroded to form the varied shapes visible today Arches on the other hand, lies on the Colorado Plateau in red-rock country, where the natural erosion of sedimentary rocks has created hundreds of arches as well as many other photogenic landforms including spires, pinnacles and petrified sand dunes.

Natural arches are constantly evolving—often imperceptibly to the naked eye—although changes may be discernible by comparing old and recent photographs taken from an identical viewpoint. Unlike natural bridges which are formed by the erosion of a stream passing through, natural arches arise

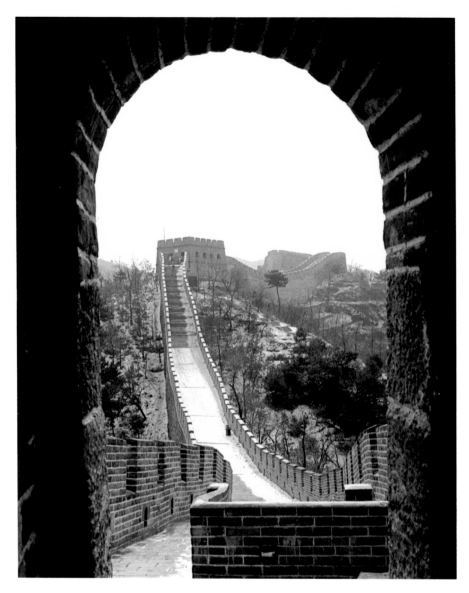

from gradual weathering. As the hole slowly enlarges, so the overhead arch becomes thinner until it eventually breaks through and is destroyed.

These natural arches, along with bridges, windows and tunnels abound on the Colorado Plateau which spans the states of Utah, Arizona, Colorado and New Mexico. Some of the well known features are sited on walking trails, but many others involve a dedicated hike to reach them. Known also as Canyon Country, this region is a photographer's paradise, although it can get extremely hot in summer. Snow falls on the higher elevations in winter and provides a striking contrast to the red rock. Even though the air temperature is below freezing, clear winter days—with a low angled light—give plenty of scope for taking geological features framed by

It is difficult to get a picture of the Great Wall of China at Badaling where most tourists visit, without masses of people. We were allowed to visit a different part in February when few tourists were in Beijing and most of the locals were celebrating the Chinese New Year. It took two hours to drive there and a ride on a mule to reach the Wall. The lone person walking down the snow-covered pathway provides a useful scale to this momentous architectural achievement, which I framed using one of the many archways along the path.

Great Wall of China at Mutianyu, February 1987. FP4, 60mm lens on Hasselblad. Diffused light

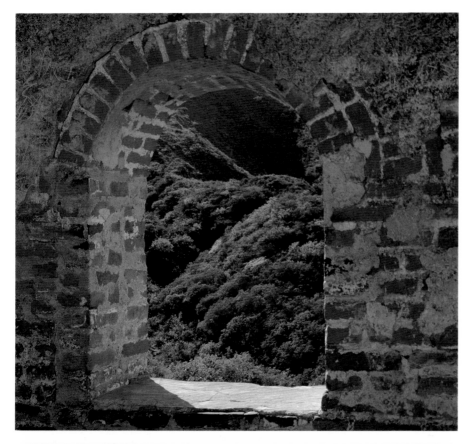

Finding an original view for taking the Great Wall of China is not easy, since millions of people visit it each year. Having seen the Wall several times in different seasons, I much prefer autumn when the hills around it are a riot of colours. At various stages along the most frequently visited parts of the wall are open windows which make useful neutral-toned frames for, in this case, the colourful vista beyond.

View at Badaling, October 1985 Ektachrome 64, 80mm lens on Hasselblad. Back oblique lighting with polarising filter

an arch, bridge or window

Marine arches are formed by the sea pounding on either side of a rocky headland so that joints or faults become enlarged until they break through. Like any solitary sea arch viewed at right angles from the cliff top, Durdle Dor in Dorset cannot be used to frame a landmark, merely the sea itself. Where several marine arches exist in a concentrated area however, as for example near Portimao in Portugal, by working from a boat on the sea one arch can be used to frame part of the coastline or another arch.

Down on the floor of a gorge or a canyon, opposing walls can be used as vertical frames on each side of the picture. Towering pinnacles, stacks or buttes also make effective side frames, as do skyscrapers (or any vertical archi-

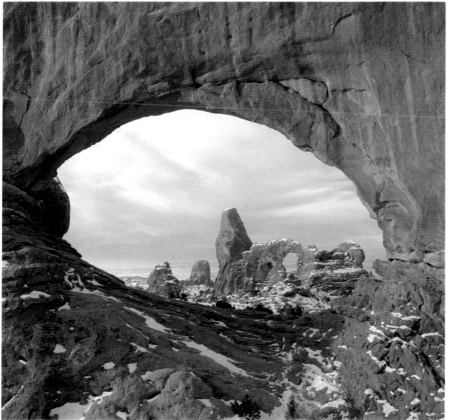

This is one of the many natural arches present in Arches National Park. We found it late in the day when the lighting was quite unsuitable for photography from this aspect looking through to another arch and other rock formations. We therefore rose early the next morning when we guessed some light would fall on the front of the arch, integrating it better with the view beyond than if the frame was silhouetted.

North window frames Turret Arch, Arches National Park, Utah, January 1988. Ektachrome 64, 60mm lens on Hasselblad Slightly diffused side lighting

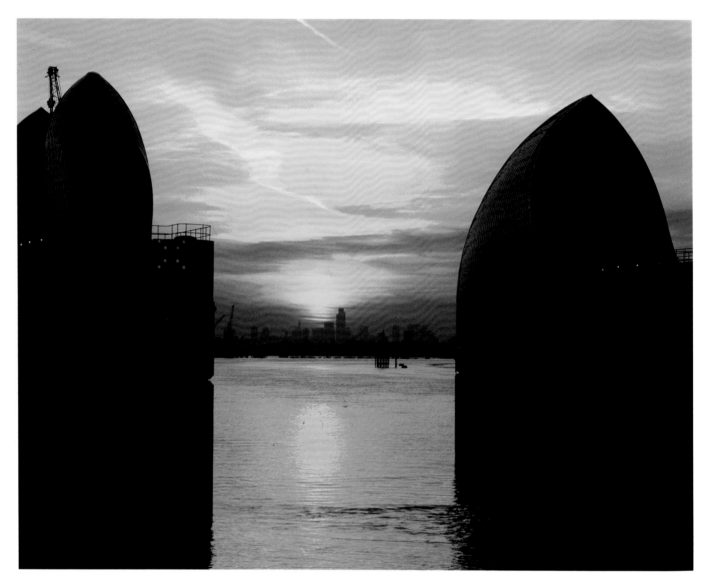

tectural structures) and upright closely clipped hedges in gardens.

It is surprising how often on discovering a pre-conceived idea for a shot fails to work, my disappointment turns to elation when I suddenly see a completely different way of tackling the shot. A case in question was a time I went to the Thames Barrier in London to get the reflection of the setting sun from the stainless steel plates covering the piers. This was to be one of the shots for my commissioned 1987 Kodak calendar on the Thames. A slight cloud cover ruined any chance of this shot working, so I started to walk back to my car. After passing the seaward side of the barrier, I suddenly turned round to see the London skyline with a dramatic orange sky framed on either side by the powerful silhouettes of a pair of piers. The solid and striking frames at the side,

make it a much more powerful picture than the one I had seen a few minutes earlier unframed.

Unlike the view itself, any vertical structure used as a frame, is illuminated by sun for only a limited time each day. A silhouetted frame can however, appear very dramatic, because of the increased tonal contrast between the frame and the view.

Man-made structures which can be incorporated as frames for landscapes include bridges, arches, walls, as well as window and door frames in houses and other buildings. For almost two years I researched and photographed frames to views for my garden book *A View from a Window*.

By no means all windows are suitable for framing a view. It depends on their size and the relative distance of the view beyond. A small window will offer only

Two piers of the Thames Barrier make powerful frames to the sun setting over the City of London. The solid silhouetted frame needs the strong colour of the sunset, while the sunset needs the frame to help draw the eye towards the bright area in the centre of the frame. This was literally a grab shot which was all over in a matter of seconds.

Sunset over London framed by Thames Barrier, August 1985. Ektachrome 64, 250mm lens on Hasselblad. Sunset

Windows in houses make effective frames to garden views, particularly unusual frames such as this gothic window in a cottage orné. I had found a black and white plate of this garden, taken more than three decades ago, reproduced in a book. There was no name given to the garden, only the British county. It took me several months of work to track it down, but when I got there, it was well worth the effort. I had to shoot at an angle through the window because there was a long brick wall on the righthand side.

View through a gothic window of a garden in southern England, July 1986. Ektachrome 64, Superwide (38mm) Hasselblad. Direct side lighting

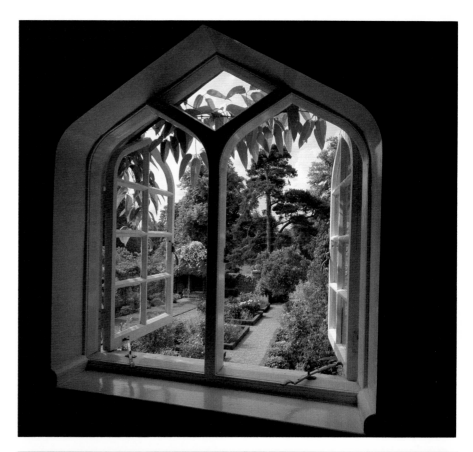

a blinkered view beyond, although a wide-angle lens will obviously help increase the angle of view. The most successful framed garden views are those where the feature is some distance away from the window.

Extending the window theme, I found windows in walls, hedges and even in an ice sculpture in Harbin, north of Beijing in China where the temperature remains permanently below freezing for half of the year. Apertures which pierce an otherwise solid expanse of wall or hedge in a garden provide glimpses of broader vistas beyond, luring the eye to focus past the barrier. From scenes depicted on sixteenth-century embroideries we know that long before photography was invented man was creating garden features specifically for framing views. Wooden framework tunnels clothed in plants provided shaded walks for strolling and viewing the garden through repeated apertures

An ornate moon gate was used to frame a pavilion with a turquoise tiled roof in China. It is not difficult to find a moon gate to frame a view in a Chinese park or garden, but it can be virtually impossible to take such a view without people in it. Even this picture, taken late in the day, includes people sitting on seats, walking down a corridor and posing to have their picture taken.

Moon gate frames pavilion in Green Lake Park, Kunming, China, April 1985. Ektachrome 64, 80mm lens on Hasselblad. Direct side lighting

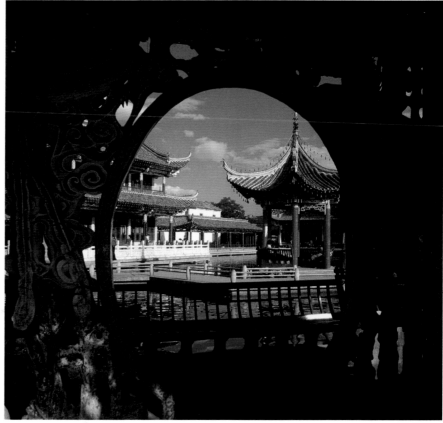

Windows are an especially important design element in Chinese (and Japanese) gardens. Windows of almost every conceivable shape including circular, square, pentagonal, hexagonal, quatrefoil, cinquefoil, crescent and fan abound in Chinese gardens. Often the windows are open, but sometimes they are infilled with a geometrical lattice-work made from tiles, bricks or wood or with pictorial scenes created by modell ing with clay on a wire framework. At the Summer Palace near Beijing there is a covered walkway perforated by double glazed windows on which a small painting gives foreground interest visa outside (p55).

Special viewing pavilions were built in both Chinese and Japanese gardens so that the best garden views could be contemplated in all weathers through an open window.

Another recurring feature in Chinese gardens is the moon gate—a large circular open doorway in a wall—which is not only functional, but also serves to break up the solid expanse of a wall Moon gates, like hexagonal and vase-shaped openings, lead the eye on to an adjacent compartment of a garden and, in the same way as ornate window frames, they can also be used to frame a photograph of the view beyond; a few have been incorporated into the design of some western gardens

Lasting Landscapes

The seasons bring different colours and moods to deciduous woodlands; they also result in changing colours and textures to arable scenes. Although the quality of light varies throughout the day, there are some landscapes which have a timeless quality spanning not just months, but years.

In particular, geological granite or basalt landscapes with little or no vege-tation around them, even if they are very gradually eroding away, change im-perceptibly to the naked eye. On the one hand, these landscapes have the advan-tage that they continue to look the same year in, year out, but because of this they present much more of a challenge trying to achieve a new camera angle on a much photographed view of an unchanging subject

Take the Giant's Causeway in Northern Ireland as an example. Look-ing straight down on to the cross-sections of the basalt columns makes an intriguing repetitive pattern of hexa-gonal shapes with no hint that these rocks are pounded by the sea I tried a

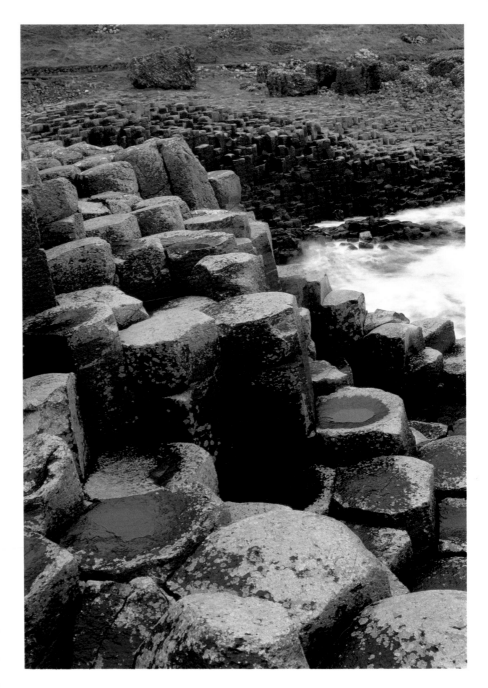

Formed as a result of volcanic activity, the Giant's Causeway is a distinctive landform which—although constantly pounded by the sea—does not appear to change from one year to the next. This detail of the Causeway shows a small portion of the distinctive basalt columns formed at right angles to the lava flow.

Basalt columns, Giant's Causeway, Co. Antrim, Northern Ireland, October 1982. Kodachrome 25, 105mm on Nikon Overcast

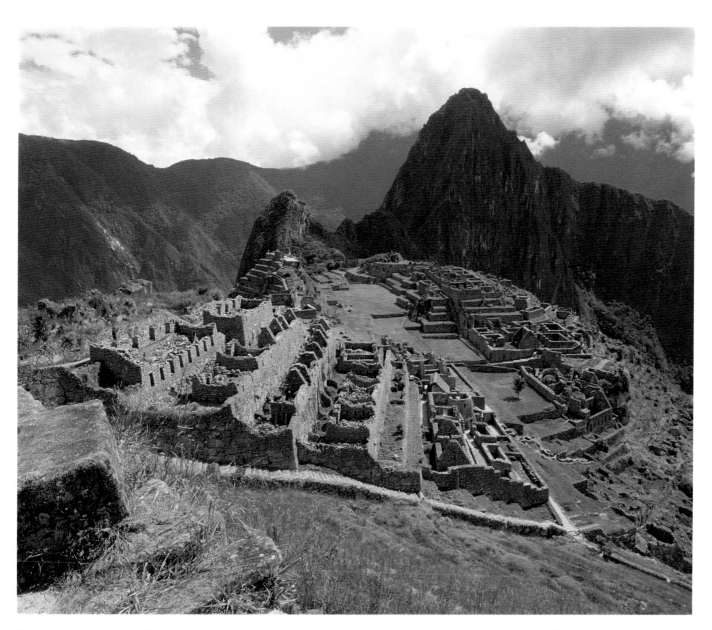

On the eastern side of the Peruvian Andes lie the remains of the fortified Inca town of Machu Picchu. Surrounded by sheer peaks, it is small wonder it lay undiscovered until 1911, when Harold Bingham stumbled across it. The best way to see the ruined town in its mountain setting is from the air when the swirling mists lift, but by climbing up an overlooking slope at the end of the day and using a wide-angle lens, I was able to show much of the site with the mountains behind. The site is continually being restored.

Inca town of Machu Picchu, Peru, May 1979. Kodachrome 25, 20mm lens on Nikon Direct side lighting

conventional horizontal view looking out to sea with the Causeway in the foreground, but there was too great a contrast in exposure between the black basalt, white waves and colourless sky. Even though the sky could have been improved with a graduated filter, I am not in favour of using such a filter to give additional colour to sea or land. So, in the end I opted for a vertical shot of a raised part of the Causeway, with the sea breaking against the edge of a more distant section.

Archaeological landscapes such as Machu Picchu in Peru, also have a timeless quality, but if they are photographed with people in the picture, the style of dress may date it. One or two people can help to provide scale

though, but if none are required in this popular tourist site, the only way is to spend the night in the adjacent hotel. Then, when the day trippers have left, it is possible to take pictures without lots of people swarming over the site like a mass of ants.

Throughout the world there are still communities living off the beaten track where the houses and way of life have seen virtually no change for centuries. During my travels to China, I have come across places where time seems to have stood still. However, now that tourists are being granted access to travel much more freely and the Chinese themselves are travelling further afield, the traditional way of life will gradually disappear

Transient Scenes

The ever-changing interplay of light and shadow on any landscape scene with both vertical and horizontal elements—even if they do not both appear in the viewfinder—produces fleeting moments of harmonious accord. The juxtaposition of light and shadow momentarily creates a perfect composition, but as the sun is hidden by a passing cloud or dips down behind a hill, it becomes lost. Maybe not quite forever, but the odds of precisely the same combination of weather conditions prevailing when the sun is at the same position in the sky, must be remote. It is only an acutely observant eye which exploits the optimum moment, not necessarily by a happy accident, for the chosen composition will have pre-empted decisions about the camera position and the lens ready for that moment. Using the camera under these conditions must be completely instinctive, for any hesitation will lose the picture.

Short-lived natural phenomena such as rainbows, water spouts and lightning flashes, produce transient scenes which also have to be photographed quickly before the event passes, whereas natural disasters such as volcanic eruptions, hurricanes and floods may persist for hours or even days.

Recording such ephemeral natural disasters, is a question of being in the right place at the right time. It was most frustrating to find I was unable to drive out of my home town in Surrey on the morning after the October 1987 hurricane, because all the main roads were blocked by fallen trees! By the time the roads had been cleared, some of the shots I wanted to take had been ruined by a few strokes of a power saw. However, I did record the damage to trees in Kew Gardens and many other parts of the south-east over the following week both from the ground and the air (p159).

The aftermath of the hurricane brought home the fact that gardens are far from static; they are constantly

After a long drive I arrived in Death Valley just as the sun was setting. I had time to take a few shots of a pink afterglow reflected on a hill dusted with snow before all trace of colour was lost. I would have completely missed this shot if I had arrived much earlier or any later in the day.

Sun setting on snow-clad hills, Death Valley, California, February 1979. Ektachrome 64, 150mm lens on Hasselblad. Dusk.

evolving. As trees and shrubs die, other plants will invade the gaps if they are not replanted.

Changes wrought on the landscape by the hand of man may be temporary and help to enhance it, or they may be catastrophic leading to long-term harmful effects. The photography of man-staged spectacles introduces colour and action to an otherwise static landscape. Events such as a balloon race, a regatta, aerial acrobatics or a fireworks display, can be preplanned and the best viewpoints sought by speaking to the event organisers.

Forest fires, detergent or oil pollution spills arising as a result of an accident

For a brief period each year, the deserts of southern Arizona and California become transformed as drifts of colourful annuals as well as perennial brittlebush burst into bloom. Rather like the fall colours further north, if you hit the peak time, there are some unbelievable sites. Individual cactus flowers are very beautiful, but because the plants tend to grow individually, they do not produce the same effect as the massed annuals.

Blooming of desert annuals in Organ Pipe National Monument, March 1983. Ektachrome 64, 60mm lens on Hasselblad. Backlighting.

are likely to be short-lived catastrophes, but the knock-on effects to wildlife can be considerable so that recolonisation extends over a lengthy period.

The blooming of annual desert flowers (see previous page) is comparatively short-lived and the extent of the spectace varies from year to year depending on the amount of rain which fell several months previously. A visit we planned to South Africa specifically to see the Namaqualand flowers had to be modified on arrival when we discovered lack of rain meant only a few flowers had been produced. The deserts in southern Arizona and California are easily accessible by road and the peak time for notable places can be found by calling a special desert hotline telephone number—regularly updated—to hear descriptions of the most colourful routes of the moment.

A Sense of Scale

When a scene is taken without any object to provide a natural scale, it becomes impossible to gauge the size of a tree or cascading falls. But if a well known object—such as a human figure or a horse—is included in the picture, we can immediately visualise the scale. However, if the photograph illustrates a pattern or a design in the landscape, a person will spoil the composition by breaking up flowing lines or introducing contrasting colour.

There are two distinct approaches to taking landscapes. One is that the natural landscapes in wilderness areas should be recorded quite simply as they appear—without any human figure or vehicle. I would argue very strongly if the composition is striking and harmonious, does it matter that the scale is not immediately obvious? The image surely stands or falls as it is presented. On the other hand, if a picture of a record-breaking feature is to be included as an illustration in the *Guinness Book of Records*, some scale *is* important.

If you need a person for scale and there is no one else around, you can always set up the camera on a tripod to use the delayed action mechanism and move into the shot before the exposure is made. Clothes can also add colour to a landscape, but care should be taken that they do not dominate the scene.

High mountains often look disappointing in a photograph—especially if they have been taken with a wide-angle lens which covers a wider angle of view than our own eyes and so reduces the scale of features in the landscape. A

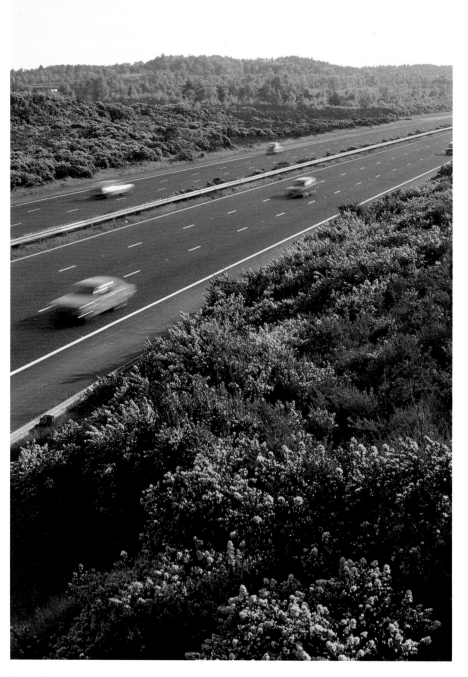

In built-up areas, cars can be used to add scale and colour to a picture. When I wanted to illustrate gorse growing on either side of a motorway, I chose a bridge spanning the motorway as a high viewpoint and selected a slow shutter speed to give the impression of the traffic speeding past. The small size of the cars helped to emphasise the extensive yellow banks of gorse.

Gorse growing beside M3 motorway in Surrey, April 1980. Kodachrome 25, 20mm lens on Nikon. Direct cross lighting.

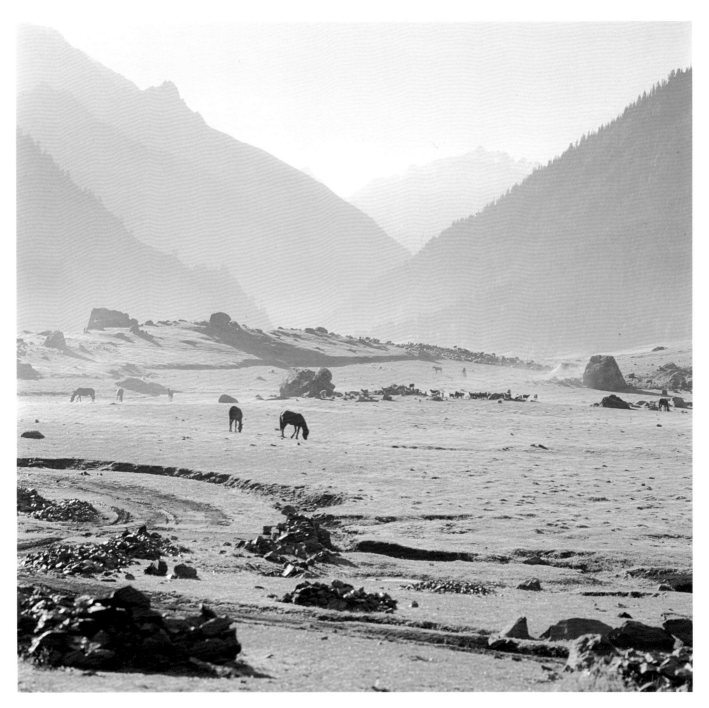

The pair of ponies grazing at dawn in Kashmir provide a focal point near the foreground as well as scale to the distant peaks. I was up well before breakfast to get this simple shot before other people began to stir and wander into the field of view.

Ponies grazing at dawn at Thajivas, Sonamarg, Kashmir, July 1974. Ektachrome Professional, 150mm lens on Hasselblad. Backlighting.

long lens can be used to select portions of the landscape and expand the size of distant objects.

Colour in the Landscape

Using colour film to photograph landscapes does not mean that views with brilliant colours should always be sought; on the contrary, some of my most memorable landscapes are simple images with either a single colour in a range of tones such as the raft on the Lijiang (p61) or recession planes of a series of hills (p41) or a single colour viewed against sky or water, such as logs floating down river (p14) and the red rock formations in Utah (p52).

Misty weather (p40) produces soft muted colours. Early or late in the day, mist may reduce the scene to a single colour shade with a variety of tones. Such a picture is mid-way between a black and white print and a full colour picture, so that tones become much more significant than in a full colour picture.

The colour spectrum seen in a rainbow (p89), or which appears when

I used a map to find this high viewpoint overlooking a Welsh estuary and I timed my visit to coincide with low tide, so I could see the pattern of the winding creeks. The lack of colour in the sky and the trees on the hills perfectly complement the sombre estuary.

Mawddach Estuary, Wales at low tide, May 1986. Ektachrome 64, 80mm lens on Hasselblad. Overcast.

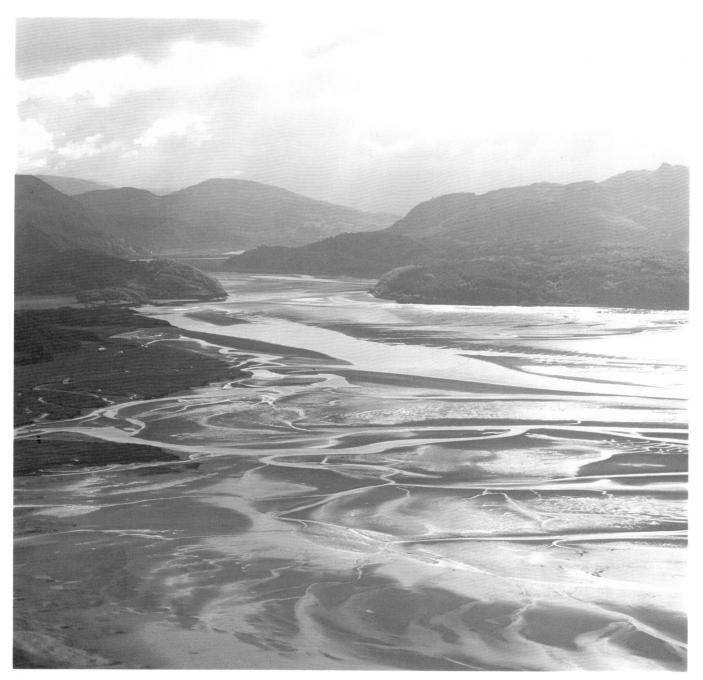

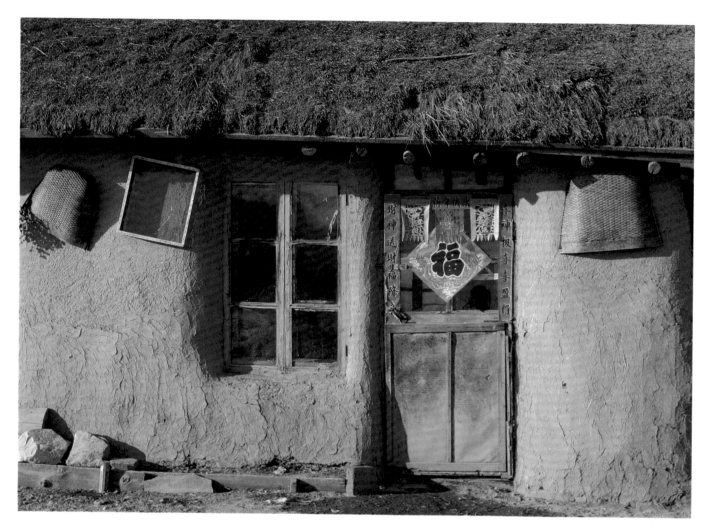

light passes through a prism, is built up of seven different rcoloured visible wavelengths ranging from long red to short blue. When lit by white light, objects appear as distinct colours because their surfaces absorb some wavelengths and reflect others. A red pillar box, for example, appears red because it reflects red wavelengths. The texture of a surface also affects the way we see colour: a shiny highly reflective surface will reflect some white light.

If the spectral hues are grouped together, the three primary colours—blue, green and red—result. When light from three torches—filtered so that each produces one of the primary colours—is superimposed, white light is produced. Strong colour filters are not normally used for colour photography which aims to reproduce the natural scene, but pale coloured filters can help to modify an unwanted colour cast. To understand the nature of how filters work with colour film, it should be remembered that a colour is modified by using a filter

of the opposite or complementary colour. This is perhaps best understood by imagining a colour circle, based on one devised by Michel Chevreul in 1854, in which neighbouring colours in the colour circle such as red, orange and yellow, appear to be in harmony with each other, whereas green appears opposite to red and is therefore a complementary colour. The bizarre colours produced on a colour *negative* film are complementary to those in the original scene and the colours produced on a colour *print* or *transparency*. Thus green grass and trees appear red on colour negatives, yellow appears blue and blue appears yellow.

Returning to the practical use of colour filters, it is a straw-coloured filter (81A, 81B or 81C) which is used to warm an unwanted blue cast out in the open on an overcast day. The 85 series (85A, 85B or 85C) used to correct the balance of tungsten light colour film in daylight, is somewhat stronger in colour but also of a yellowish hue; whereas the

A Korean house in north eastern China is finished with mud walls and a thatched roof—shades of brown from top to bottom. The red paper decorations above the door were therefore a particularly warming sight on a cold winter's day—positively drawing the eye to the point of entry.

A Korean house in Taoshan, China, February 1987. Kodachrome 25, 50mm lens on Nikon. Weak sunlight.

80 series (80A, 80B or 80C) used to convert the temperature of daylight colour films from 3200°K to 5500°K (Kelvin) for use with tungsten lighting, is blue in colour.

The yellows, oranges and reds of sunrises, sunsets (p62, 83) and autumn foliage (p108) are all warm colours of the spectrum. Bold colours, notably red, lit by direct overhead sun tend to dominate a scene, so that if red or orange foliage, a red door or lantern appears in a picture with cold blues or greens, the warm colours will appear to advance while the cold ones recede.

Landscapes sometimes can be improved by the introduction of a small area of colour. A patch of colour—however small—in a uni-toned or a drab landscape immediately creates impact and lures the eye towards the coloured area. A single red poppy in a cornfield, for example, is just as eye-catching as a person wearing a red shirt on a beach.

A colourful shrub or tree—whether it is flowering or turning colour in autumn—can give a welcome splash of colour to the foreground of a landscape lacking any contrasting colour. But if by introducing colour in this way, the composition becomes disjointed, it is far better to sacrifice the colour and keep a harmonious composition.

Distracting colour that produces discord, will need to be removed from a colour photograph. This can be done by changing the viewpoint so that the offending object either appears outside the revised framing or else is hidden by a stone wall, a tree or a building in the foreground.

Natural colours of the landscape can be changed by using strong coloured filters, but as outlines on p51. I do not believe that true landscape photographs should be tampered with in this way; although an orange sunset filter will certainly give much more punch to an insipid sunset. All the sunsets depicted in this book are completely natural.

Looking out to sea from the cliff tops on the island of Sark some of the other Channel Islands can be picked out. Early in the year the scene is relatively stark with sombre rocks projecting from the sea, so I used a gorse bush to add foreground colour and a polarising filter to increase the intensity of the blue sea.

Brechou viewed from the cliff top on Sark, April 1980. Kodachrome 25, 24mm lens on Nikon. Direct backlighting.

When I was shooting the Kodak calender on the river Thames, I wanted some additional colour for a tributary bordered by green emergent plants on one side and trees in full leaf on the other. My young son obliged by fishing at the water's edge; by using a wide-angle lens on a Hasselblad I kept the figure fairly small in the frame.

Boy fishing in tributary of river Thames, August 1985. Ektachrome 64, 60mm lens on Hasselblad. Direct side lighting.

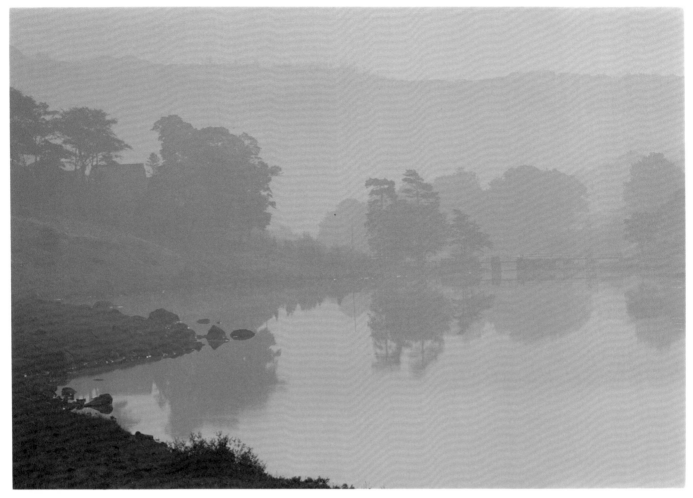

Atmosphere

While it is difficult to convey in a still photograph all the senses which we experience by using our eyes, nose and ears, it is possible to convey atmosphere. Most obviously this is an ephemeral moody misty scene, but it may equally well be stormy seas crashing against a breakwater or a geyser erupting. If we have experienced a similar event, it makes it much easier to interpret the atmosphere of the photograph.

Moody atmospheric landscapes can rarely be pre-planned; they have to be taken when they present themselves; although the odds of getting such a picture are reduced by going out early on an autumnal morning when mists often linger until the sun rises and burns them off.

When the air temperature drops rapidly at night so that it falls below that of water, it will appear to 'steam' early the following morning before the air temperature begins to rise again. This temporary climatic condition gives tre-

mendous scope for taking atmospheric landscapes—providing you are prepared to get out early before most people are even awake. I have seen this effect on rivers, streams, ponds and lakes, and on some occasions I have had to work fast as the warmth of the direct sun rays began to boost the air temperature.

Atmospheric haze—particularly early in the morning and late in the day—renders mountain ranges as a series of ridges with their colour and tone fading off into the distance. Known as aerial perspective, it results from dust or moisture in the air scattering the light. The resulting series of recession planes of colour—looking for all the world like cardboard cut-outs—produce especially moody and atmospheric photographs of hilly and mountainous areas. Indeed, it is one of the effects frequently depicted in Chinese art and pottery. A similar effect can be reproduced in miniature by building up a series of 'hills' with successive layers of tinted tissue paper Photographs of misty conditions are most effective when shooting into the

Early morning mist produces delicate, almost ghostly shapes of trees repeated as silhouettes in water. Such a simple scene with virtually no colour—just shades of grey—is peaceful and relaxing to the eye.

Early morning near Capel Curig, Snowdonia, September 1980. Kodachrome 25, 135mm lens on Nikon. Misty haze.

light with powerful foreground silhouettes.

When a city is shrouded in mist or, as Beijing in winter, has a permanently smoky atmosphere, tall buildings appear as successively fainter images which can produce a much more atmospheric picture than one taken on a clear day. As mist envelopes New York, it takes on a magical quality as skyscrapers appear to loom out of the haze. The gradual tonal range achieved by exploiting aerial perspective gives a photograph a wonderful feeling of depth.

Since the length of time when this effect is best depicted may be brief, it is important to seek out the most advantageous camera viewpoints beforehand. Overlooks constructed specifically for their spectacular views of mountain ranges are always worth visiting early or late in the day, although it may be a question of jostling for the best camera position with other photographers. But when I rose before first light to drive up the winding road known as Clingman's Dome in Great Smoky Mountains National Park one October, the temperature was below freezing and I had the dawn to myself.

If natural mist is lacking, a moody effect can be achieved by using a soft focus lens or simply by breathing on the lens to produce an ephemeral misty layer. Smearing vaseline on the lens is another technique used by some cameramen but I would not recommend it, for it takes an age to remove every trace of vaseline afterwards.

Abstracts and Patterns

Patterns and designs abound at varying magnification scales in the landscape, it only requires a seeing eye to select them from the mêlée of shapes and colours. On a large scale, there are the dendritic branching patterns—best appreciated from the air—of rivers feeding into an estuary at the mouth of the sea. The sinuous curves of a meandering river are also more apparent from a plane—indeed this is the only way they can be seen where a river passes through impenetrable tropical rain forest. Fields with recently ploughed furrows or parallel crop lines can be taken at close range end-on with obvious perspective distorsion (p25) of the lines, or from a more distant viewpoint so that the fields appear as a multi-coloured patchwork.

Repetitive patterns—whether they be parallel or wavy lines—such as ripples on a sandy beach, curves, circles or polygons—make exciting images. A

From the overview at the top of Clingman's Dome in the Great Smoky Mountains National Park the changing quality of light can be appreciated as dawn breaks. From here there is plenty of opportunity to use lenses of different focal lengths to illustrate the recession planes as the hills fade away into the distance, although the profile of the hills tends to be somewhat flat.

Dawn light on hills from Clingman's Dome, Smoky Mountains, October 1986. Kodachrome 64, 200mm lens on Nikon. Against the rising sun.

Walking down a back street in Shanghai, I found the entire face of a high-rise building covered with bamboo scaffolding. By the time I had set up my camera on a tripod, a large crowd had gathered, eager to look through my camera. A weak cloud cover fortunately helped to soften the strong light and reduce the strength of the shadows across the scaffolding.

Bamboo scaffolding, Shanghai, April 1985. Kodachrome 25, 200mm lens on Nikon. Slightly diffused sunlight.

familiar sight to anyone who has visited the Far East is the terraced rice fields which look especially stunning soon after the seedlings have germinated when the young leaves appear a rich green. Fields which have been cultivated as a series of repeated curves appear much more restful to the eye than narrow rectangular terraces.

With an attuned eye, patterns—not immediately obvious—can be found

from unexpected sources. For instance, I found high rise buildings being built in Shanghai festooned with bamboo scaffolding, produced a series of criss-crossing lines. Adjacent to the river Thames at Wandsworth, rubbish is compressed into containers which are temporarily stacked up on the quayside. Highly mobile cranes lift the yellow containers into barges for transportation—most appropriately to a place

downriver called Mucking! The stacked bright yellow containers provide scope for plenty of variable designs depending on the focal length of the lens used. Often when a long lens selectively frames a small portion of a scene, the effect becomes completely transformed.

When water in a pond or lake evaporates to reveal a muddy bottom, the stress patterns which arise as the mud dries out result in intriguing polygonal

A riverside depot where rubbish is packed into yellow containers is a study in lines. The red vertical struts support a moving gantry with a crane; stacked up below are the yellow containers at a time when the Greater London Council (GLC) was still in existence.

Western Riverside Transfer Station, Wandsworth, river Thames, September 1985. Kodachrome 25, 35mm lens on Nikon. Oblique backlighting.

When a muddy-bottomed pool dries out, the surface cracks into polygonal shapes, which present intriguing patterns for photography. The dark rounded impressions are footprints made by a giant tortoise walking across the floor of the dried up pool.

Giant tortoise track in dried up muddy-bottomed pool, Alcedo Crater, Isabela, Galápagos, March 1975. Plus-X Pan, 80mm lens on Hasselblad. Overcast day.

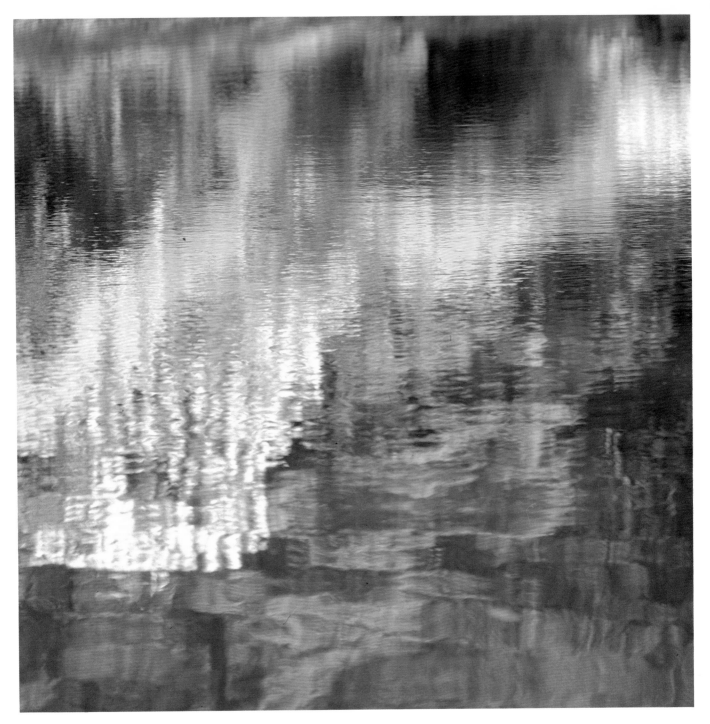

shapes. This pattern was reproduced as a graphic poster campaign during the 1976 drought in Britain in an attempt to get people to use less water.

Abstractions of the landscape are more difficult to interpret; indeed, they may be created in the camera or the darkroom. Modifications of a conventional straight image can be seen when a reflection on water is distorted by ripples, or when a heat haze forms a mirage. Shooting through a steamed up window gives a similar effect to using a soft focus lens (p50). Abstract images can also be produced by using a slower shutter speed to record blurred movement of coloured objects. Defocusing an image of multi-coloured objects—such as flowers in a field—has the effect of producing blobs of colour not unlike an impressionistic painting.

While I was photographing a bank of flowering azaleas beside water, a light breeze began to ripple the water surface. I decided to lower the camera angle to get this impressionistic view of the coloured reflections.

Abstract reflection of azaleas at Leonardslee, Sussex, May 1985. Ektachrome 64, 150mm lens on Hasselbad. Early morning light.

Equipment

Unlike close-ups or action shots which necessitate a single lens reflex (SLR) system, landscapes can be taken with any type of camera. Indeed, my young son has taken some excellent pictures using a 35mm compact camera. However, there are distinct advantages to be gained by using a reflex or a field camera for taking landscape photographs.

The choice of camera will depend on the amount of time that will be spent taking landscapes, how much walking or climbing is likely to be involved and, perhaps not least, what system comes within budget. Because most of my time is spent taking wildlife pictures which necessitates using SLR cameras, I also use these (both 35mm and 6 x 6cm systems) for taking my landscapes.

Cameras for Landscapes

The simplest kind of camera which will give good quality pictures is a 35mm compact. Originally, these were made with a fixed 35mm lens, but there are now several models available with a zoom 35–70mm lens which allows the choice of using the lens either in a wide-angle mode or in a tele mode. The film speed does not have to be manually set, for cameras which can read the DX coding—the pattern of 12 conducting (silver) and non-conducting (black) squares on the outside of each 35mm film cassette unique to each film—for speeds from ISO 64–1600. DX coding was originally developed by Kodak, but is now present on all 35mm films. The bar code on the cassette is used by automatic processors to identify the kind of film and its length. Compact cameras have an auto-focus system which operates by aligning the centre of the frame on the subject. Models with a focus lock allow the subject to be offset to one side of the frame after it has been focused.

The main problem with simpler automatic cameras with a built-in flash

without an optional on/off switch, is that when the available light is low the flash automatically fires. While this will illuminate foreground objects, it will not light up distant landscapes which will therefore appear underexposed. Some up-market models, however, do have a synchro-sunlight facility which balances the flash with the available light.

Perhaps the biggest advantage of a compact camera is that it is extremely quick and easy to use and may enable a shot to be taken even before there is time to change a lens on an SLR system. It is therefore more appropriate for candid and travel photography than for landscapes, although the weatherproof and waterproof compacts are ideal when working in wet environments.

Without doubt though, the most versatile system is the 35mm SLR, which no enthusiastic photographer would be without, because it offers such a wide range of lenses (see below). Having said that, however, there are some people who argue that you do not need to use more than one lens to take landscapes.

35mm SLR cameras can be as simple as a light-tight container for film which is exposed one frame at a time by manually focusing the lens and by winding on by hand; or as complex as an auto-focus, auto-exposure, auto-flash model fitted with an auto-winder or a built-in motor drive which allows several frames to be exposed within one second. Although I use motor drives for wildlife action shots, I see no point at all in investing in a more expensive camera to gain this facility solely to take landscapes. Nowadays, more and more SLR cameras are being produced with a built-in auto-wind which aids taking repetitive shots where the action is rapidly changing.

I consider the most successful landscapes are the simplest ones; so I am convinced it is better to keep the camera system as uncomplicated as possible without all the gimmicks and flashing

lights present on some modern cameras. I certainly do not want my camera to think and act for me.

The twin lens reflex camera offers a square format 6 x 6cm (or $2^{1}/_{4}$ x $2^{1}/_{4}$ inch) at a price considerably below a 6 x 6cm SLR camera. Among the best known twin lens reflex models are the Rolleiflex, Mamiya and Yashica, but a camera which is extremely popular throughout China is the Shanghai-made Seagull which, for some strange reason, the average Chinese tourist persists in holding at ground-level and tilting skywards—thereby exaggerating the perspective distortion!

The two lenses on a twin lens reflex are mounted one above the other, the upper one is the viewing lens and the lower one is used for taking the picture. These cameras enable a medium format transparency (or negative) to be taken on roll film with an area twice as great as the 24 x 36mm frame on 35mm cameras, but they are not nearly so versatile as the 6 x 6cm SLR cameras with interchangeable lenses, magazines and viewfinders such as the Hasselblad, the Bronica and the Rollei 6006.

At the same time as the area of the film is increased, so the number of exposures per film is decreased. A conventional 120 roll film has only 12 exposures compared with 24 or 36 exposures on 35mm film; however, 220 rolls are available which provide 24 exposures. 6 x 6cm square format cameras—even with through-the-lens (TTL) metering—are a lot slower to use than a 35mm TTL camera because they do not fit so conveniently in the hand. But generally this is no problem, since landscapes should not be rushed.

There are some people who would dogmatically state that landscape pictures should never be taken on a square format, but always as a horizontal picture. Indeed, when researchers contact my picture library for stock photographs they invariably refer to horizontal formats as 'landscape' pic-

tures and verticals as 'portraits'. As someone who uses both 35mm and 6 x 6cm formats, I do not believe all landscapes necessarily work as a horizontal picture. In any case, it becomes rather tedious to look at an entire book with every picture framed as an identical shape. Many of my landscapes I shoot specifically to fill a square frame, deliberately including only a narrow sliver of sky on a dull day. For example, I took nearly all the pictures for a book about gardens seen from a window, on Hasselblad cameras and virtually the full frame was reproduced in each case. At least one reviewer took umbrage at this, I quote: 'Square is a *horrible* shape for a picture, neither one thing nor the other!'

Many people ask how I choose which format to use. The decision depends on several factors any one of which may influence my choice. As I have a much bigger range of lenses for my Nikon system, I have to use this when I want an ultra wide angle or a very long lens. Other factors include the purpose for which the picture is to be used; the lighting conditions which may dictate

using a certain filmstock and, not least, what kind of terrain is involved. For example, if I am climbing high up a mountain or working in small boats on the sea, I work solely with Nikons, which considerably reduces the weight as well as the volume of the gear.

Some photographers who want to use a medium format—without taking a square picture—have opted for the 6 x 7mm so-called 'ideal' format SLR cameras, but not all systems have interchangeable film magazines. In any case, providing the subject does not completely fill the square frame, it can always be cropped to a rectangular shape—although the film size will then be 6 x 4.5cm instead of 6 x 7.

It would be surprising if every scene was perfectly suited to being photographed as a horizontal, a vertical or a square. For example, there are some vistas I have taken which work neither as a square shape nor as a conventional rectangular picture, but which work well cropped into a narrow horizontal (see p151). If twenty people were given the same camera and told to shoot an

When I spent a week whale-watching in Baja California making frequent trips out in small boats, it was essential to keep the equipment as basic as possible, so I opted for two Nikon bodies and one motor drive. This shot of kayaks moving away from a camp site was taken early in the morning when no whales were surfacing. Working in dull light and from a moving boat, I was glad of the extra speed gained by using Kodachrome 200.

Kayaks, Magdalena Bay, Baja California, February 1988. Kodachrome 200, 200mm lens on Nikon. Overcast

identical vista, it is doubtful even two of the pictures would approach duplication. A case in point is the pair of pictures taken by my husband and me of the Hickman Bridge in Utah. Martin chose to move round to the left and climb a rock so a large area of sunlit rock face filled the left of the frame and both sides of the picture were softened with foliage. Instead, I decided it was too difficult to clamber onto a smooth rock with my Hasselblad and Benbo tripod, so I stayed down on the ground, using the fallen rocks in the foreground as the base to my natural frame.

Many audio-visual presentations may be very slick and impressive, but I cannot help being slightly irritated when *every* image appears as a horizontal landscape format irrespective of the subject and the lens used. The result is that some pictures—such as skyscrapers, a tall church steeple or a group of Lombardy poplars—are crying out to be taken vertically!

Another variable when buying an SLR camera is the type of shutter. 35mm systems have a focal plane shutter which usually synchronises with flash up to 1/125 or 1/250 second. The Hasselblad 500CM, Rollei 6006 and Bronica on the other hand have a shutter which synchronises with flash at any shutter speed. For landscape work—which necessitates the use of flash only rarely—this is perhaps of academic interest.

Some photographers regard the field or view camera as the landscape camera *par excellence* because of the large size of frame (usually 10 x 12.5cm [4 x 5 inch] or larger) and the highly flexible camera movement. The cost per frame of sheet film is considerably higher than roll film (for example, 4 x 5-inch Ektachrome 64 Professional Film is approximately ten times the cost of a 35mm frame) but when perfectly exposed, the quality is superb. The biggest disadvantage though, is that being both bulky and heavy (coupled with the obligatory tripod), it cannot be carried on foot over large distances. A century ago when all cameras were large format ones, it was not unknown for photographers to use a wheelbarrow to transport their equipment over even short distances. In 1875, William Henry Jackson used pack-mules to transport cameras—complete with 20 x 24-inch plates—up into the Rocky Mountains. They were the largest plates used in the field in the United States up to that time. His spectacular landscapes taken somewhat earlier in Yellowstone, led to this area being designated the first National Park in the United States.

My husband chose a 24mm lens on his Nikon to photograph this natural bridge in Utah, while I opted for a 60mm lens on my Hasselblad (overleaf). It is interesting that with only a slight adjustment to the viewpoint, we have both managed to fill the different shaped formats with the arched bridge.

Hickman Bridge, Capitol Reef. National Park, Utah, January 1988. Kodachrome 25, 24mm lens on Nikon.

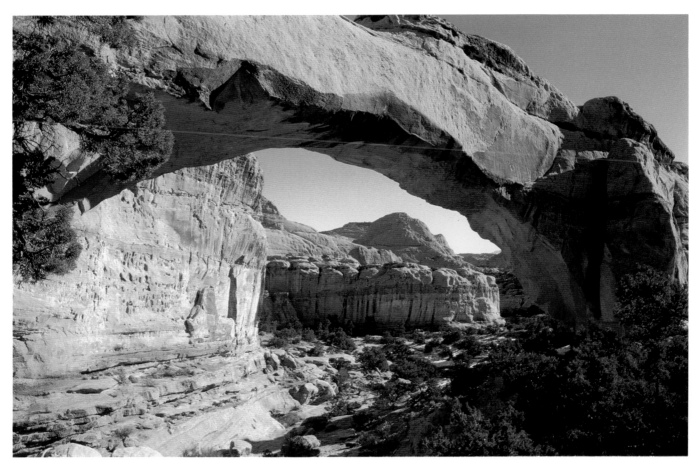

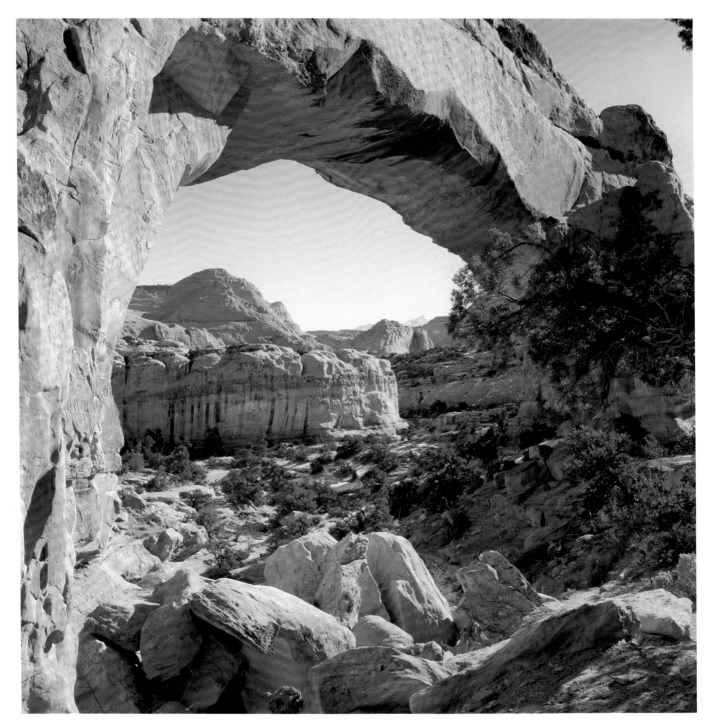

Although the perspective-correcting (PC) lenses available for several single lens reflex systems do allow for some correction of converging verticals when a wide-angle lens is tilted up or down, it is not comparable with the infinitely possible variations with a view monorail camera. When the relative positions of the front and back of the camera are adjusted, converging or diverging verticals can be corrected. Thus, dropping the front corrects the diverging verticals gained when a camera is looking down on a subject, while raising the front corrects the converging verticals produced by tilting a camera skywards.

Panoramas are always appealing and the highly specialised Alpa roto camera—which rotates as it takes a picture—enables a totally distortion-free panorama to be taken on roll film through any angle up to 360°.

Compare the framing gained by using the square Hasselblad format with the rectangular one of a 35mm single lens reflex camera reproduced on the previous page.

Hickman Bridge, Capitol Reef National Park, Utah. January 1988. Ektachrome 64, 60mm lens on Hasselblad oblique backlighting.

Lenses

Anyone working on landscapes does not have to think in terms of investing in a wide range of lenses, although I do not believe that *every* picture can be taken with say, solely a 50mm lens. If I had to single out three lenses for landscapes for a 35mm SLR system, they would be 35mm (wide-angle), 50mm (standard) and 85 or 90mm (medium long focus) lenses. Alternatively, a zoom 35–70mm lens would cover almost the same range as the three single lenses quoted above *and* allow continuous precise framing of all pictures. Although the top quality zoom lenses are now extremely good, like several professionals, I am not convinced that a zoom lens offers the same pin-sharp quality that I require in my pictures for reproduction purposes as I can achieve with my fixed focus lenses.

A glance through the captions to the pictures reproduced in this book will show that they were taken on lenses with a focal length ranging from 8 to 400mm. The reason is probably because I happen to have such a wide range of lenses for my wildlife photography. I am used to viewing landscapes with them and so I am not blinkered in terms of seeing landscapes with a limited angle of view. The important thing to remember is to compose the picture so that it fills the frame. If the sky is the most attractive feature, then this can fill most of the picture; always try to avoid large areas of dull, lifeless sky. If it is impossible to include all the features you want with a standard lens, then switch to a wide-angle lens; conversely, if it is impossible to physically move in closer to the subject, then a long focus lens could be the solution.

However, the increased image size gained by using a long focus lens means that the depth of field is decreased, so that deciding the plane on which to focus the camera needs to be done with even more precision than with a standard or a wide-angle lens. A long lens can be used to focus attention on part of the landscape by selectively focusing on a particular feature and throwing everything else out of focus by using a wide aperture. Alternatively, the depth of field can be increased by stopping down the lens to a smaller aperture. Most modern lenses have depth of field scales marked on them. If the maximum depth of field is required, focus on the nearest object noting the distance, then refocus on the furthest object and note that distance. Select the aperture which

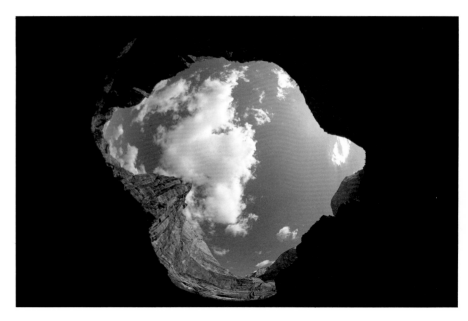

Throughout Zion National Park high walls thrust skywards and I decided to use an 8mm fish-eye lens making the walls a solid frame to the picture. With the camera mounted on a tripod so the lens pointed skywards, I crouched on the ground and used a cable release to take the picture so as to avoid appearing in the field of view.

Zion National Park, Utah, February 1982. Kodachrome 25, 8mm fish-eye on Nikon. Direct sun with polarising filter.

After we had stopped the car to fill up with petrol, I looked up and saw snow being blown off the mountain ridge rim-lit by the sun. I tried using a 135mm, then a 200mm lens, but I finally opted for a 400mm lens so that the blowing snow was more obvious. There was so much light reflected off the snow; it gave an exposure reading of two stops higher than normal.

Snow blowing off mountain, Utah, December, 1987. Kodachrome 25, 400mm lens on Nikon. Backlighting.

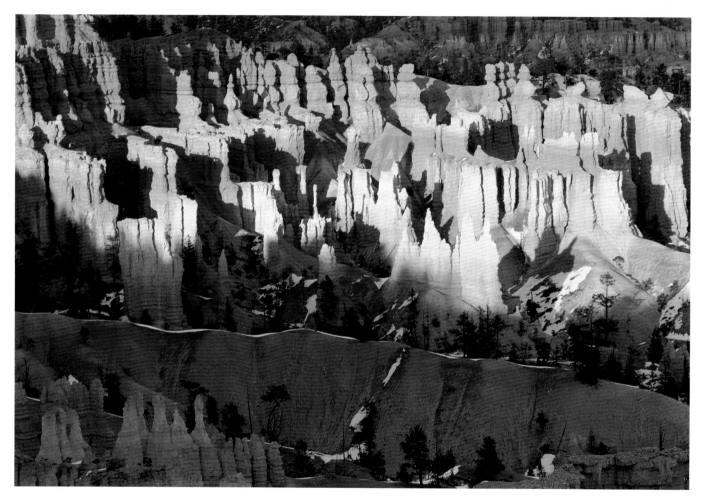

Of all the canyons I have visited in Utah and Arizona, Bryce manages to be both spectacular and intimate. The weathering of the limestone pinnacles into intricate shapes is best appreciated after a winter snowfall. No single lens can do justice to the multitude of coloured limestone pinnacles which project skywards from Bryce Canyon. A very wide angle lens will encompass a broad vista, but then the detail becomes lost; while a long lens highlights shape and pattern without any feeling of the magnitude of the landscape. Bryce is a place where the interplay of light and shadow gives limitless opportunities for getting new pictures with different focal length lenses, with and without snow.

Bryce Canyon, Utah, Kodachrome 25 with Nikon. March 1982, 135mm lens.

covers this range, making sure to focus the lens not on the nearest object but about one third of the way beyond it and the furthest plane of focus.

A wide-angle lens is often thought of as the ideal landscape lens, but if by using one, a larger area of dull sky or foreground is seen in the frame, then there is no inherent advantage to be gained. A wide-angle lens is most useful for gaining a bigger angle of view in places where it is impossible to move any further back or to provide foreground emphasis.

On one trip to China I worked with two other British photographers, Jane Bown of *The Observer* and Martin Parr. Repeatedly I noticed they wanted to get as close as possible to their subject using a 50mm or even a 35mm lens, while I preferred to stand back and use a 135mm or a 200mm lens. Working at close range is a popular photo-journalistic approach, but I find it is much better to keep my distance when taking landscapes where I definitely do not want people looking directly at the camera.

Lenses with a wide maximum aperture—so called 'fast' lenses—which may be essential for getting a grab shot for a newspaper, are a waste of the extra money for landscape work, since it is rarely appropriate to be working with a lens wide open at the maximum aperture.

A special kind of wide-angle lens known as the perspective-correcting (PC) or shift lens, was designed specifically to be used to correct the converging verticals in architectural photography. Most of the better quality camera systems produce at least one, sometimes two, PC lenses. Nikon, for example, have a 35mm and a 28mm PC lens.

The perspective distortion gained by tilting the camera up or down is corrected by off-centring the PC lens. The design of these unique lenses means that they have to be stopped down manually.

A soft focus lens (attached to the front of a camera lens like a filter) creates soft muted colour which produces a more romantic effect than a sharply defined image.

Detail of snow-clad Bryce Canyon Utah, in winter. January 1988. Kodachrome 25. 300mm lens on Nikon. Direct sunlight.

myriad of silver reflections in leaves and grass disappear) and the colour of rocks is better saturated. It will greatly clarify any scenes which include an area of calm water by removing the skylight reflections so that water weeds (or seaweeds) may be distinguished. The main disadvantage of this filter is that

As the sun began to set behind the dunes in White Sands National Monument, the dunes lost their surface detail and became flat and uninteresting. I therefore decided to use a starburst filter and shoot straight at the sun to give a more interesting focal point to a dull picture. The effect of the starburst can be varied by adjusting the size of the lens aperture and judged by using the preview button.

White Sands National Monument, New Mexico, March 1983. Kodachrome 25, 85mm lens on Nikon. Sunset with starburst filter.

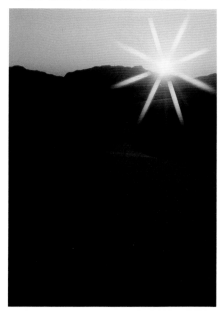

Filters

When taking representative landscape pictures on colour film, very few filters are necessary to enhance the natural scene. Certainly none of the many gimmicky filters such as cross-screen, spectral star, multivision and—horror of horrors—colour multivision, are appropriate for straight landscapes. In a very simple scene with the sun in a clear uni-toned sky, a starburst filter can provide an eye-catching focal point to an otherwise flat picture and it does not appear too exaggerated since natural starbursts (p69) are not infrequently seen.

Most often, filters are used by attaching them to the front of the lens, but fish-eye and mirror lenses have built-in filters mounted into a disc brought into position beside the lens. Three basic types of filters are available for use on the front of the lens. Gelatine squares are the cheapest, but easily get damaged, so they are most useful for experimenting before buying a more expensive glass or plastic filter. Glass filters that screw in to the front of the lens although the most expensive, are also the most durable. The main disadvantage of screw-in filters though is that separate ones have to be bought for different diameter lenses. Also, with a graduated screw-in, no adjustment can be made to the extent the colour area impinges into the frame, so that the end of the colour zone tends to dictate the position of the horizon in the frame.

More versatile are the Cokin and Hoyarex filter systems. Each consists of a universal filter holder easily adapted to fit a lens of any diameter (apart from very large telephotos) simply by changing an adapter ring. This ring is screwed directly into the front of the lens, for connecting to the filter holder. A square plastic filter is then slid into the grooved holder. Using this system, a picture can be composed and a graduated colour filter moved into the holder to suit the scene. Multiple filter combinations can be used by combining filter holders. Plastic filters, although much more durable than gelatine, can scratch more easily than glass, so they do have to be handled with care and like all filters, kept clean.

In my photographic waistcoat I always carry with me skylight, ultraviolet (UV), polarising, graduated grey, neutral density and warming filters. A skylight filter reduces the blue cast which can appear in shady parts of a scene, while a UV filter (by absorbing the ultra-violet rays) can help to clarify a vista. Both these filters also help to protect the lens from dust, rain or salt water spray. A polarising filter helps to change the nature of scenes as we see them, by removing skylight reflections from non-metallic surfaces such as leaves, water and windows. The effect, which works only when the sun is shining and the camera is used at right angles to it, can be judged by holding a filter in front of the eye and rotating it. Generally, a polarising filter helps to increase the contrast between blue sky and white clouds. It also enriches colours of landscapes so that vegetation appears much greener (because the

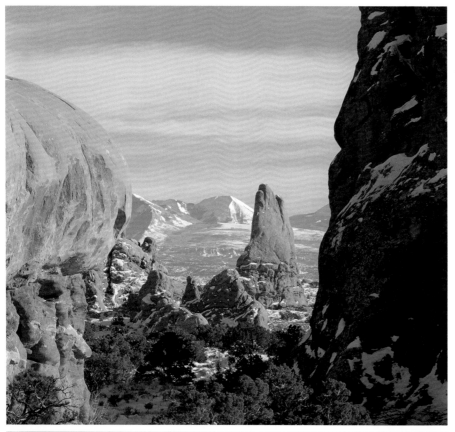

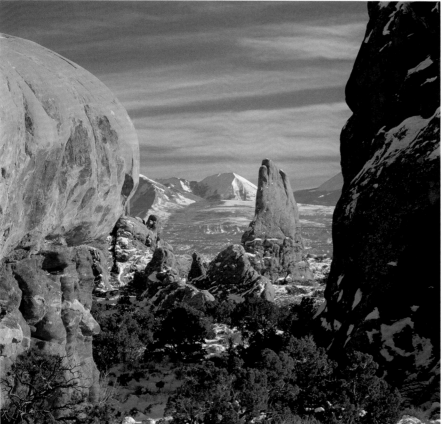

when it is used fully polarised, there is loss of 1¹/₂–2 stops which may be a problem when using a slow speed film on a windy day; but this loss in effective film speed can, like a neutral density filter, be used to advantage to gain a slow shutter speed for deliberate subject blur.

When taking landscapes on a day with a virtually colourless sky, there are two possible options: either exclude the sky from the picture, or use a graduated grey filter to reduce the contrast between the darker foreground and the pale sky. Unlike the tobacco, magenta or blue graduated filters, this looks acceptably natural for a straight landscape, although care will have to be taken about positioning the darker land in the frame. This presents no problem with the square plastic filters which can be dropped into a filter mount.

Colour pictures taken on overcast days tend to have a bluish cast. This can be counteracted by using a pale straw-coloured so-called warming filter (81A or 81B). Whenever I use one of these filters, I always take the same scene without a filter, so that I can compare the colours. Sometimes—notably with snow or frost scenes—I prefer the unfiltered shot, since it helps to convey the cold temperature at the time.

Colour conversion filters which balance the light for the particular colour film, are useful for anyone who uses only a single camera and wants to change film type in the middle of the roll. The 80 series (blue in colour) are for use when exposing daylight colour films in artificial light sources and the 85 series (straw-coloured) are used when tungsten light films are exposed in daylight.

As with colour films, a polarising filter can be used with monochrome films to increase the contrast between a blue sky and white clouds when shooting at right angles to the sun. Since a coloured filter

This pair of pictures taken within a few minutes of each other illustrate how a polarising filter (used bottom left) enriches the colour of rock as well as enhances the contrast between snow-capped mountains with white clouds and a blue sky.

Arches National Park, Utah, January 1988. Ektachrome 64, 250mm lens on Hasselblad. Oblique direct light: Top, without a polarising filter, Bottom, with a filter.

used with monochrome films will darken its complementary colour and lighten its own colour, yellow, orange or red filters will also darken blue sky and hence increase the contrast between the sky and white clouds. A green filter will help to make a red flower stand out from green foliage.

On days with an overcast sky, polarising and coloured filters will not enhance the sky; however, a grey graduated filter will introduce a grey tone to a white sky or strengthen the tone of a grey sky. The tone can be enhanced still further by giving it additional exposure in the darkroom.

Camera Supports

Even though the quality of ISO 200 films is now very good and allows a reasonable shutter speed coupled with a small aperture to be used, better quality landscapes will be taken using slow speed films such as ISO 25 or 64 with the camera mounted on a robust and rigid tripod, for a flimsy tripod that wobbles in the slightest breeze will cause more problems than it cures.

There are three main reasons in favour of using a tripod for all landscape photography. Firstly, it allows the camera to be panned across the scene so that different ways of framing the

view can be compared; secondly, it allows a slower shutter speed to be used so that the lens can be stopped down and the depth of field increased; it also enables the scene to be framed ready for capturing the optimum lighting which may pass in a fleeting moment.

I never travel anywhere without the versatile Benbo tripod. The unique design allows the legs and the centre column to be manoeuvred into any position simply by unlocking a single lever and locking it again. Although many landscapes can be taken with the camera supported at a normal eye level position, it is sometimes necessary to use a lower (or a higher) camera position. Using the standard (Mark I model) Benbo, the camera can be supported on the roughest terrain from ground level up to 1.57 metres (5 feet 2 inches), while the Mark II can be used from ground level up to 2.6 metres (8 feet 1 inch)—although when fully extended, the latter requires a stepladder to see through the camera viewfinder!

There are three basic types of tripod heads, a ball/socket, a pan/tilt and a tilt top. I tend not to favour a pan/tilt head because I spend a lot of time bending over my tripod and I do not like being poked in the chest by a long arm! Instead I use a robust ball/socket head

which gives me great flexibility of movement and can be adjusted and locked into position very quickly. The tilt top is a cross between a ball/socket and a pan/tilt head. The Spiratone Super tilt top has three individually locking planes of rotation. It provides a 360° rotation and a 210° tilt control.

In addition, the panorama head is of special interest to the landscape photographer. It also rotates through a complete 360° which is useful for taking a series of landscape pictures so that they join up to make a complete pano-

A tripod was essential for ensuring a crisply defined picture of these moss-covered benches and table in dull light and for composing the picture. Even slight adjustments made to the camera on the tripod can alter and improve the composition. Once the best viewpoint has been found, several identical exposures can be made which are both cheaper and better quality than duplicates.

Moss-covered table and benches, Paco de Oca, North Spain, March 1987. Kodachrome 25, 35mm lens on Nikon. Overcast.

rama. Calibration scales for different focal length lenses on a 35mm format (from 28mm to 100mm) indicate the degree of rotation for each exposure in the panoramic series.

Colour Films

The plethora of colour films now available on the market makes the choice somewhat bewildering; but once the initial decision to use colour negative (print), positive (transparency) or instant print film is made, the choice is somewhat narrower. Since negative films have a greater latitude, they do not require such precise metering of the light and they can be exposed in daylight or in artificial light. Small colour prints are a convenient way of showing pictures to a few people or good quality colour negatives can be enlarged as exhibition prints.

Positive or slide films on the other hand, which have relatively little exposure latitude, are much easier to under- or over-expose. They are used most obviously for projection, but many people are not aware that they are also used for reproducing the colour plates in magazines and books (as here). Colour prints can be made directly from colour slides using reversal paper such as Cibachrome or by making an internegative and printing on colour negative paper.

The speed of the film indicates the film's relative sensitivity to light. A high ISO number means that the film is more sensitive to light than a low number. Such films are referred to as 'fast', in contrast to films with low ISO numbers which are 'slow'. The best definition will be gained by using slow films with an ISO of 25–64. They are easiest to use when there is plenty of available light, but if the subject is static and the camera is supported on a firm tripod, they can be used in poor light by giving a long exposure. Medium speed films (ISO 100–200) can be used outdoors on sunny or overcast days. The majority of landscape work can be done using slow to medium speed films and (apart from Kodachrome) they can, if necessary, be 'pushed' by double rating the normal

When using a medium format for taking landscapes, I nearly always elect to use a slow speed film such as Ektachrome 64 or Kodachrome 64. However, when action dictates using a fast shutter speed, I opt for a faster film such as Ektachrome 100 or 200 and use a motor drive to expose a rapid sequence.

Family of mute swans *(Cygnus olor)* swimming in River Itchen, Hampshire, May 1988. Ektachrome 100, Rollei 6006 with 150mm lens. Direct side lighting.

film speed of say ISO 64 to ISO 128 if additional speed is required. Once the film speed has been changed, then the entire roll must be exposed at this speed and the processing laboratory informed. A surcharge is usually made when a film has been re-rated. If, however, prints with conspicuous grain are required, these can be made by deliberately underexposing a fast film (such as ISO 1000) on a dull day by four stops.

I use a Polaroid back on my Hassel-

blad in the studio to determine the exposure with new lighting set-ups. In the field I use it in quite a different way to record locations and viewpoints where the light is not suitable for exposing transparency film. I can then use the instant print as a convenient way to compile a visual file in a card index as an *aide memoire* when I want to return at a later date. Postcards can also make a useful visual index—not that I would want to copy what someone else had done (in fact I nearly always strive to find a different viewpoint) but to get some idea of a photogenic area, particularly when I am visiting a country for the first time.

Infra-red film produces a false colour image that can be used both for scientific and for creative photography. The emulsion layers of Kodak Ektachrome infra-red film 2236 are sensitive to both visible and invisible infra-red wavelengths. If a deep yellow filter is used to absorb the ultra-violet and blue light, the overall effect is that living vegetation (which reflects infra-red) appears red/magenta on the slide and dead or diseased trees can be distinguished as a bluish-purple colour. Aerial infra-red photography of forests is therefore an invaluable tool to the commercial forester in monitoring the spread of disease through a forest. Since 1984, each federal state in West Germany has made a standard aerial survey of their forests using false colour infra-red film. Back in the laboratory, photo-interpreters then look at two copies of each view through a stereo microscope with a magnification of X20–30. From studying the pictures it is possible to calculate the percentage of healthy and diseased trees in a given area.

When using infra-red film, the camera lens should always be well stopped down so that this compensates for the discrepancy between the visible and the infra-red plane of focus. Some cameras have an infra-red dot on the focusing ring for realigning the plane of focus after visually focusing the camera. Since infra-red films cannot be given a precise speed rating and because the film produces pictures with rather a high contrast, the exposures need to be bracketed either side of the probable exposure. Kodak Ektachrome infra-red film 2236 is given a nominal ISO rating of 100.

The false colour photography of earth taken from the Landsat satellites is both scientifically informative and aesthetically appealing. For example, it can

detect pollution and natural disasters such as earthquakes and volcanoes.

Monochrome Films

In today's world of multi-coloured images—in books, on television and on advertisement hoardings it is not surprising that when a small boy experienced an exhibition of monochrome prints, he exclaimed 'How dull it must have been for people when they lived in a black and white world'!

The approach to taking black and white landscapes should not be simply to duplicate colour shots by using a second camera body loaded with black and white film. Each individual picture has to be seen and composed. Unlike when taking colour pictures, it is tones, not colours, that make the image, so that the relative strength of grey tones, between white on the one hand and black on the other, becomes all-important. The eye for selecting striking black and white landscapes must therefore be quite distinct from the eye that selects colourful scenes.

Bold simple shapes and designs work well in black and white which is a particularly effective medium for emphasising texture since the eye is not distracted by a colour element. Working with black and white films allows a much greater control over the final picture than when using transparency film when, for most people, the work begins and ends with the composition in the viewfinder and release of the shutter. Working in a darkroom to produce your own black and white prints will make you much more aware of

The simplicity of this picture belies the time spent taking it. This double glazed window is one of many piercing covered walkways overlooking Kunming Lake at China's renowned Summer Palace near Beijing. I selected this particular window because the glass was not cracked and the painting of a potted miniature tree, or *penjing*, would work equally well in black and white or colour. To take the picture I had to balance precariously on a narrow bench with the camera on a tripod beside me. I ended up spending much more time climbing down and removing the tripod to allow visitors to pass than taking the pictures. Since I wanted both the painting and the distant scene—of people walking over the frozen lake—sharply defined, I had to use a small aperture to gain the maximum depth of field.

Glazed window with painting frames view onto lake at the Summer Palace, near Beijing, China, February 1987. FP4, 60mm lens on Hasselblad. Overcast and slightly hazy.

highlights and shadow areas. This in turn leads to decisions about exposing the film specifically for one rather than the other, so that the final effect is changed. In addition, the negative can be greatly enhanced by the type of printing paper and the way it is exposed and developed in the darkroom.

When working with monochrome

films, you can forget colourful dawn and dusk skies, although it is well worth looking at these times of day for shapes that will make striking silhouettes as well as rimlit clouds. Red flowers no longer stand out from a green meadow, because they are reproduced as a similar tone of grey, but they can be highlighted by using an appropriate filter.

When I first took up photography, the proportion of black and white shots I took far exceeded colour. The prime reason for this was an economic one—as a penniless student I had to ration my colour films; but I was impatient to see the results of my experimenting as soon as possible. In those early days, I used an Exakta Varex IIa camera fitted with a film cutting knife which enabled me to use and develop short lengths of film most economically.

In the natural world, colour plays an important and often essential part in the way animals survive in the wild by blending in with their surroundings to avoid detection by predators or by advertising their presence (coupled with a noxious taste or sting) with warning colours so that predators learn to leave them well alone. Many birds and mammals attract their mate by displaying attractive colours. It is therefore essential to record these, and many aspects of the natural world, on colour rather than black and white film.

The demand for black and white wildlife photographs is therefore extremely limited and as it is also much more time-consuming to develop films and make prints than to shoot trade-processed transparency film, nowadays I tend to shoot monochrome film only when someone commissions me to produce monochrome prints for a specific purpose.

As with colour film, the speed of black and white film ranges from slow speed ultra-fine grain such as Panatonic-X (ISO 32) to fast films such as Tri X-Pan or HP5 (ISO 400). Slow speed films are preferable for reproducing intricate detail in architectural studies: they also provide greater contrast than fast films. The unique T-grain emulsion of Kodak T-Max films (ISO 100 and 400) produce sharp images with extremely fine grain.

All black and white films can, if necessary, have their film speed (ISO rating) modified from the normal speed (although this adjustment will have to be used throughout the film). If a grainy print is required, the size of the grain can be exaggerated by increasing the speed of a fast film and by printing on a hard

paper. Grainy prints are very effective and can enhance the mood of a landscape picture, but I prefer to use fine-grain films for all my work.

Useful Accessories

Often I find it is a small piece of equipment which helps me get a better picture. I therefore always carry a length of black tape for tying back unwanted branches out of the field of view; a compass to note what direction a subject faces when the sun is completely obscured by clouds; a pair of binoculars to look down in to canyons or up on to ledges to see if it is worth walking down or climbing up to get a picture and, perhaps most important of all for landscapes, a small spirit level to check the camera is level. Small spirit levels are now made which conveniently slide into a hot shoe attachment.

A variable time release is useful for making controlled long exposures on cameras which do not have a shutter speed in excess of 1 second, although I find I can accurately count out loud a long exposure by adding the word thousand after each number of seconds. The Prontor release has a dial which can be set for an exposure time between 2 and 32 seconds.

A periscope viewfinder has always struck me as a useful gadget for gaining a clear view when standing at the back of a crowd without a stepladder, but I have never used one and I suspect a fast

I rarely take pictures of people at work in Britain, but this was one originally used to illustrate the economic importance of reeds in a book about aquatic habitats which I illustrated. Since I could only stand on the cut part of the field, there was little scope for varying the camera position—although I could take the return trip as the operator drove his machine from right to left. This was not an opportunist shot; I had to check beforehand the season and the precise date when harvesting was likely to take place.

Modified rice harvester used to cut reeds at Wicken Fen, March 1981. Plus-X Pan, 80mm lens on Hasselblad. Against the light.

shutter speed would be essential to steady the 40cm high viewfinder made by Hama. The base of the periscope is held up to the eye in one hand while the other triggers the cable release.

Last, but by no means least, I would be totally lost without my field notebook, which I use not to record the exposure, but notes about the angle of the sun, ideas for future pictures or problem areas encountered. All this helps to build up experience as well as providing a useful *aide memoire* when I come to write a book such as this one!

Quality of Light

The quality of light is in the eye of the beholder. On the rare occasions when natural lighting appears especially dramatic, such as when the sun shines on to a house, a hill or a boat backed by dark storm clouds, it immediately stimulates comment from someone—photographer or not—who experiences it at the time. More subtle diffuse light is unlikely to evoke any such reaction, yet this is ideal lighting for photographing pastel-coloured subjects such as a pale green mossy carpet growing out in the open in a high rainfall area.

As an artist uses paints to create his picture, so a photographer utilises the available light—or adds his own light—to 'paint' his picture by highlighting colour, creating shadows or emphasising texture.

Light, be it natural or artificial, is essential for an image to form on the film emulsion; but it is the quality of light which can make or mar a picture.

The changing qualities of light may produce optimum conditions for a particular subject only briefly; for example, low angled sunlight helps to sculpt a three dimensional image by casting shadows. Direct sunlight also helps to highlight wet surfaces or glossy paint, while diffuse light prevents distracting highlights appearing where they distract attention from the main subject.

The odds of being in the right place at the right time can, however, be considerably reduced by getting to know a location at different times of day and at different seasons, so that the best time for photography can be anticipated at specific viewpoints. Landscape photographers generally prefer to work early or late in the day when the shadows are long, although this will depend on the latitude and whether the lighting is direct or diffuse. It is well known that each part of the world has its own distinctive lighting.

Daylight colour films are designed to produce the most authentic colours by exposure in daylight when the colour temperature is between 5200° and 5800°K. At sunrise and sunset, the colour temperature falls below 5200°K resulting in a warm colour cast. The colour temperature of artificial light is only 3200°K and so then either tungsten light colour films should be used or else daylight films can be used with a colour conversion filter (p52).

Metering Light

For taking landscapes, above all subjects, there is no need to use a fully automated camera. Although I use Nikon F3 bodies for my 35mm system, I very rarely use the automatic mode, since I much prefer to meter manually and make any necessary adjustments, especially for a tricky subject. All cameras which meter light reflected from the subject directly through the lens (TTL) are able to cope with average tones and non-extreme lighting conditions, but they are by no means foolproof. Anyone who goes out and buys an SLR camera assuming they will never fail to get a correctly exposed picture, is in for a surprise, for the camera meter is programmed to read an 18% grey Kodak card correctly. It cannot make adjustments for very pale or very dark subjects. Snow scenes, which reflect more light than an 'average' scene will therefore tend to appear

For much of the day, the deeply entrenched meanders of the San Juan River—known as the Goosenecks—lie in shadow while the upper slopes are bathed in sun. I returned to this site several times during the day and found the late afternoon lighting in early January was the best from this viewpoint, because the contrast between the slopes and the river was then minimal.

Great Goosenecks of San Juan River, Utah, January 1988. Kodachrome 25, 20mm lens on Nikon. Backlighting at 4pm.

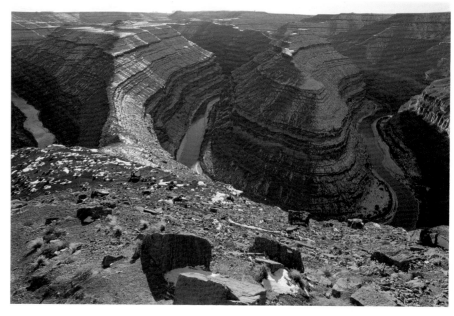

underexposed; while dark subjects, such as black sand beaches, will appear overexposed unless some adjustment is made to the metered exposure.

For cameras with an exposure compensation dial, to overexpose (for snow or white sand) the dial should be moved away from the centre 0 position to a positive (+2) reading; whereas to underexpose (for dark rocks) it should be set to a negative reading. On cameras without a dial, which do not operate solely by reading the DX coding on the film cannister (p45) an adjustment can be made to the film speed setting. When the film speed dial is set to a slower speed, overexposure will result and snow scenes will be correctly exposed; alternatively, a higher speed is used to underexpose for dark subejcts. This method is advisable only if an entire film is being taken of a similar toned subject, for if the speed is changed in the middle of a film, it is all too easy to forget to change it back to the correct film speed for an average toned subject. I therefore prefer simply to adjust the shutter speed or the aperture after having taken the exposure reading (opening up the aper-ture or using a slower shutter speed has the same effect as setting a slower film speed).

If your slides appear consistently dark (underexposed) or pale (overexposed) either you are not using the meter correctly or else the meter needs calibrating. Cameras which have a *spot* metering system meter the light over a specific area of film. With centre-weighted systems this is in the centre of the frame. This part of the frame therefore needs to be placed over the area that requires precise metering and for automatic modes the exposure locked before the camera is moved to recompose the scene with an off-centred subject.

Cameras which have an *integrated* TTL metering system, meter different parts of the image and take an average, will tend to overexpose a small brightly lit area against a dark background and underexpose a dark subject against a bright background. The solution is to look for a larger area of a similar tone and to meter off this.

You can calibrate your own meter by measuring the amount of light reflected from a natural mid-toned subject such as green grass. Note this exposure and take a picture. Then adjust the exposure by opening up and closing down by half-stop increments to one full stop on either side of the metered exposure. Make sure you keep a careful note of the precise exposure used for each frame. After processing, write the exposure used for each frame on the frame mount and lay them on a light box noting the frame which gives the best colour saturation. If this was not the original one, note by how much the lens was closed down or opened up. For example, if you were using Koda-chrome 25 and the best exposure was gained by closing down half a stop, the camera should be set to ISO 40° for this film (or the exposure compensation dial permanently adjusted to read $-\frac{1}{2}$ stop). You will then be able to expose all mid-toned subjects correctly.

By using a light meter separate from the camera, it is possible to take an incident light reading of the light falling onto the subject. This is done by holding the meter, fitted with a white diffusing cone, in front of the subject facing the

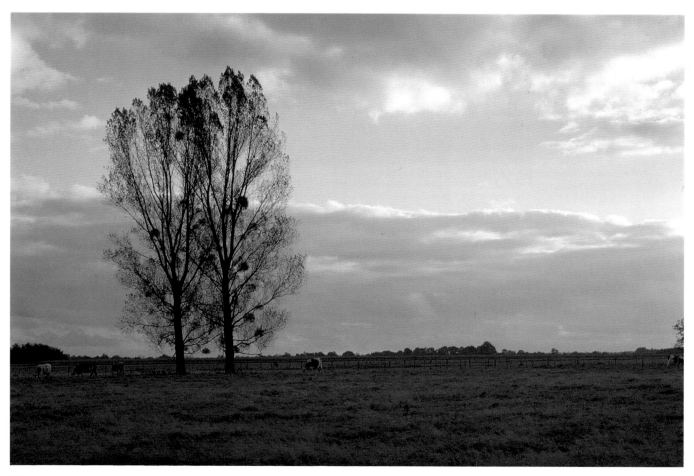

direction of the light source. This method gives a very accurate reading and is the way workers using cameras without TTL metering determine the exposure.

One of the most common recurring problems of landscape photographs, which include a large area of bright sky, is the tendency to underexpose the land below. If the light reading is taken from all or even part of the sky, this will give a false high reading for the land, resulting in underexposure. The solution is to meter from the land and to use a graduated filter (p51) to add some colour to the sky and thereby reduce the contrast.

Reference is sometimes made in this book to bracketing exposures. After the metered exposure is used, this involves making a range of exposures on either side of it. Some photographers—especially if the film is paid for by someone else—habitually bracket to make sure they have at least one usable shot. I do this occasionally when I discover different parts of a scene have different exposures, so it is difficult to be sure of the correct average reading. To

adopt bracketing as a standard belt and braces policy is not only very wasteful of film, but it also means you are going to miss getting the one-off action shot which cannot be covered by bracketing.

The multiple choice metering programmes now available on many up-market SLR cameras, are designed for taking all kinds of photographs, including rapid action. They are a good deal more sophisticated than is necessary for taking the average landscape photograph. Some models with a built-in motor drive have no facility for using a cable release. Small wonder that many people are buying up second-hand 35mm cameras without all the modern gizmos—such as flashing lights in the viewfinder—which inevitably distract attention from composing the picture.

Flash is rarely appropriate for taking landscape photographs, unless it is balanced with the available light. More and more 35mm cameras are being produced with the facility for taking automatic synchro-sunlit pictures.

As we were driving across Normandy towards the Channel ferry, I spotted a pair of poplars with mistletoe. By the time we stopped the car and I found the best framing, the sun was blotted out by a cloud, so I metered off the sky to show the trees in silhouette. When the sun reappeared, I metered off the field so that the colour of the grass, trees and cattle would be apparent. This pair of pictures illustrates how, within minutes, the mood of a scene can change dramatically, simply by a cloud passing over the sun.

Poplars with mistletoe, Normandy, France, September 1977. Kodachrome 25, 50mm lens on Nikon. Indirect skylight (facing page) Direct oblique light (below)

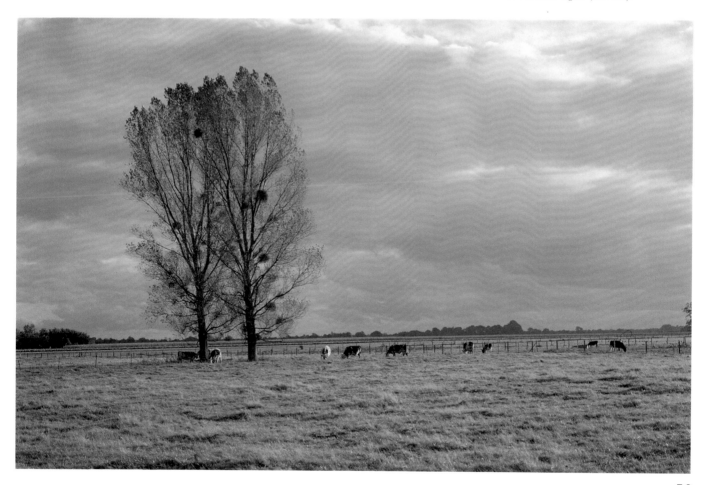

Dusk and Dawn

Among some of the most evocative landscape photographs are the ones taken at dawn and dusk, not necessarily always of sunrises or sunsets. One way of making sure of getting moody misty shots early in the morning is by camping on site so that time does not have to be wasted driving to a location.

The rich colours of sunrises and sunsets form when the low-angled sun penetrates the atmosphere so that the short blue wavelengths are refracted and reflected while the long red ones pass through to give a warm cast. This is most obviously apparent when sun shines onto snow, pale coloured sand or water.

When the sun is near the horizon, the camera can be pointed towards the golden ball to take a light reading, without risk of damage to the retina; although if a reading is taken from the sun, the rest of the sky will appear underexposed, while if the exposure is taken from the sky, the sun will be overexposed. Often the only solution is to compromise; I find a longer focal length lens is useful to meter off an area of sky adjacent to the sun. Even then,

this is a case when it is sensible to bracket the metered reading since it is arguable what is the 'correct' exposure. Each pair of eyes may interpret the scene in a different way and therefore look for a variable end result.

When the sun is below the horizon, it can produce a dramatic pre- and after-glow to light fluffy clouds or a pale pink or orange aurora to a clear sky. During this twilight period, before the sun rises or after it sets, the sky colour is repeated when reflected in water or ice. In the

Leaving base in darkness is like setting off into the unknown, but this is essential to be on site ready for sunrise. I was doing a recce along the river Thames one winter, when I noticed this old barge with the pink pre-glow of the rising sun reflected in the water repeating the barge colour.

Barge on the river Thames, February 1985. Kodachrome 25, 200mm lens on Nikon. Pre-glow of dawn light.

The Lijiang or Li River near Guilin is a magical setting for landscape photographers and artists. On two visits there, the light was quite different, but each time I came away with some striking pictures of bamboo rafts being paddled on the river against the dramatic karst backdrop. To get this picture we chartered our own boat before dawn broke so we could climb a hill to a favourite viewpoint of Chinese photographers. Compare the light here with the light on the same view on page 127.

Dawn over Lijiang, near Guilin, China, October 1985, Kodachrome 25, 50mm lens on Nikon. Dawn.

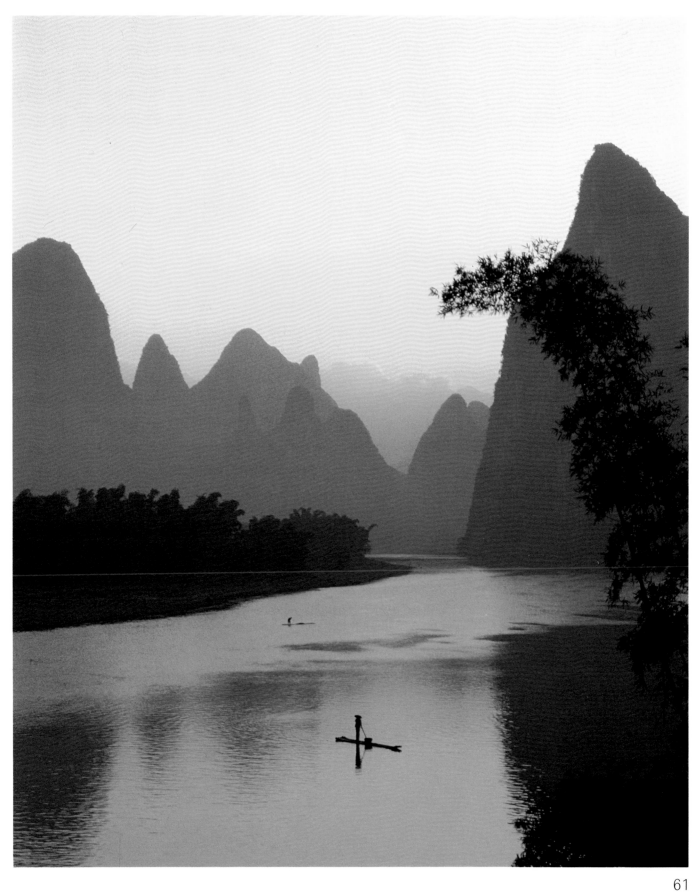

tropics, the sun goes down very quickly, so there is virtually no twilight. With increasing latitude this period is extended, until north of 49 °N latitude, midnight twilight is experienced at mid-summer.

The purest twilight colours occur when there are no clouds in the sky and no dust in the atmosphere. Dust results in the sky appearing yellow or even grey as can be seen by comparing the picture of the cacti at dusk overleaf with the one

of the sun on p98. An orange sunset filter therefore only succeeds in enri-ching the colour of a pale yellow or orange sky behind a silhouette; it cannot add authentic-looking colour to a grey sky.

This simple picture belies the time and effort that went into finding a lone cactus with a clear view of the colourful sky behind the silhouette. The brightest part of the setting sun is deliberately obscured by the cactus stem.

Sun setting behind Saguaro cactus, *Cereus giganteus*, Arizona, February 1979. Ektachrome 64, 80mm lens on Hasselblad. Dusk sky.

Taking pictures at dusk or dawn that include the land can be particularly disappointing, since colour film cannot cope with the latitude of a bright sky and unlit ground. If a camera position can be found so that distinctive foreground subjects can be isolated against the sky, such as skyscrapers or columnar cacti, these can be reduced to silhouettes by exposing for the sky, yet the type of location will still be immediately apparent.

Depending on how it is metered, quite different effects can be produced with a built-up city scene at dusk. If it is exposed for the foreground, the horizon and sky will be clearly distinguished and the lights somewhat burnt out, whereas exposure for the illuminated buildings will render the rest of the scene underexposed so that it appears to be a nocturnal photograph.

In winter, only the road round the south rim of the Grand Canyon is kept open, but from here there are many overviews into the Canyon. I arrived before the sun rose when the temperature was well below freezing, but gradually the sun's rays began to warm the chill air. As the first rays appeared above the horizon, the upper strata momentarily became spotlit with a rosy glow.

Rising sun lighting Grand Canyon, Arizona, from Yavapai Point view, February 1979. Kodachrome 25, 135mm lens on Nikon. Dawn.

Silhouettes

The maximum contrast between objects and the background is seen when they are backlit against brightly lit sky or water so they appear silhouetted. Then, all traces of colour and texture are lost and outline shape becomes all important. The term originates from a French Minister—Etienne de Silhouette —who used black paper to cut out profiles of people, thereby capturing their personality as a silhouetted profile.

There are two types of subjects which work most effectively as silhouettes. Solid forms, with an outline shape that is instantly recognisable in profile— such as statues, trees, boats, buildings and people—abound. Not so widespread are the intricate designs of wrought ironwork such as gates, balustrades and arbours in parks and stately home gardens, where these features have been carefully positioned so they can be viewed against brighter sky and water.

Selecting the prime viewpoint is essential for getting good pictures of silhouettes. An easy approach is to scan the horizon for trees or buildings silhouetted against the sky. In other places, a low viewpoint may be needed to isolate subjects against sky; whereas for boats on water, a high viewpoint looking down on to the sea will prevent the horizon cutting across the middle of the frame. Avoid having a silhouetted area filling the lower half of the frame, for this will give a very heavy feel to the picture. If you cannot move any nearer, try using a longer lens.

Once a striking shape has been found, taking a silhouette is extremely easy. The exposure is calculated by deliberate under-exposure of the subject by metering directly off the sky or the water. If you want to retain colour in a sky at dawn or dusk, avoid metering directly off the sun itself. Including the sun in the field of view may prove a problem unless it is completely or partially hidden by part of the silhouette. A dramatic natural tarburst can be created, however, by allowing a small portion of the sun to beam through tree branches or the edge of a building.

People fishing, or in small boats, always make for photogenic silhouettes against water. When viewed against the light, water is highly reflective, giving an exposure much higher than green fields, so this means that fast shutter speeds can be used for moving subjects. Early or late in the day, however, when a colourful sun is reflected on water, the

The intricate lacy ironwork 'bird cage' arbour designed by Robert Bakewell for Melbourne Hall, can be appreciated only by viewing it as a silhouette against a clear sky in winter. Once the trees overhead leaf out, they block out some of the light. To show the full sweep from the edge of the lake to the top of the arbour, I stood inside and used a 20mm lens which has produced slight perspective distortion.

1706 iron arbour, Melbourne Hall, Derbyshire, November 1985. Kodachrome 25, 20mm lens on Nikon. Against a bright sky.

Facing page: **Trees with large simple leaves, such as these coconut palms, make particularly graphic silhouettes. Since coconuts favour growing along the coastal fringe of tropical locations, it is not difficult to take this sort of picture early or late in the day. This, the sole monochrome picture in the book taken on 35mm film, is because my Hasselblad ended up in the sea on the first day of my trip!**

Silhouetted coconut palms, Mahé, Seychelles, May 1973. Plus-X Pan, 50mm lens on Nikon. Against the light late in the day.

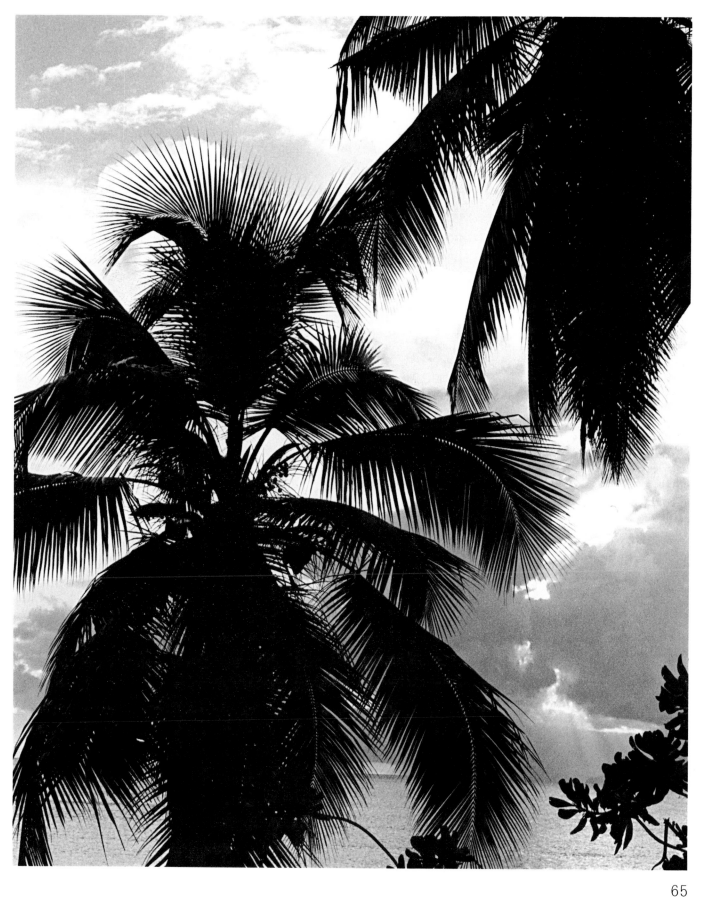

I saw this boat moving towards me and then stop, so I set up the camera on a tripod with a long lens, in the hope that somebody might come ashore. By framing the picture beforehand, I was able to get several frames of the person wading ashore. I metered through the camera straight off the water to get the silhouettes.

Boat and boatman in river at Jinghong, China, March 1986. Kodachrome 25, 50mm lens on Nikon. Against the light.

exposure drops considerably, which means a faster film may be needed if a fast shutter speed is required with a slow long focus lens. This is the sort of situation which arises just as a boat moves into the golden band produced by the reflection of a golden sun on water.

Animals such as horses or elephants work best in silhouette when they are standing side-on to the camera, so that the head, legs and tail are distinct. Dramatic silhouettes of race horses jumping fences are taken by remotely firing a camera with a wide angle lens placed on the ground near the jump.

Large birds which tend to fly in a distinct formation, such as swans, flamingos, pelicans or geese, make striking silhouettes against a colourful sky. A chance encounter of a skein of geese against a perfect sky would, indeed, be lucky. The odds can be substantially reduced though by finding out where regular flight lines occur so that the best camera position can be determined well in advance of a sunrise or a sunset.

People are recognisable in silhouette from almost any stance—particularly if their arms are separated from the body. But like any mobile subject, confusion will arise if people move around in front of one another. A skier caught in mid-flight during a leap in a downhill run, can make a striking silhouette, but this, too, will involve considerable planning with maybe even a dummy run proving necessary to check camera angles.

Silhouetted buildings, rocks or trees also make very effective frames to a more distant well-lit picture beyond.

While I was visiting Kyoto, my Japanese guide was very keen I should make a pilgrimage to see the wedded rocks, linked together by a rope. He assured me this was a popular dawn location for Japanese photographers. At first I had the beach to myself, but within minutes the photographers began to arrive until, just before sun rise, there was hardly room for another tripod. At the first hint of colour a chorus of approval went up but, in the end, it proved something of an anti-climax, although it does show that any striking shape works well as a silhouette.

Myotoiwa or wedded rocks, Futamigaura Beach, Japan, June 1983. Kodachrome 25, 135mm lens on Nikon. Against dawn light.

Direct Sunlight

Sunlight unfiltered by clouds casts a uni-directional light with sharply defined shadows that increase in length the nearer the sun is to the horizon. The angle of the sun relevant to the camera also affects the way the shadows are seen in a photograph and the way a subject is modelled.

Not only do shadows appear and disappear when the sun shines or is hidden by clouds, but also the tone of colours change. This is most noticeable on areas of natural green such as grass and leaves. In sunlight, greens appear brighter and truer to life, whereas on a dull overcast day they often have a noticeable blue cast which can, if necessary, be reduced with a warming filter (p52).

One of the few times that a front lit landscape can look very dramatic is when it is backed by dark storm clouds. Apart from this, front lighting does not do a contoured landscape justice since,

unlike side lighting, it lacks any modelling because the shadows fall behind the subject. Since a separate section in this chapter concentrates on shadows, this section considers the use of direct lighting in general.

We have already seen that silhouettes are an extreme form of backlighting when all colour and texture becomes lost from the subject. By exposing correctly for a backlit translucent subject, instead of for the sky behind, it will then appear to glow as the sun shines through it from behind. Autumnal leaves are excellent subjects for backlighting as are coloured sails of boats or flags. A TTL spot meter will be able to accurately meter the light passing through the translucent subject, although small leaves with gaps between them may prove more problematical. What I do then is to bend (but not break) another branch down into position so that the leaves completely screen the area in front of the sun.

The delicate pattern of spiders' webs

Up in Harbin, China's ice city, the river freezes solid in winter and a popular local sport is ice sailing, with sailing boats moving over the ice on outsized ice skates. Here the boats are being prepared, so I had plenty of time to move round to get the sun shining through the colourful sails. Notice also the backlit ice sculptures along the promenade behind.

Ice sailing on frozen river, Harbin, China, February 1987. Kodachrome 25, 85mm lens on Nikon. Backlighting.

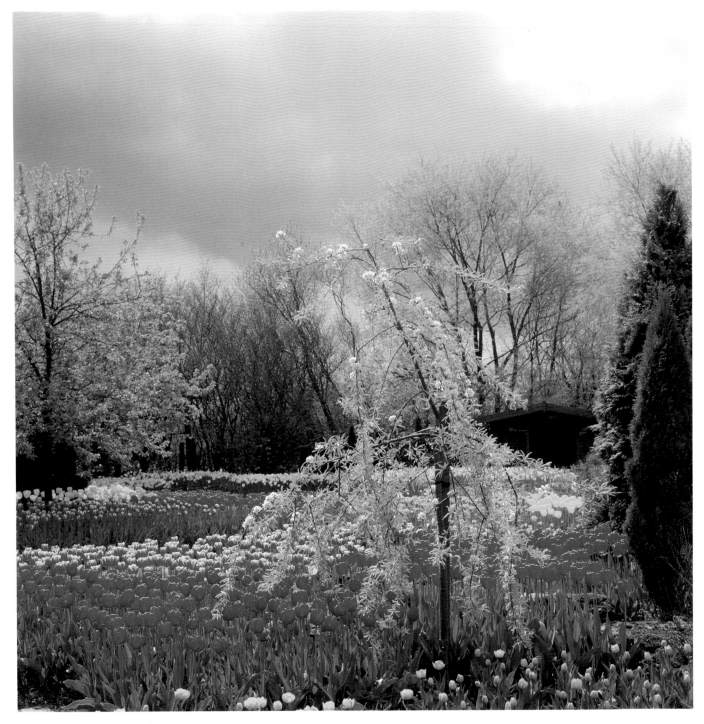

Red tulips look bright in any light, but the colours are even more intense in bright sunlight. After several hours with a completely clear sky, storm clouds suddenly rolled up and there was a brief moment when the last rays of sun shone from overhead onto the garden backed by dark clouds.

Springfields Garden, Lincolnshire, May 1986. Ektachrome 64, 80mm lens on Hasselblad. Direct front lighting.

can be appreciated only when they are viewed against the light bespangled with dewdrops. Early one summer morning I set off for a hill where I wanted to take a picture of mixed woodland on infra-red film. On seeing the hill shrouded in thick mist, I turned back down a low road to find the sun breaking through the mist revealing a heathland area covered with spiders' webs. I had never seen so many, because come the late autumn when misty mornings are fairly common, the spiders are beginning to die off. There were large sheet webs on the ground with orb and tent-like webs up in the gorse bushes. Seen from a distance it was an unbelievably magical scene, but on closer inspection it was difficult to find a good composition with several webs in the foreground and the heathland behind, because the vertical webs are woven at different angles, yet the dewdrops only showed up when lit from behind.

When the sun's disc is partially blocked by a solid object, such as branches of a tree, the rays appear in the form of a natural starburst. I have used this technique several times to provide a focal point to a picture. The example shown here was not an opportunist shot, I had to work hard to achieve the end result I visualised.

If detail is required in a back-lit solid subject the shadow areas must be metered in preference to the sunlit ones. With a TTL spot meter this presents no problem, but otherwise it may mean moving in a bit closer to avoid metering some of the bright spots as well.

If solid objects are metered on their sunlit side and then photographed from the opposite side they will appear dramatically rim-lit with a halo of light. This can be a most effective way of lighting spiny cacti

When I arrived at an Oxfordshire garden, the maze was lit by an overhead sun. By the time I returned to my car, the sun had dropped behind the trees, giving a silvery sheen to the maze when it was viewed against the light. By using a very wide-angle lens *and* standing on top of a stepladder which happened to be in the car, I could include the maze in the lower half of the frame and the leafy branches—complete with sunburst—above.

Natural sunburst over Archbishop's Maze, Grey's Court, Oxfordshire, June 1986. Kodachrome 25, 20mm lens on Nikon. Early evening backlighting.

This was the only morning during a ten-day trip up Mount Ruwenzori in Uganda, that we enjoyed breakfast with the warming rays of the dawn sun; the rest of the time we were either bathed in mist or sheltering from rain or sleet. The low-angled sun rim-lights our porters and highlights their colourful plastic mugs.

Porters around camp fire on Mt. Ruwenzori, Uganda, September 1984, Kodachrome 64, 35mm lens on Nikon. Backlighting at dawn.

Using Shadows

The relative position of the camera to the sun determines how shadows appear in a photograph. For example, when the sun is lighting the front of a landscape the shadows will fall behind high features away from, and invisible to, the camera. A wide angle lens therefore has to be used with caution early or late in the day on a front-lit landscape, otherwise your own shadow will impinge forward into the field of view.

However, the long shadows produced by extreme side lighting early or late in the day help to add impact and drama to a landscape. A large expanse of lawn seen at mid-day is simply not worth exposing film on, but shadows cast early or late in the day by a line of bordering trees immediately create interest and give a feeling of depth.

Strong side lighting also helps to emphasise texture. Any extensive sand dune area looks uninspiring for most of the day. Low angled light is needed to reveal the overall shape and form of the dunes. It is fruitless attempting to photograph White Sands National Monument in New Mexico (where the dunes are built up from white gypsum) any time after a couple of hours following sunrise or much before a couple of hours prior to sunset, because no surface detail is apparent. Also, a tremendous amount of heat builds up on the dunes from the reflected sunlight.

After a long drive, I arrived at the dunes around mid-morning, so I bought a selection of guide books and drove off to a cooler location to study the books before returning late in the day one hour before sunset. Immediately I arrived, I could see the dunes were transformed by the long shadows.

Shadows thrown forward on pale toned ground by the backlighting of tall objects such as trees or statues can themselves be used as the main feature of a photograph. This is the sort of picture which often arises when snow is blanketing the ground, since the sun's arc is lowest during the winter. The shadow cast by a single tree or a tall giraffe on a uniform expanse of sand or bare ground can make the picture, if it is so exaggerated that it cuts across the diagonal of the frame as a bold shape.

It was the dramatic cross-lighting on the branches of these young poplars which caught my eye as I was driving to a late evening location in New Zealand. Quickly glancing in my mirror, I made an abrupt stop, knowing that every second counted. Even so, I still had time to take a few frames in both colour and monochrome, for the dramatic bands of light and shadow worked equally well in both media. Notice the sheep picked out by the angled sun.

Poplars and sheep, North Island New Zealand, November 1975. Plus-X Pan, 80mm lens on Hasselblad. Oblique direct sunlight late in the day.

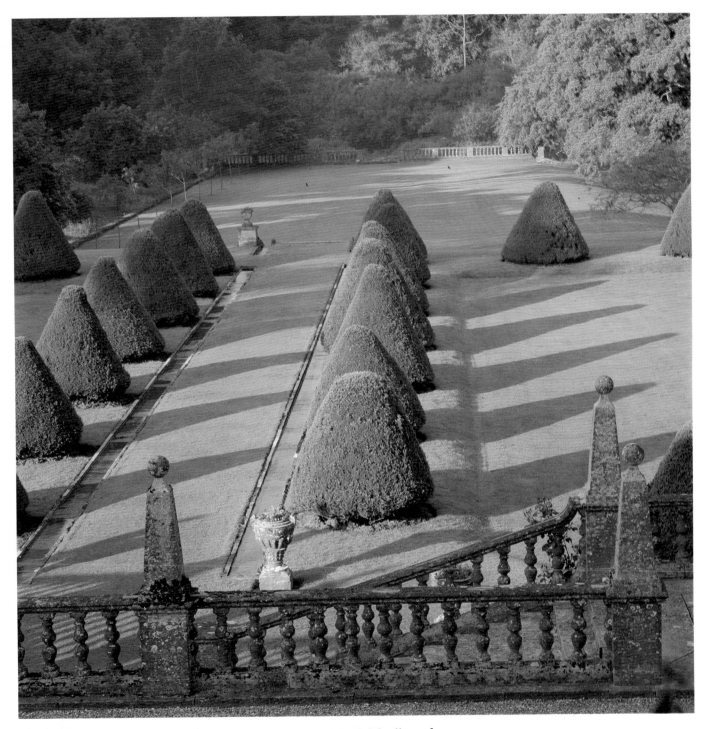

One of the most dramatic views I have ever seen from any bedroom window was at Parnham House in Dorset, when I awoke at 6 am on a June morning to see the lines of conical clipped yews with their elongated cross shadows cast on the grass terrace. Without the shadows this essentially green landscape would not be particularly striking; with them it gives a wonderful feeling of depth to the picture. As the morning progressed and the shadows shortened, so the scene became less arresting.

Yew terrace Parnham House, Dorset, June 1987. Ektachrome 64, 150mm lens on Hasselblad. First morning light.

Returning to White Sands
National Monument one hour
before sunset, the solid white
expanse I had seen earlier in the
day was gone. Now the dunes
appeared as three-dimensional
forms, with intriguing surface
patterns from the rippling sand
waves. Unlike a flat
snow-covered landscape, the
exposure was not too tricky,
since the shadow areas were
roughly equal to the sunlit areas,
so a general reading gave an
average between the two.

Dunes in White Sands National
Monument, New Mexico, March
1983. Ektachrome 64, 150mm lens
on Hasselblad. Extreme cross lighting
at dusk.

Facing page: This picture was
the result of going for a walk on
a bright but cold Christmas
morning. Walking through a
narrow band of pine trees with
the sun on my back, I could see
the long shadows of the trunks
stretching in front of me, so I
turned around to take this
picture into the light, partially
blocking the direct sun's rays
with a trunk.

Surrey pinewood, December 1981
Ektachrome 64, 60mm lens on
Hasselblad. Backlighting.

72

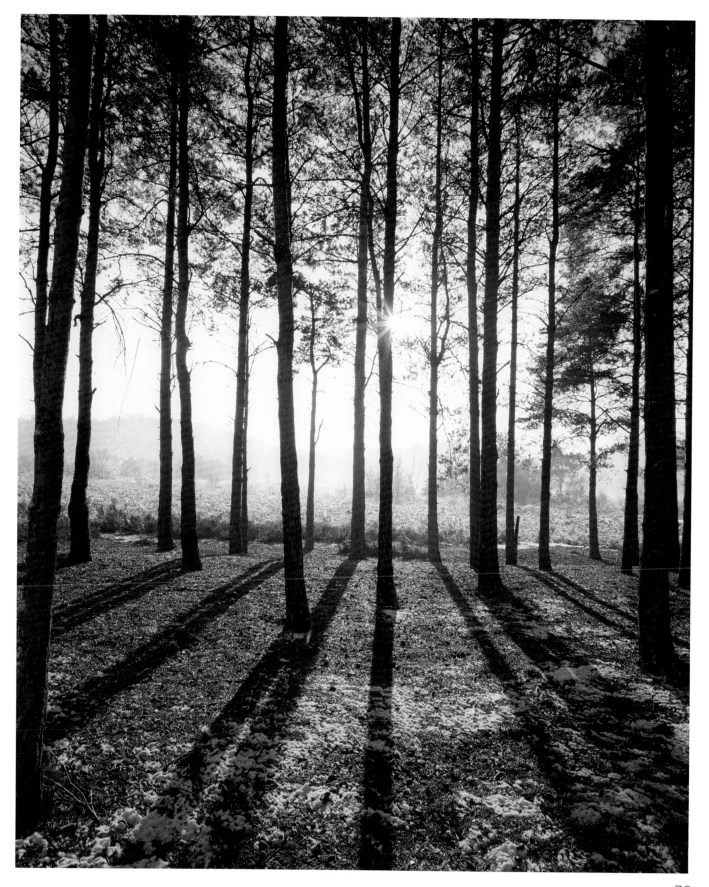

Diffused Light

A cloud cover changes harsh direct sunlight into a soft indirect light with virtually no shadows, since the light is no longer coming from a point source but the whole of the sky. Light mist, smoke or dust in the atmosphere also create a soft light.

Colour film cannot cope with the wide latitude created by strong sun shining on pale stonework or flagstones, so that some parts appear in bright sun and others in deep shadow. Diffused light removes this problem by rendering the whole stonework as an identical tone.

The array of colours and tones in beds and borders in parks and gardens often looks better when seen in diffused light because there are then no strong shadows to further complicate what is already a very busy image.

These cloisters were built in 1914 in the Italian Romanesque style at Iford Manor by Harold Peto, the architect and garden designer. I was glad to see the day on which I had arranged to photograph the cloisters was overcast, since a soft light was exactly what I wanted to show up the detail in the pale stonework.

Cloisters, Iford Manor, Wiltshire, July 1984. Ektachrome 64, 60mm lens on Hasselblad. Diffused lighting.

Latitude and Light

In temperate regions, the quality of light is quite distinct in each season, which is hardly surprising since the angle of the sun varies so much between one season and another. Also, the length of time the sun rises above the horizon varies with the latitude as is clearly shown in the table comparing the time at different locations north and south of the equator.

The quality of light is also particular to different parts of the world, so that anyone who has experienced the harsh Mediterranean light will instantly recognise a picture taken there. A huge country such as China experiences widely different light. In Beijing, smoke from fires and dust both tend to produce hazy light; whereas Yunnan province in south-west China is renowned for its clear air, blue skies and white clouds so it is therefore much favoured by film producers.

The sensitive eye of the Japanese photographer Shinzo Maeda selects remarkably simple images—invariably with a strong element of pattern. In his book *A Tree, A Blade of Grass,* Maeda shows a stem with limp bamboo leaves—yellowed by frost—projecting through deep snow; elsewhere, evening sunlight is reflected on lotus leaves. An intriguing picture appears in his later book *The Nippon Alps.* It simply shows larch needles floating on water. By using a long exposure, the needles carried in the current are recorded as blurred golden lines aligned with the current, while the rest of the needles floating on surrounding static water are crisply defined lying in a haphazard arrangement.

The theme of the Kodak 1988 Desk Diary was landscapes, most of which were taken in North America. All the pictures are undoubtedly very graphic; but, on the whole, they tend to be less subtle than those of Shinzo Maeda—no doubt due to the variation in the quality of light in different latitudes.

Lying close to Mauritius in the Indian Ocean are several small islands. This view shows Serpent Island framed by endemic palms on Round Island. The harsh light of the Tropic of Capricorn is anything but subtle, but it is acceptable with a simple image.

Serpent Island from Round Island, Indian Ocean, April 1976. Professional Ektachrome, 80mm lens on Hasselblad. Direct overhead lighting.

LOCATION	LATITUDE	No. of hours' sun above the horizon at 19 June 1985	No. of hours' sun above the horizon at 20 December 1985
Tip of South America	55 °S	7 hrs 10 mins	17 hrs 23 mins
Santa Cruz, Argentina	50 °S	8 hrs 4 mins	16 hrs 23 mins
Wanganui, New Zealand	40 °S	9 hrs 20 mins	15 hrs 1 min
Coquimbo, Chile	30 °S	10 hrs 13 mins	14 hrs 5 mins
Mauritius, Indian Ocean	20 °S	10 hrs 55 min	13 hrs 21 mins
Aldabra Island, Indian Ocean	10 °S	11 hrs 32 mins	12 hrs 43 mins
Galápagos	Equator	12 hrs 7 mins	12 hrs 7 mins
Caracas, Venezuela	10 °N	12 hrs 43 mins	11 hrs 33 mins
Island of Hawaii	20 °N	13 hrs 21 mins	10 hrs 55 mins
Cairo, Egypt	30 °N	14 hrs 5 mins	10 hrs 13 mins
Beijing, China	40 °N	15 hrs 1 min	9 hrs 19 mins
London (51°N)	50 °N	16 hrs 22 mins	8 hrs 5 mins
Edinburgh, Scotland	56 °N	17 hrs 37 min	6 hrs 57 mins
Shetland	60 °N	18 hrs 52 mins	5 hrs 53 mins
Iceland	66 °N	24 hrs	2 hrs 47 mins

The Magic Hour

On a clear cloudless evening, after the sun has gone down below the horizon, the sky begins to darken to an intense blue. This dusk light—coined the magic hour by art and film directors—provides a dramatic yet not such a harsh backdrop as a night sky. This time of day is therefore frequently used for making commercial shots of towns, cities and industrial plants after lighting-up time. Pictures of fires and fireworks also work well when viewed against a deep blue sky.

Since the Cultural Revolution ended in China, traditional customs and festivals have been revived. One of these is the Ice Festival in Harbin. Here, large blocks of ice are cut from a frozen river and made into imaginative ice sculptures. By day, they appear glass-like but at dusk they are transformed when coloured internal lights are switched on. The intense cold (around –20°C when I was there in February) ensures clear skies so that each night there is the magical time when the lights have been switched on and the colour of the sky intensifies.

A tripod is essential for taking these and any other photographs at this time of day. In China, I had the additional problem of intense cold to cope with, but I was grateful for the cold weather battery pack (p94)

For a brief time each night after the sun has set, the lights built into ice sculptures are switched on in China's ice city—Harbin— and the colours can be viewed against a deep blue sky. The silhouetted figures at the base of this ice castle give some idea of its size. As the temperature was around − 20°C, I had to use a cold weather battery pack to take a light reading with my Nikon.

Illuminated ice sculpture, Harbin, China, February 1987. Ektachrome 64, 80mm lens on Hasselblad. Coloured lights.

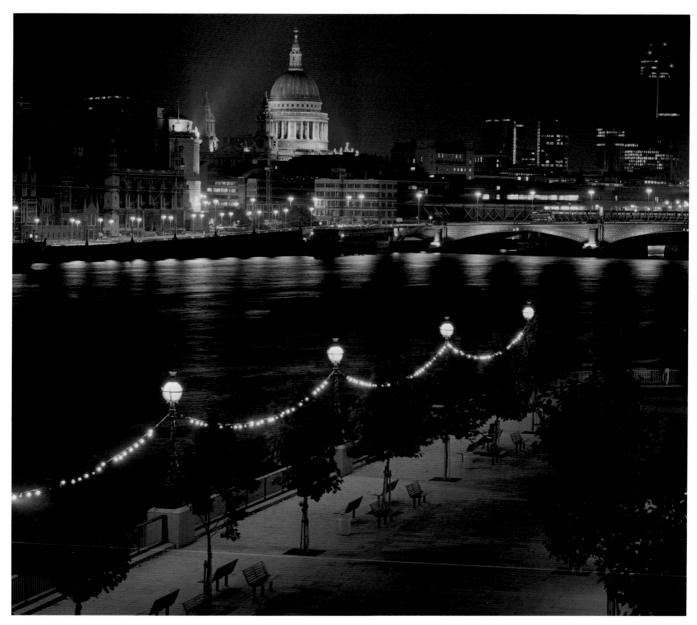

Artificial Light

One of the problems of photographing an illuminated street scene, a fairground or a boat at night is that it can end up looking like a series of bright spots looming out of an inky blackness. Better by far is to photograph at dusk when some detail can be picked out of the structures which are producing the lights. Water or wet surfaces will reflect the artificial light pattern perfectly in still water or distorted by ripples.

Since outdoor lights are balanced neither for daylight nor tungsten light colour films, some imbalance of colour will result whatever film is used, but with subjects such as neon lights and fireworks, this is not too crucial. The choice depends on the final result required, remembering that tungsten film is more sensitive to blue and less to red light. If in doubt, you can always use two camera bodies, one loaded with daylight colour and the other with tungsten light film amd compare the two results. I did this when taking a view from the South Bank of the river Thames looking across to St. Paul's Cathedral for the Kodak Calendar. The shot we all preferred was, in fact, taken on daylight balanced Ektachrome 64 film, as indeed was the illuminated ice sculpture on p76. If required, a warmer glow to white lights can be gained by using tungsten light film at dusk when there is some twilight present

Instead of taking St. Paul's Cathedral from the walkway on the south bank, I chose an upper floor of a building so I could include the lighted promenade in the picture, as well as the lights and their reflections along the north bank. I used my Nikon to meter the scene which needed a 10-second exposure with Ektachrome 64 film.

St. Paul's Cathedral from the south bank, September 1985. Ektachrome 64, 150mm lens on Hasselblad. City lights.

Long exposures taken at night of city scenes with moving traffic—whether on roads or water—produce long colourful streams of the car or boat lights. A tripod and a torch are both essential for taking scenes lit by artificial light. A torch is needed to check the film speed dial on a camera which does not automatically read the DX coding, and, when needed, for checking the shutter speed is set on the 'B' setting. A camera such as a Hasselblad where the mirror has to be locked up for any exposure longer than $\frac{1}{4}$ second, is not suitable for taking action scenes such as fireworks, because it is impossible to preview the composition.

If fireworks are set off at dusk, they can be taken with a twilight backdrop which is much less stark than a completely black background, and much better for taking wide angle shots of fireworks exploding above a familiar landmark such as Tower Bridge in London or a castle. Also, reflections of the fireworks will show up better in a waterfront display at this time. If the fireworks are let off against a night sky,

the red glow produced by a huge bonfire can be used to silhouette figures or trees in the foreground with fireworks exploding behind.

Slow speed films are best for taking fireworks because they allow longer exposures and provide good colour saturation. Use the 'B' setting and a locking cable release to fire the shutter just as the rockets explode. By keeping the shutter open until the display fades, spectacular long light traceries will be recorded against the sky. A zoom lens will aid a quick interchange of focal length, otherwise two cameras can be set up on separate tripods.

When fountains are illuminated at night, they too can be photographed using a long exposure with a camera on a tripod. To judge the correct exposure, I meter directly from the fountains and bracket on either side, just to be sure.

This was the view from our hotel room in Atlanta at dusk with the setting sun reflected in the high rise building and the sky still retaining some blue colour. The pattern of the long streaked car lights produced as a result of the long exposure adds to the composition of this night picture of a city.

Atlanta, Georgia at dusk, January 1987. Kodachrome 25, 35mm lens on Nikon. City lights 8-second exposure.

Moonlight

Landscapes depicting the moon are best taken at dusk, just after the moon has risen so the land is illuminated by the twilight produced by the sun just below the horizon. As the twilight fades, the colour of the land is lost and distant profiles become silhouetted. Landscapes at dusk with the full moon can be taken with quite slow colour films, but once the light fades avoid using an exposure much more than a few seconds otherwise a full moon will appear laterally stretched instead of completely round as its passage through the sky is recorded.

Dates of the full moon are published in diaries and it is also possible to get tables for precise times of moonrise and moonset. The Port of London Authority publish annually a *Handbook of Tide Tables and Port Information* which gives this data (together with the times for sunrise and sunset) for London.

Photographing authentic moonlit landscapes is rarely highly successful since the contrast is so great there is no detail in the shadows and long exposures need to be used. Simple snow scenes or sand dunes work best since they reflect a lot of light. An alternative technique used by film makers, is to shoot a landscape by day in bright sunlight on tungsten light film and underexpose by four stops. This will produce the typical advertising 'nocturnal' shot with an obvious blue cast.

Moon viewing is an age-old custom practised in Japan, whereby architectural creations made from white sand are gazed at from specially built viewing platforms, by the light of the moon.

One way of producing a graphic—yet artificial—moon shot is by making a double exposure. The moon can be shot before or after the background, but it needs to be taken in a completely dark sky otherwise the twilight will result in a yellow cast. A long focus lens will magnify the size. Then, using the double exposure button, take a typical night scene—preferably at twilight—composing it in such a way that it complements the position of the moon.

If the background is taken first, it is a good idea to sketch the scene, carefully noting the space where the moon is to be placed.

The glowing red light of a large bonfire can be used to silhouette people and trees as well as giving a spectacular and less stark background to fireworks. The white circles at the bottom right of the fire are made by people moving lighted sparklers in a circular motion.

Bonfire in Farnham Park, Surrey, November 1987. Kodachrome 200, 50mm lens on Nikon. Light of bonfire.

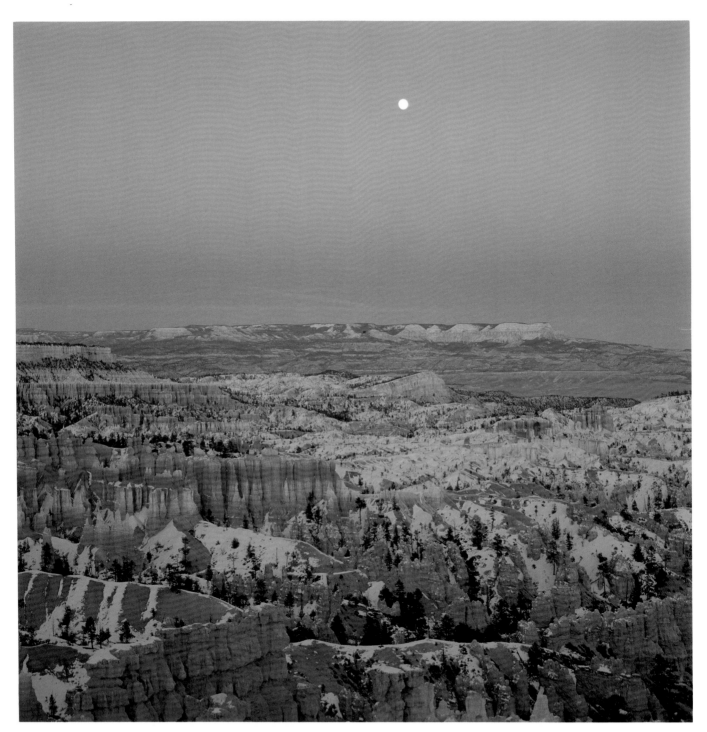

By the time the sun has set and the moon rises over Bryce Canyon in January, the temperature has fallen well below zero, so I had the overview at Sunset Point all to myself. When a full moon is photographed at the same time as a broad landscape—not by superimposing it as a double exposure—it appears relatively small in the frame. I metered off the rocks and used the blue twilight from the sun below the horizon to produce a harmonious picture that combined the two types of light.

Full moon rising over Bryce Canyon, January 1988. Ektachrome 100, 80mm lens on Hasselblad. Twilight and moonlight.

Weather

The weather and climate we experience relates directly to the solar energy beamed to earth from the sun. The amount of solar radiation varies depending on the latitude, the season and the time of day. The equatorial zone experiences more than any other area, while the polar regions receive the least amount. On 22 June when summer begins in the northern hemisphere, winter commences in the southern hemisphere. The Tropics of Cancer and Capricorn are then respectively nearest and furthest away from the sun. The positions are reversed on 22 December. The climate of a particular area is based on past detailed studies of weather conditions and looks at the overall pattern of weather for a country or region.

Some locations have a remarkably predicable weather pattern, year in year out, but others—including Britain—experience variable weather depending on where the highs or lows originate from. Mountains are notorious for rapid weather changes. Even on a small hill such as Ilkley Moor in Yorkshire I have experienced bright sunshine in April one moment, suddenly giving way to driving sleet the next.

Sun, rain, snow, wind, dust or mist dramatically affect the way we see a landscape at a given time and they either stimulate us to get out a camera and expose film, or leave us totally unmoved. Any photographer working outside in a location with unpredicable weather instinctively looks up to the sky—whether it will be included in the picture or not—to gauge how long a sunny or a cloudy spell will last. The unpredictable nature of the British weather is what makes landscape photography in this part of the world so interesting, as well as equally frustrating. Before embarking on a long trip, I make a point of listening to weather forecasts and telephoning the meteorological office, but even then the forecast can prove to be wrong if the weather system moves through slower or faster than anticipated. Unsettled weather can, in fact, produce much more striking pictures than the clear blue skies of the tropical dry season when lighting becomes monotonously predictable. Sun that beats down every minute of the day and for much of that time from directly overhead, leaves little scope for creativity.

The sky colour—with or without clouds—influences not only how a landscape is lit, but also how we frame it. A particularly dramatic sky can be used as the focal point to a picture—especially if the horizon is positioned near the bottom of the frame. On the other hand, a completely overcast colourless sky adds nothing to a photograph and is usually better excluded altogether.

Clouds

Clouds form when air cools down and condenses to form water vapour. If a sky has a dramatic cloud formation and appears much more striking than the surface below, it is worth featuring in a picture by positioning the horizon very low in the frame or by excluding it altogether to make a cloudscape.

The contrast between blue skies with

I used a polarising filter to give a better contrast between these *cirrostratus* and *cirrus* 'tufts' and the blue sky over Exmoor. These clouds form high up in the sky where the temperature is around −40°C. Condensation of air into supercooled water droplets leads to the formation of the heads of the plume. Rapid freezing into ice crystals which grow to snow crystals leads to the 'trail' effect as they fall through the air from very fast-moving ('jet-stream') levels into the slower moving air only a short distance below the 'jet'.

Cirrostratus and *cirrus* clouds over Exmoor, July 1977. Kodachrome 25, 35mm lens on Nikon. Direct sunlight with polarising filter.

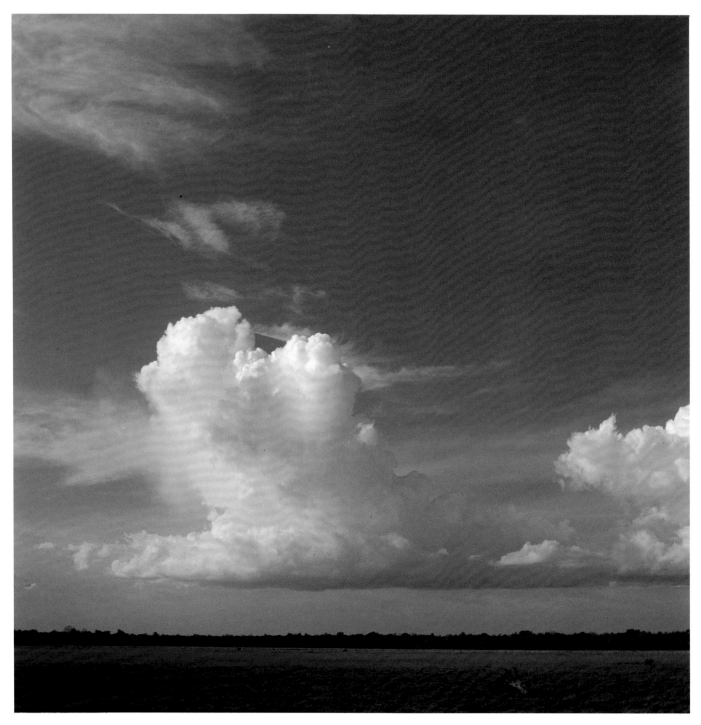

Cumulus clouds are a sign that showers are likely to develop; they may change into *cumulonimbus* clouds with the distinctive white 'anvil' formation. The warm air on the ground in Sri Lanka causes the cumulus clouds to be quickly uplifted in the convection currents. The white shapes have been enhanced by darkening the blue sky with a polarising filter.

Cumulus clouds over Sri Lanka, May 1983. Ektachrome 64, 80mm lens on Hasselblad. Direct sunlight with a polarising filter.

patches of white clouds—such as cumulus or cirrus—can be increased on both colour and black and white film by using a polarising filter (p51), although the intensity of the blue will be seen to vary across the frame if a wide-angle lens with a focal length of 24mm or shorter is used. Momentarily a clear sun below the horizon can light up clouds from below with a magical pink or orange light.

Clouds are constantly on the move, although when they blot out essential sunlight, it seems an eternity before they move away. Rapidly moving storm clouds can produce fleeting drama such as beams of sunlight shining through a chink in the cover; times like these obviously require a faster shutter speed than clouds which appear virtually static.

When metering a view which includes both land and sky, it should be remembered that usually the sky is several stops brighter (exceptions are pale sand dunes and sunlight reflected off water) so that it is impossible to expose correctly for both. When taking a landscape which includes blue sky (with or without clouds) the exposure is calculated by metering off the land, but if the sky is the main feature then the reading should be from the sky itself; always try to exclude the sun when metering sky, otherwise the rest of the sky will appear underexposed. A graduated filter can help reduce the exposure difference between a colourless sky and the land.

Mist

Mist and fog form when warm moist air either comes in contact with cooler ground or mixes with cold air. Mists typically develop in the evening, or during clear autumn and winter nights, so that early in the morning is a better bet for taking pictures of misty landscapes as the light is constantly improving rather than in the evening when it is rapidly fading—although if misty conditions coincide with an orange or a pink sky, this can be most effective. Localised pockets of mist develop above inland water and in damp hollows, but

While I was on a boat on a whale-watching trip to Baja California, there was a glorious sunset with an *altocumulus* layer lit from below by the afterglow of the sun already below the horizon. Notice how I have placed the horizon right at the bottom of the picture so I could include the maximum area of the colourful clouds. I had to use a fast shutter speed because I was in a moving boat, so I was glad to have a medium-fast film.

Afterglow on *altocumulus* clouds, Baja California, Mexico, February 1988. Kodachrome 200, 50mm lens on Nikon. Afterglow at sunset.

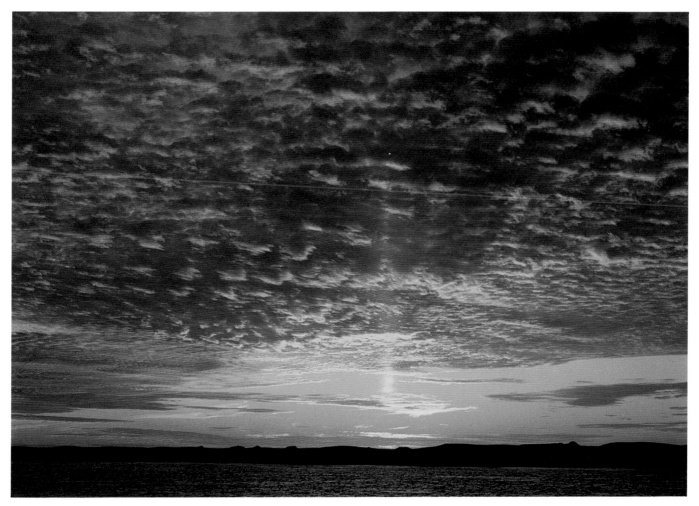

extensive misty areas may form in forests or at sea, while in mountain regions, mist and low cloud, swirl round the peaks. Mist is distinguished from fog when the visibility is 300 metres or more, less than this, foggy conditions result.

Where mist spreads over a large area it functions like a huge diffuser, softening light and shadows or even obliterating shadows altogether. A thick mist such as a pea-soup city smog is useless for photography, whereas a thin delicate mist creates an ethereal atmospheric quality to a landscape. Ideal misty conditions rarely persist, so it means getting up early before the warmth from the sun's rays evaporate the water vapour.

Pictures which have pale tones and colours are known as 'high key' in contrast to well saturated colours and dark shadows typical of 'low key' pictures. A pastel-coloured misty scene will give a high meter reading resulting in an underexposed picture, so it is sensible to increase the exposure by half stop increments up to a stop or even 1½

stops more than the meter indicates, keeping careful note of what you have done so that the frames can be compared on a light box afterwards.

Wherever mists develop, foreground objects such as trees, houses or boats take on a greater significance compared to the background which appears pale and indistinct as it fades away into a misty haze. This separation of foreground from distant parts of a scene arises as a result of aerial perspective (p40) when the greater the distance of an object from the camera, the paler its tone. A mist is also invaluable for blotting out unsightly backgrounds and eyesores which cannot be moved out of shot by changing the camera viewpoint. For a well-defined foreground subject however, it is essential to use the minimum camera-to-subject distance so that under these conditions, a wide-angle lens is preferable to a long focus lens.

Apart from sunrise or sunset, misty scenes invariably appear to have a blue cast on colour transparency film.

Mist and low cloud encourages the rich growth of epiphytic mosses on the trees in an Australian temperate rain forest. The scene was constantly changing as the clouds swirled up and down, so I decided to meter off the green ferns on the ground, knowing the tree trunks would then appear silhouetted.

Temperate rain forest, New England National Park, Australia, January 1978. Kodachrome 25, 35mm lens on Nikon. Indirect light through a blanket of cloud.

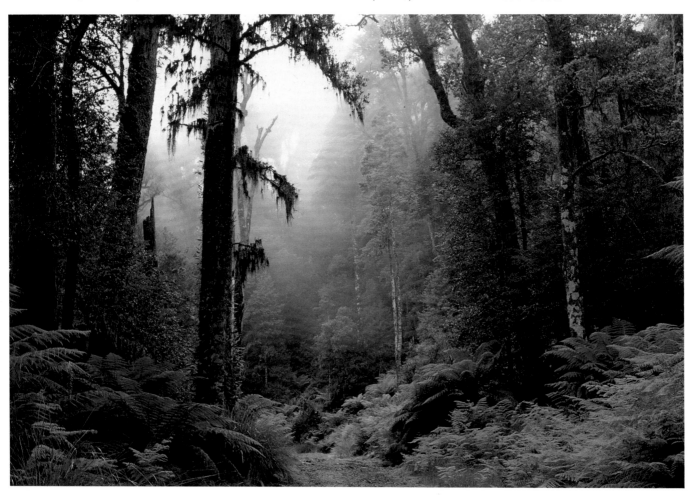

This picture was one of a series I took recording the regeneration after an extensive fire during the summer of 1976 in a Surrey nature reserve. I chose a misty morning so that the profusion of tree trunks would tend to fade away into the distance. After the picture was taken the area was declared the first National Nature Reserve in Surrey.

Silver birches regenerating after fire, Thursley National Nature Reserve Surrey, October 1976. Plus-X Pan, 80mm lens on Hasselblad. Diffused light caused by low mist.

Sometimes this can be seen by the naked eye, although it is often exacerbated on colour film, and can be counteracted by using an amber-coloured 81A or 81B warming filter.

When film cameramen require a misty atmosphere for a wide shot on a bright sunlit day, they use a smoke machine to blot out unwanted background detail and to create atmosphere. A simple way of conveying a romantic mood to a landscape is by using a soft focus lens, a fog filter or by breathing on the prime lens—although in the latter case you have to work fast before the 'mist' evaporates!

An early morning sea mist on the tidal part of the river Thames helped to blot out the confusing background behind the stranded fishing boats, thereby producing an almost uniform back drop. I had spotted the boats from the sea front, but knowing I had to find a way of getting round to the other side of them so the colours could be picked up, I walked out along Southend pier, looking back towards the town.

Fishing boats shrouded in mist, Southend-on-Sea, Essex, February 1985. Ektachrome 64, 350mm lens on Hasselblad. Weak sun through mist.

Sun

Seen from earth, the sun is the brightest of the heavenly bodies and sunlight is the prime natural light source for landscapes. The way we interpret landscapes is influenced by the direction and type of sunlight reaching the earth and the varied types of lighting are outlined in a separate chapter.

Whenever a camera—especially with a wide angle lens—is pointed towards the sun unfiltered by mist or dust, iris flare is likely to result, although this effect is not nearly so apparent with modern multi-coated lenses. A lens hood appropriate to the focal length of the lens, should always be used when shooting towards the sun. By stopping down the lens to the pre-selected aperture or by using a depth of field preview button, it is easy to check whether flare will appear and spoil the picture. With a professional lens hood (such as the Hasselblad) a variable bellows extension can be moved in and out to suit the particular focal length of lens and lighting. For 35mm systems, Hama produce a rubber zoom lens hood for use with lenses ranging from 24mm to 210mm and a metal one which can be used on 35mm to 250mm lenses.

On no account should a bright sun be viewed directly through a single lens reflex camera, for it will damage the retina. In any case, views looking directly at the sun itself are rarely particularly interesting. If a rising or setting sun is viewed through a layer of mist, cloud or dust it appears as an orange ball against a grey or beige sky. It then can be briefly viewed through the camera without risk of retina damage. The final effect of including the sun in a picture with a slight mist can be changed by the length of exposure. If the exposure is made for the foreground, the sun will appear burnt out and overexposed, but by stopping the lens down one or two stops, the sky colour becomes more intense. Another couple of stops renders the foreground as a silhouette and the sun appears as an orange ball in the sky.

A most dramatic effect occasionally occurs when the sun is low in the sky behind clouds formed close to the horizon; sunlight is then projected upwards as a fan of light beams—reminiscent of a wartime searchlight. Since the exposure can be tricky, it is worth bracketing several shots, to ensure at least one obviously shows the rays.

I could count on one hand the number of occasions when I have used a

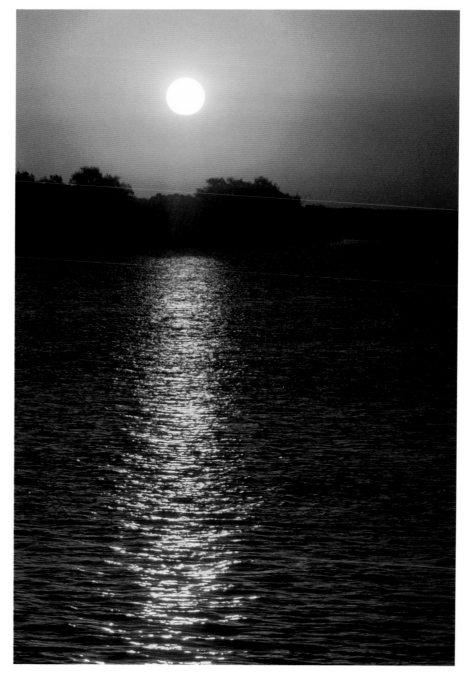

starburst filter, but I was glad to have it as part of my filter stack when I visited White Sands National Monument in New Mexico at sunset. As the sun reached the horizon, I decided to use this filter to produce a focal point in one corner of an otherwise rather dull picture because the sun was no longer lighting the dune surface (p51).

For this picture, of the sun setting over the Zambesi river, I metered from the orange sky, so that the reflection would be correctly exposed and the sun appear as a bright circle. This is the time of day when a long lens can be used to silhouette game against a bright orange sun behind.

Setting sun over the Zambesi river, Zambia, September 1981.
Kodachrome 25, 105mm lens on Nikon. Backlighting from setting sun.

Rain

The reason why comparatively few striking still pictures are taken of rain may be because most people abhor using their cameras when it is raining. If there is convenient cover—such as a building, a rocky overhang or a boat awning—to work beneath, photographing rain presents no problems. Failing this, providing precautions are taken to protect the camera, working out in the rain can be very exhilarating. A plastic bag can be used to protect a camera from rain, but it does need to be a strong one and fixed to the lens hood so that the entire camera—apart from the front of the lens—is completely enclosed. I prefer to cover the lens with a towel which absorbs any glancing rain and hold a large umbrella over the camera on a tripod.

If heavy rain falls on a camera, dry off all the surplus as quickly as possible and either put the camera in a container with water-absorbing blue silica gel crystals or in an airing cupboard.

Rain is arguably one of the most difficult aspects of weather to record convincingly on a still photograph. Particularly dramatic landscapes can be taken of dark stormy skies—with the foreground lit by a short burst of sunlight—immediately prior to a deluge, but dark rain clouds taken as a distant wide-angle shot will depict falling rain as a grey smudge. To capture rain falling requires a closer view of large rain drops against a dark backdrop. The light level will invariably be poor, but an exposure of $1/60$–$1/30$ second will record the rain drops as pale streaks falling vertically, or, in driving rain, horizontally. If the exposure is too long, so many raindrops will be recorded it becomes impossible to distinguish one from another and the scene becomes an overall pale blur.

Perhaps one of the most graphic ways of depicting rainfall is to photograph drops falling in water. In this instance, avoid using a slow shutter speed so that the radiating concentric rings can clearly be seen. I prefer to shoot against the light so that the water surface has a silver sheen and the ripples are accentuated by shadows.

This picture was the result of an abortive trip to photograph toads spawning. Apart from a few toads bobbing up and down in the pond, there was little activity. When it began to rain, I put on a long lens to photograph the pattern of distorted tree trunk reflections and radiating ripples produced wherever rain hit the water.

Raindrops falling on pond, April 1988. Kodachrome 200, 300mm lens on Nikon. Against the light.

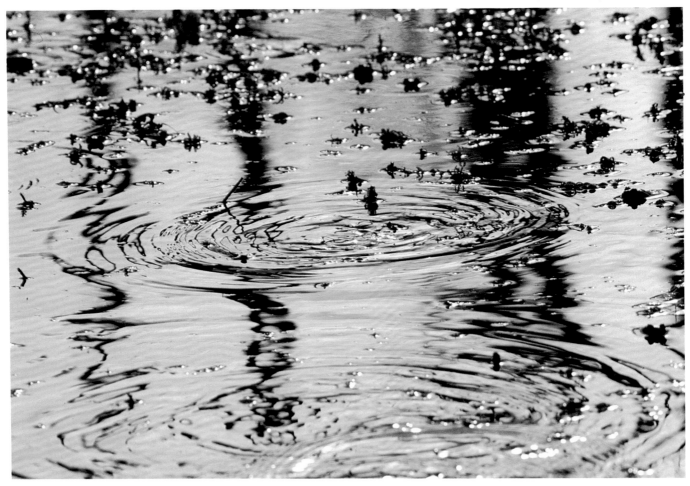

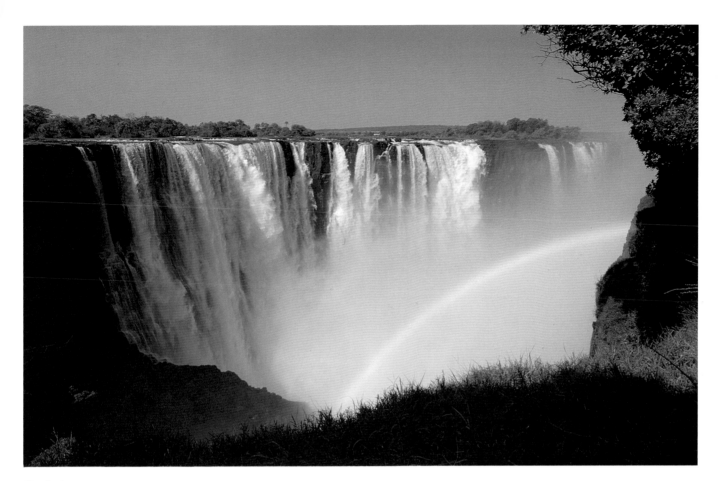

Rainbows

From time immemorial rainbows have been a source of intrigue and myths; indeed, the Greek goddess Iris, the messenger of the gods, displayed the rainbow as her sign. The multi-coloured arching bow which we see from ground level forms as a result of the refraction and reflection of sunlight inside individual water droplets 0.01–4mm in diameter—whether formed by rain or spray from a waterfall or a fountain. Seen from an aeroplane or a high mountain peak, the ephemeral spectral bow completes a full circle.

A rainbow will be seen only when the sun is shining from behind a person looking at rain falling in front. Therefore in the northern hemisphere, rainbows appear in the west during the morning and in the east during the evening. The coloured bands of the spectrum in the main or primary bow are arranged with violet at the bottom and red at the top; whereas the colours are reversed and paler when a second rainbow forms outside the primary one.

The bigger the raindrops the stronger the colours will appear, so that rainbows tend to be much more intense during tropical storms than with light showers. Photographs of rainbows have a tendency to be disappointing, with the spectral colours appearing rather pale, so it is worth deliberately underexposing so as to gain better colour saturation.

How the rainbow is positioned in a picture will depend on the viewpoint. A clear view across land (or sea) will enable the complete arch to be included in a horizontal frame. If, however, part of the rainbow is obscured, a longer lens can be used to feature part of the arch at one side of the frame.

When the sun shines on waterfalls which produce copious spray, such as the Victoria Falls bordering Zambia and Zimbabwe, a rainbow will be seen if the sun is shining on your back when standing facing the Falls. A rainbow may be a fleeting phenomenon, but so long as the sun continues to shine and there are water drops in the atmosphere, it will persist.

The rainbow filters produced by Cokin may appear very tempting, but unless they are used with great care, it will be all too obvious that the rainbow is a fake. For instance, the pictures reproduced in the Cokin catalogue

The prolific spray produced by the Victoria Falls virtually guarantees a rainbow will be seen when the sun is shining directly onto the spray. On very windy days, care must be taken to protect equipment from drifting spray.

Rainbow across Victoria Falls seen from Zimbabwe side, September 1981. Kodachrome 25, 50mm lens on Nikon. Direct front lighting

showing rainbows with the sun *behind* the bow are, in reality, quite impossible as explained above. The filters are designed for use only with wide angle lenses. The colour bands of the bow broaden out and appear less intense in colour as the lens aperture is opened up; they disappear altogether when apertures larger than f8 are used.

Rainbows that form at sunrise or sunset appear chiefly red—typical of the sun's rays at these times of day. A rare sight is the white moonbow, tinged with red, that appears when a full moon shines on rain as nightfall commences

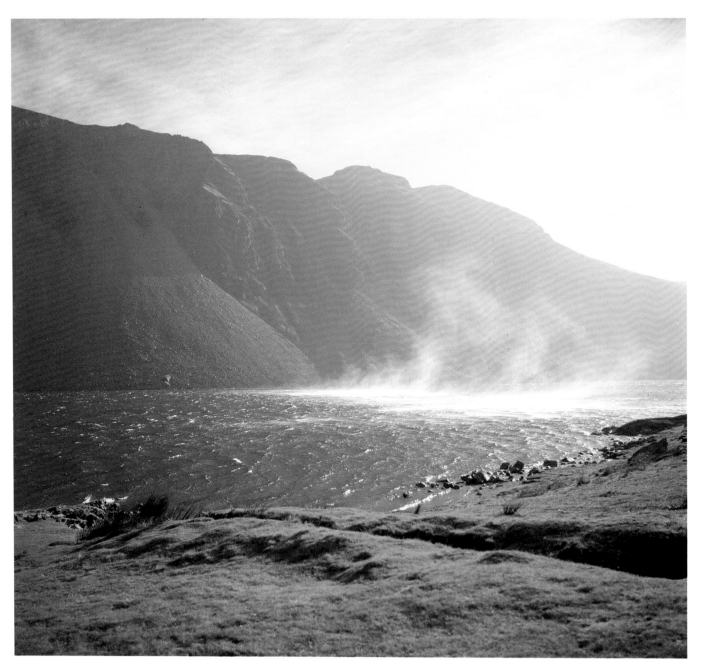

Wind

A slight breeze hardly modifies the landscape scene, but as the wind force gathers strength, it affects not only the way a landscape—notably water—is depicted, but also what kind of pictures are taken. Winds influence the weather by changing the temperature, and by moving clouds across the sky. Land warms up and cools down much more quickly than the sea, so that in coastal regions once the land gets warm and the pressure drops, breezes tend to blow inland from the sea. Trees in exposed coastal locations typically grow into

lop-sided shapes as the seaward side is constantly pruned back by buffeting from salt spray and wind. A low camera angle will help to emphasise the asymmetrical profile of the wind-pruned trees by making them stand out against the sky.

When working in the British Lake District one November, I happened to drive round Wastwater when extreme winds began to whip up the surface as a vertical spray. The force was so strong I could barely open the car door and if I left my 10 lb Benbo tripod unattended it immediately blew over.

Strong winter winds produced a rare sight on Wastwater—one of the lakes in the English Lake District—vertical spray rising several metres off the water. I chose a camera position where I could highlight the extent of the spray by shooting against dark hills on the opposite side of the lake.

Wind blowing spray off Wastwater, November 1980. Ektachrome 64, 150mm lens Hasselblad. Against the light.

The direction of a modest wind can be determined by holding up a grass stem or by releasing a column of sand from the palm of the hand. Winds are described by the compass direction from which they blow. Along the west coast of Britain, the prevailing winds are westerlies. Comparative strength of wind speeds is given by the twelve point Beaufort scale which describes both the character of the wind and the effects it produces inland. For example, a scale of 2 denotes a slight breeze which causes flags to move; while 6 on the scale denotes a strong breeze when thick branches of trees move and umbrellas are difficult to hold steady. The maximum level of 12 denotes hurricane force winds which result in severe destruction.

The highest wind speed recorded during the storm which blew across south-east England on the night of 15/16 October 1987, was 100 knots at Shoreham-by-Sea in Sussex. As the hurricane swept from the south-east coast through London and across to East Anglia, some 15 million trees were uprooted in the wake of the storm and many familiar landscapes—especially in gardens and parks such as Chartwell, Scotney Castle and Hever Castle in Kent, Petworth Park in Sussex and Kew Gardens in London—were drastically changed. Soggy ground, produced by heavy rain for a fortnight before the storm and virtually no leaf-fall from deciduous trees, were factors which exacerbated the ease at which large trees were uprooted by the storm-force winds.

As I travelled through Surrey, Kent and Sussex in the following week, I found that at ground level one fallen tree looks very much like another. Camera angles from the ground are limited—either from beside the root ball looking down the trunk or a side shot of the whole tree. Climbing up on to the fallen trunk helps to get a different perspective and I also searched for trees which had uprooted seats or crushed objects in

These pines were among the many trees at the Royal Horticultural Society's garden, Wisley, which were brought down by the 1987 October hurricane. It will be seen that one has completely crushed a wheelbarrow propped up against a tree.

Wind-blow damage at Wisley Garden, Surrey, October 1987. Ektachrome 64, 80mm lens on Hasselblad. Diffused light.

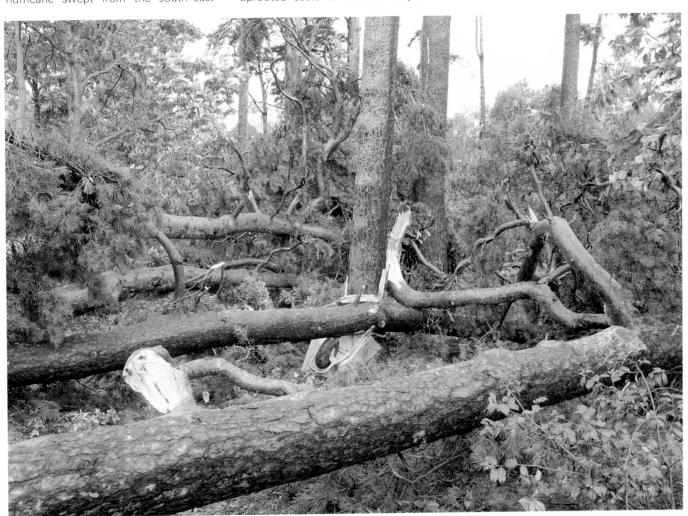

their path. A power saw soon reduces a fallen tree to a pile of logs, so it was essential to make a few telephone calls before setting out. Some of the most graphic press pictures were taken from the air and showed complete avenues of trees fallen across roads in built-up areas. A week after the storm I went up in a hot-air balloon to get some aerial shots myself (p159).

This has been the only time when my landscape pictures of an exceptional event proved to be newsworthy—with the result that they appeared in 10 magazines in 3 countries. The last graphic account we have of a severe storm in Britain is by Daniel Defoe writing about the 'Great Storm' of 26/27 November 1703—alas well before photography was invented.

Man utilises wind power to produce energy and to move over water. Individual windmills and billowing spinnakers of sailing boats both provide tremendous photogenic potential, but when I was suddenly confronted by the wind power park in the San Gorgonio

Pass northwest of Palm Springs in California, it was a mesmerising sight Here rows upon rows of windmills dominate the landscape—unquestionably an eyesore to any environmentalist— yet, they also represent extremely graphic repetitive shapes. On a clear day, the contrast between the white blades and the blue sky can be increased by using a polarising filter. I chose to do this with a slow speed film, so I could use a slow shutter speed to deliberately blur the moving vanes—thereby giving a better impression of the wind turning the vanes than if I had frozen all movement with a fast shutter speed

Among the many picture lists we receive from editors and art editors sitting at their city desks, have been requests for leaves blowing off trees in autumn. An easy enough action shot you would think, although in reality leaves do not blow off *en masse* but gradually a few at a time, which does not look very impressive in a still picture Swirling gusty winds will, however whip up dry, freshly fallen leaves

Wind turbines rotate in a wind power park in southern California. By using a polarising filter and slow speed film, I was able to darken the blue sky and use a shutter speed of 1/15 second to create deliberate blurred images of the vanes.

Wind power park, California, January 1988. Kodachrome 25, 50mm lens on Nikon Direct side lighting

Frost and Snow

At latitudes where frost or snow are not regular features of the winter landscape, the sudden appearance overnight of a hoar of frost or snow transforms a drab beige scene into a white winter fairyland. A blue sky backdrop will reveal the branching pattern of a frost or snow-covered tree more clearly than a colourless sky, but it is essential to be out early in places where the daytime temperature is unlikely to remain below freezing, since warmth from the sun's rays will quickly destroy the magical scene. Still greater contrast between blue sky and white objects will be gained by using a polarising filter.

It is hoar frost or rime, rather than a ground frost, which produces the most attractive landscapes. Hoar frost forms in very cold weather by the super-cooling of water drops in freezing fog so that they coat every surface they touch with a layer of ice crystals. Snow also forms from super-cooled water drops when they pass through air temperatures of $-12°C$ to $-16°C$.

Hailstones begin life in clouds high above the earth. The stones get bigger and bigger as successive layers of ice crystals build up until they reach 5–50mm in diameter. The damage they cause when they descend to earth in a storm shower ranges from shredded leaves and beheaded bulbs in gardens to extensive damage to crops and fruit as well as dents in car bonnets. Since hailstones tend to be even more ephemeral than frost and many snowfalls, it is essential to be out taking pictures immediately after the hail storm has passed. When exceptionally large hailstones fall, an object of a known scale needs to be included in the picture. Even if the hail has melted, damage caused by the force of the stones may still be worth taking.

In temperate latitudes, snow falls in winter when the temperature is around 0°C (it may even fall when the air temperature is above freezing), but since extremely cold air contains little moisture, heavy snow falls are rare in the Arctic and Antarctic regions.

Even though a snowscape looks so attractive, photographs can often be disappointing. One of the recurring problems is incorrect exposure since snow acts like a huge reflector and bounces back the light that falls on it. Any method of directly metering snow will therefore register a higher reading than an average grey card and so tend to underexpose the scene, which results in dirty looking snow. Knowing this, there are several ways to counteract the problem. Cameras with automatic metering with an exposure compensation dial should have the dial set adjusted to the +2 setting.

On cameras where the exposure is set manually, it is simply a question of opening up the aperture by $1–1\frac{1}{2}$ stops and bracketing several exposures by half stop increments to be sure of getting one perfectly exposed picture. With a separate light meter, it is possible to take an incident light reading.

Think very carefully about the camera viewpoint *before* striding forth into a snowy scene, because footprints in the wrong place cannot be erased, although footprints in the right place can add interest and texture to the foreground. When I visited the Oxfordshire garden of Rousham—the finest surviving example of a garden landscaped by William Kent (1685–1748)—one February morning several inches of snow had fallen and strong winds had blown it sideways beneath trees. This produced a rare picture revealing the shape of an octagonal pool fed by a winding rill beneath yew trees. Normally, it is difficult to distinguish the shape of the pool, since it is a similar colour and tone to the surrounding brown earth.

I was not so lucky when working on a commission up in Tyne and Wear for the Council for the Protection of Rural England (CPRE). As I flew up north from London during an extended freeze in the latter part of February 1986, the white fields surrounded by dark hedges, walls and roads appeared as a monoch-romatic patchwork. In places where light snow had fallen, it looked for all the world as though the land had been dusted with a giant sugar canister. Hills in the Peak District glistened as the surface of their flanks melted from the warmth of the sun. I landed in Newcastle with high hopes of getting some exciting landscapes, but throughout the next day the clouds clamped down until late in the afternoon when the sun began to break through. As soon as I saw an open gateway looking towards a shot with backlit clouds, I instinctively exclaimed about the lighting and my ever-obliging chauffeur reacted by sweeping into the gateway! I did get my shot, but had to crop the foreground very tightly to exclude the tracks of the car.

Snow like water, reflects the sky colour, and a blue cast tends to appear in the shadow areas. This can be counteracted by using an 81A or 81B warming filter. When a pink afterglow appears in the sky, this will momentarily be reflected in the snow and no warming filter is necessary.

Within seconds, a colourful display of spring bulbs was ruined by a brief hailstorm as hailstones perforated the leaves and broke the tulip stems. This picture was taken immediately after the storm passed, before the hailstones began to melt.

Hailstone damage to spring border, April 1979. Kodachrome 25, 50mm lens on Nikon. Diffused lighting.

The phenomenon known as 'red snow' which appears in alpine, Arctic and Antarctic regions, can be photographed at any time of day for it is not caused by reflected sunlight, but by red pigment inside huge numbers of microscopic organisms.

Walking any distance in deep snow is quite impossible without wearing either snow shoes or skis and these can easily be hired in popular tourist areas. Since batteries cease to function when kept at sub-zero temperatures for any length of time, it is inadvisable to put a gadget bag down onto cold ground. Gear should be carried so that it is easily accessible without having to take off the bag. A wading bag or a skier's pouch which fastens around the waist are both suitable, although the wading bag is more capacious and better padded.

If hand-held pictures will be sufficient, a camera (plus batteries) can be kept warm by tucking it inside an anorak between shots. If a tripod is essential however, the camera will be exposed for longer periods so that either batteries (or battery packs) will need to be frequently changed or else a spare camera kept warm. When I worked in Harbin in China at temperatures around −20°C, I found the anti-cold battery pack kept my Nikon F3 powered for as long as I could stand working out in the open. The normal batteries are removed and one end of the pack inserted into the camera body. This is connected via a cord to two 1.5-volt penlight batteries kept permanently warm inside an anorak.

As soon as I saw the snow-covered ground contrasting with the dark unfrozen water of an octagonal pool and the narrow winding rill in an Oxfordshire garden, I stopped in my tracks. So as not to spoil the scene with my footprints, I made a detour above the pool through the wood.

Octagonal pool with rill in Rousham, Oxfordshire, February 1985. Ektachrome 64, 60mm lens on Hasselblad. Indirect lighting.

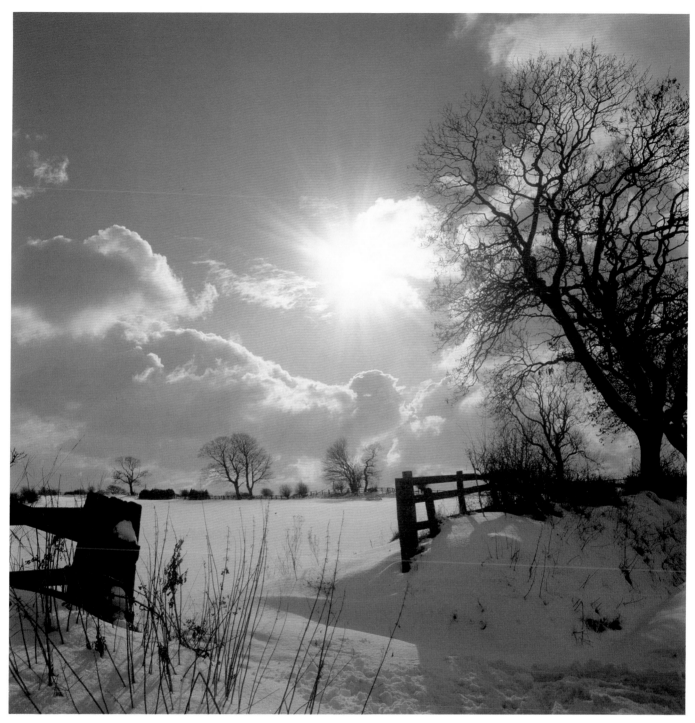

As the sun broke through the clouds, a dull winter scene suddenly came to life—proving how sun brings a sparkle to any snowscape. I used the silhouetted open gateway both to frame the lower part of the picture and to lead the eye to the backlit clouds and natural sun starburst behind.

Sun over snow-covered field in the Derwent Valley, Tyne and Wear, January 1986. Ektachrome 64, 60mm lens on Hasselblad. Backlighting.

Other problems which arise when working in sub-zero temperatures include moist breath condensing on the camera as ice, and brittle film which breaks very easily. For this reason, a camera in which the film can be wound on manually is preferable to a motor-drive or an auto-wind. Spare films should be stowed in an outside pocket, for if they are kept too warm, condensation droplets will form on the film when it is brought out into the cold. Hands can be kept warm by wearing several pairs of gloves and by keeping a hand warmer—available from sports and mountaineering shops—in a pocket *without films*. I find changing films is quite impossible with thick gloves, so I wear a pair of thin silk gloves beneath padded ski-gloves. I can then briefly remove the thick outer pair when I want to change a film.

A geological landscape comprising one kind of rock which is scantily clothed with vegetation—such as much of America's canyonlands—needs low-angled light to separate the unitoned features. A light snowfall therefore provides not only a welcome contrast to the rock colour, but also defines subtle contours.

When walking any distance over icy snow—especially when carrying camera equipment—it is most important to wear proper boots with good grips to the soles. During a visit to Utah, knowing I would not be doing any climbing, I abandoned my climbing boots in favour of moon boots, so I would have warm feet all day. As I returned to the car, I slipped on an icy patch in the car park, managed to regain my balance, only to have the weight of my camera rucksack send me flying flat on the ice. I was very lucky not to break a tooth or my nose, as I had very misshaped lips and nose for several days

Having photographed this restored gothic temple in summer, I knew the location and viewpoints well. After a heavy snowfall I felt sure the white exterior would look particularly striking within the snow-covered landscape. So it proved, with the snow carpet functioning as a huge soft reflector. The temple is one of several architectural features in an important eighteenth-century landscaped garden in the process of restoration.

Restored gothic temple, Painshill Park, Surrey, February 1986. Plus-X Pan, 50mm lens on Hasselblad. Complete cloud cover with diffused light in morning

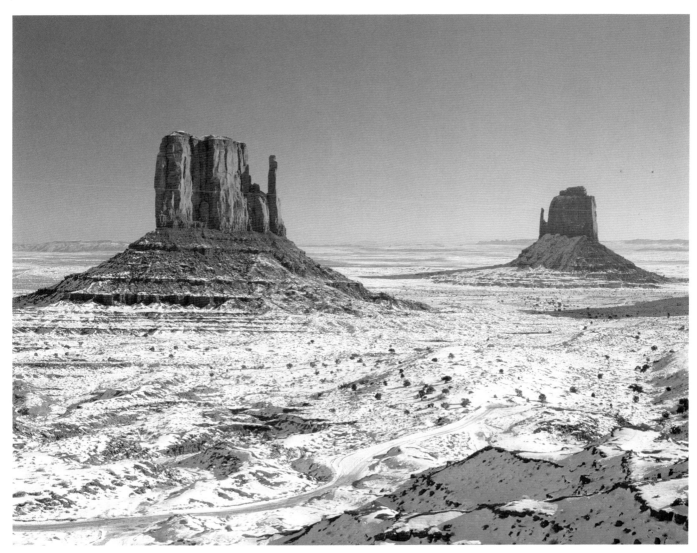

The westerns filmed on location in Arizona's Monument Valley with the striking rock formations rising up from the floor of the valley, give no hint of the winter scene. Snow transforms the valley, as the brown buttes and mesas, castlelike, become clearly separated from the surrounding white floor.

Monument Valley, Arizona, January 1988. Ektachrome 64, 80mm lens on Hasselblad. Direct light with a polarising filter.

Dust

Working in dusty conditions necessitates taking special care of equipment. Since fine particles will penetrate the smallest of cracks, it is sensible to tape up all hinges, cracks and flash sockets beforehand. If possible, load up more than one camera with film so as to avoid exposing the inside to a dusty atmosphere. Lens caps should be kept on all lenses not in use, but if a layer of dust does build up on the front lens element (or filter) a blower brush should be used to remove it. If possible, try to avoid travelling in convoy on an unmade dusty road—such as in East Africa during the dry season—otherwise everything and everybody behind the front vehicle gets covered in a continuous dust shower. Even if cameras are stowed away inside gadget or plastic bags, dust will still build up on the outside of bags and hence get onto hands.

A dusty atmosphere produces a similar effect to mist on landscapes in that it cuts down visibility and produces a soft light. This can result in some dramatic sunsets, with the sun appearing as a fiery orange ball in a grey or beige sky surround.

Camera equipment is best kept under wraps if a sandstorm blows up, for just one grain of sand inside a camera can completely ruin an entire film.

Lightning

Photographing bolts of lightning is not easy, since it is impossible to predict precisely when and where a flash will occur. However, if a slow speed film such as Kodachrome 25 is used, a time exposure of 10–20 seconds can be made without any risk of over-exposure. If more than one bolt is required on a frame, the shutter can be kept open, for if the sky is completely dark, the film will not be exposed between the lightning flashes.

Since lightning always finds the quickest route from a cloud to the ground, it will tend to strike high-rise buildings. Most of these have built-in lightning conductors, but anyone caught out in a thunderstorm should avoid standing next to large open-grown trees, metal fences or moist ground. In parts of the United States where lightning is not uncommon such as Utah, warning notices are posted at lookout areas with metal safety rails.

At the end of the dry season in Africa, when dust is constantly blowing up into the atmosphere, the setting sun frequently appears as a fiery orange ball in a grey sky. To increase the size of the sun, I used a 400mm lens; even then, the sun appeared relatively small in the frame—the diameter covering a mere 4mm across the 35mm frame.

Sun going down in dusty atmosphere, Zambia, September 1981. Kodachrome 25, 400mm lens on Nikon. Twilight.

Seasonal Effects

The cyclic pattern of the changing seasons produces dramatic colour changes to the landscape. In temperate regions, the seasons arise as a result of the earth tilting towards and away from the sun. On 21 June—the longest day in the northern hemisphere—the sun is closest to the Tropic of Cancer, while on 21 December—the shortest day—it is furthest away. The reverse applies to the southern hemisphere, so that midsummer is in December and midwinter in June.

While the average landscape photographer may not want to know details of how and why the seasons arise, the fact that they do exist is crucial to understanding the nature of light so that it can be exploited to the full.

The length of time the sun rises above the horizon varies with the latitude as is shown in the table on page 75. In temperate regions, on each successive day after midwinter, the proportion of light to darkness gradually increases, until midsummer's day when it begins to wane. Quite simply this means that at midsummer in London on latitude 51 °N, the sun rises above the horizon for over twice as long as in mid-winter. Up in Shetland on 60 °N, the sun is above the horizon for 18 hours 52 minutes in midsummer, but for only just over 5 hours in midwinter. In Shetland the midsummer noon altitude of the sun is 53.5°, but by midwinter it rises to only 6.5°. Locations within the Arctic Circle experience an extended twilight which merges into dawn so that while there is no true darkness in midsummer, correspondingly there is also no true daylight in midwinter. At this latitude it is possible to make a multi-exposure picture in midsummer showing the sun dipping down towards the horizon and gradually rising again. Allowances will have to be made for the build-up of light on the film emulsion by underexposing each exposure—allowing least when the sun is brightest.

It is therefore not only the number of daylight hours, but also the height of the arc described by the sun which has a direct bearing on how landscapes are lit at different times of year. Each season sees a change in the proportion of daylight to darkness and the angle of the sun. Fine days in spring tend to produce excellent visibility whereas summer days are often hazy and the sun is high in the sky; in autumn (especially in the morning) days tend to be misty, while winter light can appear rather cold. So that although a summer's day offers plenty of potential photographic time, in reality several hours on either side of mid-day the light is quite unsuitable for landscape photography. This means that the total number of hours spent on taking landscapes in summer may barely equal the total time spent throughout a winter's day when the sun maintains a low arc.

In temperate regions, spring brings green flush to the fields, hedgerows and deciduous forests; by summer, leaves turn a darker green with pockets of other colour as wild flowers begin to bloom out in the open. Autumn follows with fruits ripening and the leaves on deciduous trees and shrubs changing from green to yellows, browns or even reds so that by the time winter is upon us, trees are leafless skeletons and the ground may be clothed with a white blanket of snow.

The tropics do not have four different seasons, instead they experience alternating wet and dry periods. After several months without rain, the parched vegetation covering the ground becomes transformed when the rains eventually fall and trees leaf out.

Although the British nation is renowned for complaining about the unpredictable weather, the non-stereotyped pattern in many ways is a blessing to the landscape photographer in that it brings such a variety of lighting types and sky patterns to the scene. On the other hand, it can also be very frustrating if rain perpetually falls for days on end when direct light and strong shadows are required or, alternatively a spell of fine weather extends over a period when soft muted light is required for a specially commissioned shot. This is one of the major reasons why I prefer not to work to a specific brief and a rapid deadline, since the odds are that ideal weather conditions will not prevail.

Nearly all of my best landscape pictures have been taken when I happened to see a scene that caught my eye. That is not to say however, all my pictures are chance ones taken as I aimlessly wander around the countryside. On the contrary, I do my homework first—especially when flying to a remote location overseas so that, for example, I shall be sure of coinciding with the peak fall colours in New England, or the deep freeze conditions in Harbin, China during the ice festival (pp 76 and 133). Once on location, I have to work hard to make the most of limited optimum photographic conditions; selecting the subject, the best viewpoint and the focal length of lens to capture the essence of the particular season.

Spring

Spring is the season to which everyone—whether they are a photographer or not—looks forward, most especially if the winter has been a long and hard one. As the temperature rises and the daylight hours increase, buds begin to burst. Well before the deciduous trees begin to leaf, cutting out the light reaching the forest floor, carpets of flowers appear in time honoured succession. When landscape artists or photographers include a type of wild flower which is inextricably linked with a particular season, it immediately conveys the time of year when the painting was made or the picture taken. Even if spring comes early or late, we know that by the time primroses are flowering in one location in Britain, snowdrops will

Carpets of bluebells flourish in recently coppiced woodlands in older woods without a dense overhead canopy. The diffused light produced on a cloudy day is best for recording the true blue on colour film. Bluebells are easily damaged by trampling so, either photograph them from the edge of the wood or be sure to keep to well-worn paths.

Bluebells in Surrey woodland, May 1988. Ektachrome 64, 80mm lens on Hasselblad. Indirect light late in day.

have faded and poppies are yet to come. But the time when a particular species of plant flowers or a tree leafs out will depend on both the latitude and the altitude. Naturalists and gardeners are well aware that spring comes early to south-west Britain, before the south-east counties, which in turn are ahead of northern counties. This means that if a particular kind of flower required in a landscape picture is past its best in one place, it may be possible to find it in good condition further north (or further south in the southern hemisphere), although the topography of the landscape may be completely different in the two locations.

Snowdrops are the earliest woodland flowers to open in Britain and produce a floral carpet. They are locally abundant in damp woods and beside streams. Since colour film will not be able to cope with patches of bright sun and shadows on the white flowers, snowdrops are best taken *en masse* lit by the diffuse light produced on an overcast day. Compared with an open habitat, where it is possible to move freely in any direction to find the best camera position, a woodland is restrictive. Moving backwards to gain a wider angle of view is rarely beneficial since more trees begin to appear in the viewfinder thereby blocking a clear view. The best solution is usually to use a wide-angle lens.

After snowdrops, yellow and blue carpets appear when first primroses, then bluebells, flower. They both grow best in coppiced woodlands where they receive plenty of light through conspicuous gaps in the overhead canopy. If one or more trees is included in a photograph of a natural spring carpet, this provides a useful scale. A bluebell wood somehow typifies Britain in spring; small wonder that European and American visitors marvel at the azure carpet. But the colour we see and know often turns out to be disappointing and erroneous on colour transparency film because unlike print film, the true blue is not faithfully reproduced. The reason is that slide films record some of the far red and infra-red wavelengths emitted by the blue flowers so that they appear pinky-blue. With a wide-angle shot including both trees and green leaves, it is obviously impossible to use a pale blue colour compensating filter to correct the unnatural looking cast, but working on a dull day will help.

When clusters of wild flowers bloom in open situations, they bring a contrasting colour to an essentially green

landscape. Wet meadows and the margins of streams are enlivened in spring by yellow kingcups or marsh marigolds. But the flowers of these plants are never concentrated enough to produce the blocks of solid yellow achieved by buttercups or more especially rape fields. In the last decade, the face of lowland Britain had been transformed by farmers planting an increasing acreage of rape. There is nothing subtle about these uni-coloured expanses, so that time has to be spent looking for contrasting shapes or colours to relieve the monotony. A long lens can be used to telescope blocks of colour into an abstract pattern as perfected by the Italian photographer Franco Fontana in his striking landscapes taken in southern Italy using a 100–300mm zoom lens. He sees his landscapes as bold shapes, form and colour and he abhors detail. By underexposing a film by 1 stop (for example, rating a 64 ISO film at 128 ISO) the colour and contrast of a landscape can be increased, thereby accentuating the abstract interpretation. Depending on the weather, the intense yellow colour produced by a flowering rape field is at its peak for about a week,

The intense blocks of colour introduced to the landscape by rape fields in flower are so conspicuous, effort has to be spent looking for ways to disrupt the colour. To get this picture of a line of trees between two rape fields, I had to find a place to park my car off a busy road with no pull-outs and then walk round the edge of three fields.

Flowering oilseed rape fields, Oxfordshire, May 1988. Ektachrome 64, 250mm lens on Hasselblad. Hazy but bright.

although this can be prolonged with a spell of cool windless days.

When bulbs are grown commercially, they too provide opportunities for getting abstract pictures of brilliant blocks of colour. In Britain, the flat fenland reclaimed around the Wash in Lincolnshire is rich agricultural land ideal for bulb growing, which is centred on the town of Spalding. The end of April is the best time to visit when acres

Sheep with lambs in a flowering cherry orchard typifies spring in Kent. The shadow of the foreground tree makes a solid base to an almost circular frame—topped by the arching branch above—to the sheep and lambs, while the backlighting helps to separate the sheep from the background.

Sheep and lambs in Kent cherry orchard, May 1986. Ektachrome 64, 150mm lens on Hasselblad. Backlighting.

of bulbs come into bloom. As this is a great tourist attraction, the traffic builds up at weekends. Early in May the town comes to a standstill when the Flower Parade is staged with floats made from countless spring blooms.

An excellent place to see a huge variety of bulbs grown in a garden setting is at Springfields Gardens near Spalding (p68), although an early start is advised because once the coaches arrive, it is impossible to get a picture without several people wandering into the field of view. Spectacular floral bulb landscapes can, of course, also be seen in Holland where the peak time is the end of April.

The warmer weather and burst of plant growth makes it a congenial time for many animals to produce their young. The classic spring landscape includes sheep with their lambs and, if it was taken in Kent, backed by cherry blossom. Precise timing is vital for this sort of picture since blossom lasts for a few brief days. My picture was lucky in the sense that I had not done my homework as thoroughly as normal—although I did check with the Kent Tourist Board that the blossom was at its peak before I set out. At this time of year, several blossom routes are clearly marked for motorists. I followed these, taking pictures as and when a scene caught my eye. As I drove round a corner and down a hill, I saw some sheep and lambs in an orchard beside the road. I managed to get permission from the nearest house to enter the field, where I took half a dozen frames before huge clouds rolled up and the backlighting was lost.

The flowers associated with spring vary in different countries. In China, for example, deep pink peach blossom has been revered for more than 3000 years and is frequently depicted in Chinese paintings. According to Chinese folklore, peach blossom brings good luck and happiness, while the fruits symbolise longevity. Peach grows wild in northern and central China, but is cultivated throughout the country and, like the plum (native to eastern Sichuan and western Hubei provinces), is often featured in courtyards of gardens and temples. The plum has white or pink blossom and blooms earlier in the year—in late winter or early spring.

Magnolias and camellias are also popular garden plants in China from where several species (as well as many rhododendrons) have been exported to Britain. China's south-westerly province Yunnan is glorious in spring when

magnolias and camellias come into flower. Trees such as peach, plum and magnolia which bloom on bare branches before the leaves open are very susceptible to frost damage. In Kunming the capital of Yunnan, frost is a rare occurrence, so I was surprised to see the normally green surrounding hills looking distinctly white as my plane descended early in March 1986. As we stepped out onto the runway, I noticed huge icicles on the terminal building and our local guide soon confirmed freak frost and snow had struck during the two previous days to produce the coldest spell for a quarter of a century! I did not need to look at the magnolia and

Spring comes early to south-east China; in Yunnan the blossom reaches its peak in March. These trees have been planted near the entrance to the Stone Forest, a natural wonder of eroded limestone peaks, to give a welcome contrasting colour to the sombre grey rocks. I tried taking pictures from ground level, but I needed some hanging branches to soften the blue sky, so I climbed onto a low rock.

Blossom in Stone Forest, Yunnan, China, March 1986. Kodachrome 25, 85mm lens on Nikon. Oblique side light.

camellia flowers, for I knew all the white and pink blossom would be brown from the frost. We therefore had no option but to revise our itinerary for the botanical tour and head further south. *En route* for Simao—situated near the Burmese border in the tropical zone—we paused at the Stone Forest where the pink blossom trees brought attractive, but fleeting, colour to the grey limestone peaks. Boughs laden with blossom can be used to frame a picture and even after the petals have fallen, they can add foreground interest to a path or lawn.

Spring is heralded in the south-eastern part of the United States by dogwood flowering. Driving along freeways in Georgia and South Carolina in late March, the conspicuous flowers (in fact white bracts around tiny flowers) stand out among the other green trees—especially at twilight. The most popular plants in parks and gardens of this region are dogwood and azaleas, reaching their peak flowering early in April when places like Savannah and Charleston are a joy to behold.

May is my favourite month for working in Britain, for it is then that most deciduous trees leaf out, so I gravitate towards the New Forest in Hampshire. I go there to see old poll-arded beeches in the Ancient and Ornamental woodlands clothed in a delicate green. For a very brief time, before the leaves have fully opened out, it is possible to see the branching pattern through the translucent green leaves. Old beech trees can also be seen in Burnham Beeches in Buckinghamshire and at Savernake Forest in Wiltshire.

Spring comes late to the alpine pastures high up mountains for the floriferous swards do not appear until after the snow has melted. Then, for a few brief weeks, alpine meadows in Austria and Switzerland are a botanist's paradise. Other mountainous areas are also especially photogenic at this time of year when the slopes are backed by snow-capped mountains. Over a decade ago, I went pony-trekking in Kashmir specifically to see the alpine flowers. All my previous expeditions in search of alpine flowers had been on foot and being small, I found the additional height gained by riding on horseback a great advantage. It is the larger and more conspicious flowers—especially erect ones—which make good foreground subjects to a wide-angle view of a snow-clad mountain. Small, prostrate plants cannot easily be distinguished in a wide-angle picture and so are better taken as a close-up.

Summer

As the daylight hours lengthen, so the end of spring passes into the first days of summer, the bulbs and blossom have long since faded, but many wild flowers adorn the hedgerows and meadows. Before the hay is cut, some fields are golden with buttercups; although superficially reminiscent of the rape fields flowering earlier in the year, they somehow appear much more attractive. On roadside verges, tall-stemmed ox-eye daisies wave their white and yellow flowers, while rosy swards of rosebay willowherb or fireweed appear on waste or burnt ground. When a mass of brightly coloured flowers is taken with a wide-angle lens so that it fills the foreground backed by a blue sky with fluffy white clouds, this typifies a perfect summer's day.

To the uninitiated, summer might appear to be the best season for taking landscapes, but the relatively high angle of the sun from mid-morning to mid-afternoon provides little modelling and the only way reasonable looking landscapes will be taken is well before breakfast and late in the day. For this reason, when I am abroad on location, I tend to get up early to work, have breakfast, then spend the middle of the day driving to the next location. If it is productive, I stay overnight to see it in the morning light; otherwise I will drive to a new site for first light the following morning.

Before the corn crops ripen, green grass is cut for silage and birds are attracted to feed on the insects which appear. Like the gulls which follow the plough in winter, this can make an attractive picture illustrating the interaction between wildlife and farming.

As crops begin to ripen, fields take on a golden hue in marked contrast to the grey stone walls or green hedgerows of the field boundaries. It is only when you travel abroad to places such as the United States or Australia that you appreciate hedgerows are essentially a unique feature of the English landscape. The patchwork of fields and hedges originate from the thousands of Enclosure Acts, most of which were passed between 1760 and 1820. Originally, hedges were made from cut brushwood, but later they were replaced with live shrubs. During the heyday of the enclosures, nurserymen made a thriving business selling hedgerow seedlings—notably hawthorn. Like all living hedges, hawthorn provides shelter and food for wildlife; in addition it

forms striking white ribbons when in flower.

Vast areas of monoculture such as the North American prairies are rather boring landscapes since they provide no contrast apart from the succession of combine harvesters in action. It is becoming increasingly difficult to get pictures of traditional methods of harvesting crops, but this is still carried out in the more remote villages in Europe. Cutting corn by hand makes for a much more intimate picture than a bright red or green combine towering above a sea of corn. Gathering and packing oranges by hand makes a particularly colourful rural scene.

The appearance of a field after harvesting varies from regular rows of unbaled straw to outsized bales, both offering scope for seeing patterns and designs in the landscape.

The widespread use of herbicides has meant that the traditional weeds of cornfields—cornflowers, corn marigolds and corn cockles—are now rarely seen on modern farms. However, red poppies continue to reappear in cornfields, since these plants also grow on any waste ground, including new roadside cuttings. Poppies in cornfields can be photographed either as a straight record with the whole frame in focus and the corn and poppies pin sharp, or they can be taken using a slow shutter speed so that they appear like an impressionist's painting.

Other colourful summer crops include flax, lavender and sunflowers. Most of the commercially produced lavender in Britain is grown at Heacham, near King's Lynn in Norfolk where the fields take on a purple haze at the end of July (p25).

Extensive fields of sunflowers are planted in southern France. Typical of the daisy family, the sunflowers turn their heads to face the sun so that all the plants in a field will face the same direction. Quite different effects can be produced on the one hand by looking towards the front of the flowers showing the yellow petals; on the other by looking at the rear of the heads showing the conspicuous green bracts. Jerusalem artichokes also have yellow flowers but being much smaller in diameter, they do not make such impressive repetitive shapes.

Heathlands are transformed in summer when heather blooms, but in exceptionally dry years they become a great fire risk. A careless match can then easily set a heathland alight, resulting in dramatic scenes of leaping flames and a

Even the most ordinary of wild flowers—in this case dandelions and cow parsley—when growing as a mass, make a striking foreground to a rolling summer landscape.

Meadow flowers at Whittonstall, Derwent Valley, Tyne and Wear, June 1986. Ektachrome 64, 60mm lens on Hasselblad. Direct sunlight.

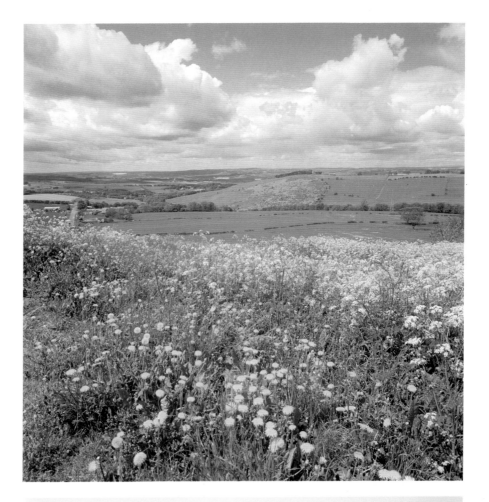

This study in lines was a chance picture found *en route* when driving to a location further away. Lines of loose straw left by a combine harvester run up at right angles to the field boundaries parallel with the road, except where the combine had to make a small detour to go round the lone tree.

Straw lines in a field, July 1986. Ektachrome 64, 150mm lens on Hasselblad. Diffused light.

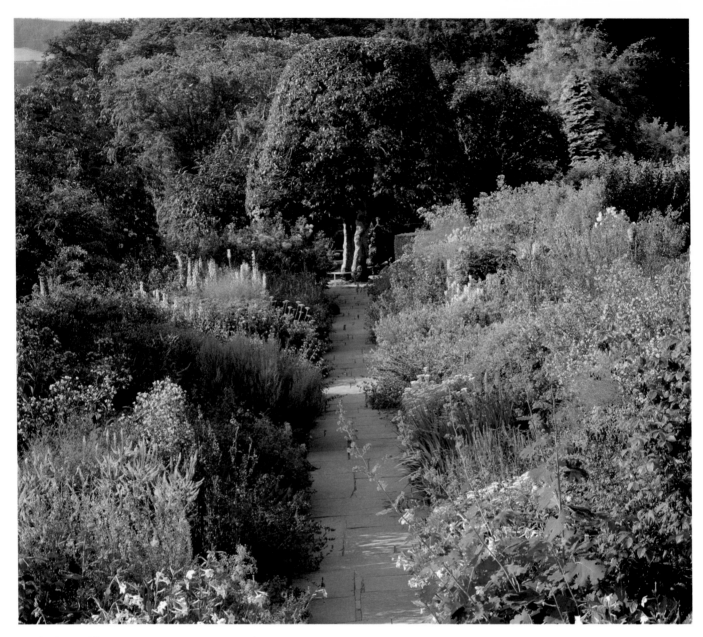

smoky haze. After the harvest, there are plenty of opportunities for taking pictures of stubble burning.

The quintessence of an English summer though must surely be a garden vista looking through a pair of herbaceous borders in full bloom. I have photographed many such borders up and down the country and I find much the best light in early July is either before breakfast or in the evening around 8pm. It is also worth looking down from a high viewpoint—such as an upstairs window—to see if this gives a better perspective to the linear borders.

In the southern hemisphere, summer coincides with Christmas and the New Zealand Christmas tree is not the tradi-

tional Norway spruce used for hanging presents, but an evergreen which produces bright red flowers. When in full bloom, powderpuff flowers enliven the native evergreen forest known as 'the bush' and provide brilliant splashes of colour along the coastline in the northern part of the North Island

A raised walk running at right angles to these herbaceous borders gave a perfect viewpoint looking down towards the neatly clipped tree at the far end. Since I last photographed this view, the grass path worn thin by trampling feet, had to be replaced by flagstones. However, their neutral colour tones in well with the pastel shades of the flowers.

Double herbaceous borders, Crathes Castle, Scotland, July 1986, Ektachrome 64, 150mm lens on Hasselblad. Cross lighting from first rays of early morning sun

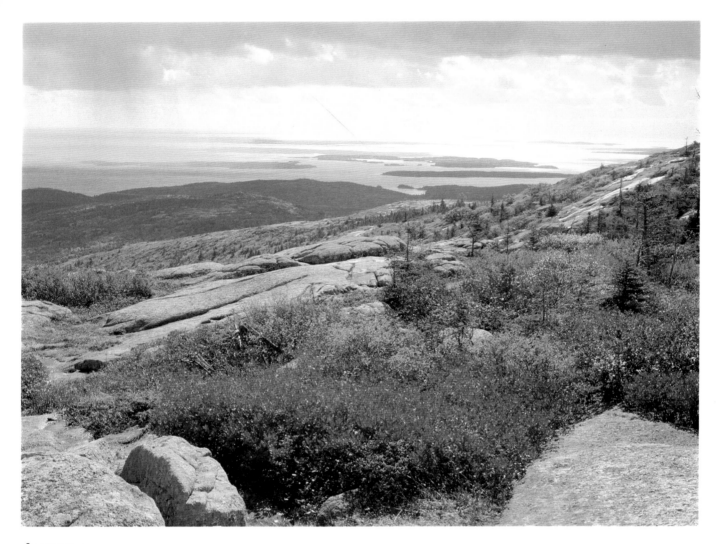

Autumn

Autumn is a season of change when prior to deciduous trees shedding their leaves, green chlorophyll is no longer produced and other pigments begin to colour the leaves. The precise time for the peak colour depends on several factors, including the amount of rainfall in the summer. The best autumn colours appear when sunny autumn days alternate with cold nights.

The actual tints depend on the tree types and range from yellow, to orange, brown and red. Some of the most spectacular autumn landscapes are to be seen along the eastern seaboard of the United States where the kaleidoscope of colours is legend. The clear reds of red maples, red oak and sweetgum add a special fiery magic to the fall vistas. Once the September night temperature drops, waves of colour begin to appear first in more northern latitudes and at high elevations. When the fall colours are established in New England,

the trees gradually turn in the more southern states.

All over this part of the United States, volunteers—known as leaf peepers—are out checking the fall foliage. They provide regular updates on the rate of colour change in different parts of the state. New York alone has 100 leaf peepers spread out all over the state who call in once a week to report the amount of coloration in their area. The information gleaned from the leaf peepers is collated for reporting to the media prior to each weekend. Most states have a special free Fall Hotline number giving visitors regularly updated information on the estimated dates for the peak coloration and the best routes to follow. Once the colours have turned, the percentage leaf fall in each area is also given.

Since the fall foliage season normally lasts for only three to four days in any given area, it is well worth ringing ahead to check the dates estimated for the

Colourful fall foliage in the New England states is provided by low growing shrubs as well as large trees. By using a wide-angle lens, I was able to include colourful blueberry leaves in the foreground as well as the distant view across Acadia National Park out towards the eastern seaboard of the Atlantic coast.

Fall colours on Cadillac Mountain, Acadia National Park, Maine, October 1986. Ektachrome 64, 60mm lens on Hasselblad. Direct overhead lighting.

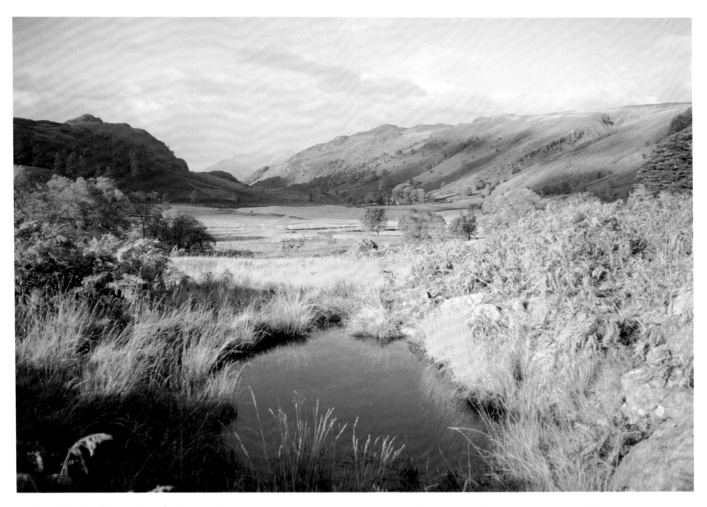

peak colours. However, if the peak happens to coincide with wind-free days (and nights) the trees will hold their colour for a longer period. Anyone prepared to spend time travelling from the northernmost New England state southwards would be rewarded with a feast of fall foliage landscapes from mid-September through to early November.

I have seen spectacular autumn tints in China adjacent to the Great Wall (p27) as well as in Sichuan and Anhui provinces. The colours of autumnal foliage are enhanced still further when they are growing intermingled with green conifers. Since green is a complementary colour to red, it helps to separate the shapes of red trees better than when deciduous trees are growing en masse together. A high viewpoint such as a bridge spanning across a valley will give a good overview of an adjacent hillside. If the sun is shining, colours can be enriched by use of a polarising filter.

Britain may lack the brilliant reds, but I find the autumn colours here are equally

attractive in a more subtle way. Autumn landscapes work best when water and/or hills are included in the composition with the autumnal foliage. For this reason, the Lake District is a much favoured photographer's haunt in autumn. Here, reflections can be found in still water and when individual trees are viewed into the light against an unlit background, they appear to have an especially rich luminosity.

Ripening fruits add colour to both natural habitats as well as crops specifically cultivated for their fruits. At Hallowe'en time, roadside stalls piled high with pumpkins and squashes are commonplace in New England and further south in the States, while in England a specialist Sussex grower always has an impressive array. When lit by the evening light, this seems to enhance the golden glow of the fruits.

One of the most colourful sights involving the harvesting of fruits however, takes place in the Cape Cod area of Massachusetts. Here in October, commercial bogs are flooded to a depth of several inches over the cranberry

One of my favourite British landscapes is this view in the Lake District showing how dead bracken fronds bring colour and warmth to a late autumn landscape. The intense blue sky reflection in the water is typical of a low angled sun. This is not a difficult landscape to photograph, since the bracken fronds will persist as this colour throughout much of winter.

View across Watendlath Tarn, Lake District, November 1974.
Kodachrome II, 35mm lens on Nikon. Direct side lighting.

This was only a small part of an eye-catching display of pumpkins, squashes and gourds for sale in a Sussex village. The larger fruits are edible while the small gourds are ornamental. I came across this display quite by chance as I was driving around Sussex photographing trees felled by the 1987 storm; the stall was fortuitously piled high with fruits.

Pumpkin stall in Sussex village, October 1987. Ektachrome 64, 80mm lens on Hasselblad. Diffused lighting.

vines so that machines with balloon-like tyres can be driven over the bog agitating the water with a huge rotating frame. The water turbulence causes the spherical red berries to float to the surface and produce a sea of scarlet cranberries. These are then coralled and sucked up through a large flexible tube and discharged into lorries.

As dawn breaks on an autumnal morning, mist (p40) is often present, which adds atmosphere to a landscape as well as helping to blot out unsightly backgrounds. Since the visibility falls off markedly in misty conditions, the camera needs to be focused on a subject at close range for any foreground to be discernible.

As water in a flooded cranberry bog is agitated, the fruits bob up to the surface and the blue water is covered by an ever-increasing red layer. When taking any flat wetland site I always look around for something to boost my height. At the cranberry bog I longed for the additional height provided by the roofrack on my 4-wheel drive estate, but a wide-angle lens did help to accentuate the mass of red berries.

Cranberry harvesting, Plymouth, Massachusetts, October 1986. Kodachrome 25, 24mm lens on Nikon. Direct overhead light.

Winter

Overcast days in winter bring a cold grey light to landscapes which often tend to show a bluish cast in a colour photograph unless a warming filter has been used. But there are days when the sun shines through a blue sky and the colours of dead bracken fronds or rocks appear to glow. In extremely cold places, even with an air temperature as low as −20°C, on days with no wind and clear skies, working out in the open all day is perfectly possible, providing you are well insulated against the cold.

Conifers look their best when they are dusted with a light snowfall so that the pattern of the green branches shows through the snow. A very heavy snowfall not only masks all trace of the branching shape, but also invariably cascades off the trees on to the ground or even results in branches breaking off the tree. The length of time snow stays on trees also depends on the ambient temperature.

Shortly after it had stopped snowing, I climbed a small hill to get this view looking down onto a regular formation of planted conifers. The snow helps to lighten the sombre needles yet the shape of the branches is still discernible through the light dusting of snow.

Snow-covered conifers, Surrey, February 1985. Ektachrome 64, 150mm on Hasselblad. Diffused light

A light snowfall can be helpful in breaking up a solid expanse of red rocks as well as defining bumps and ridges, as I discovered on a trip to Utah early one January. All the National and State Parks in Utah are well endowed with automobile and walking trails with vantage points overlooking the most spectacular views. Some parks which experience heavy winter snow such as Sequoia National Park in California, or which have tracks with a steep gradient such as Monument Valley in Arizona, insist either on 4-wheel drive vehicles or chains being used on ordinary cars.

Winter is a time to take advantage of the low-angled sun accentuating shadows of trees cast on a uni-toned background. When sun strikes an avenue of trees from the side, shadows from the trunks are cast as a series of conspicuous parallel lines across the avenue; or a narrow band of regularly planted straight-boled trees viewed against the light will have their exaggerated shadows thrust forward towards the camera (p72).

The pair of pictures from a high viewpoint looking down on to the river Thames exemplifies how varied an identical winter scene appears with or without snow. The December view without snow and bathed in sun, looks so much more appealing than the overcast day in February when snow blanketed the ground. When I returned, I took the first picture with me to make sure the framing would be similar.

The techniques for photographing the most obvious winter subjects—scenes blanketed with snow (p93), or water frozen to ice (p131)—are covered elsewhere.

Wet and Dry

Tropical rain forests develop in places where the mean annual temperature ranges from 24°–30°C coupled with a high and regular rainfall. When the annual rainfall drops and comes in concentrated periods—known simply as wet seasons—the lush tropical rain forest gives way to open forests, although there are verdant narrow forest strips bordering river valleys.

For much of the year, African savannah grasslands appear golden in colour and the unmade tracks are notoriously dusty. However, when the rains come, the grasslands turn green, wild flowers pop up all over the place and many trees leaf out. Dramatic skies may occur with sun spotlighting the landscape against a dark stormy sky. Dry

From a high viewpoint overlooking the river Thames, I used a long focus lens to home in on one of the many locks on the river. The February snowfall, coupled with the sombre light, reduces the scene to virtually a monochromatic image with the field boundaries being more clearly defined than in the December light. Then, the oblique lighting clearly highlights the weir and lock gates as well as the brickwork of the house surrounded by the green fields.

Day's Lock, River Thames, from Wittenham Clumps, Berkshire. Kodachrome 25, 300mm lens on Nikon. *Above:* December 1985. *Below:* February 1985.

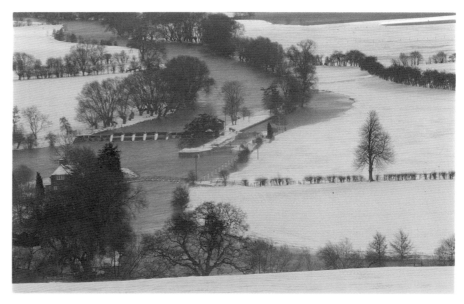

river beds suddenly become raging torrents and, since few tracks through the parks have bridges, flooded rivers can impede progress for a short time.

However, the most dramatic change in the landscape I have ever experienced was in the Galápagos. I first visited this archipelago, lying on the equator off the coast of Ecuador, in December, when, (like Darwin during his 1835 visit) I found the arid zone looking dry and parched after many months without rain. Darwin stresses, in his account of the Galápagos, how inhospitable he found the islands. But what a different scene he would have found had he visited them during, or immediately after, the brief wet season. The extent of the rain depends on the strength of the warm El Niño current which diverts the cold Humboldt current that usually bathes the Galápagos. When the rains come, temporary rivers gush and temporary lakes appear; trees leaf out, annuals germinate and flower. As can be seen by the pair of pictures reproduced here, the arid zone is transformed after rain and is barely recognisable as the same landscape I had experienced only four months previously.

When heavy rain falls in a hot environment, this results in a high humidity which is detrimental to both cameras and film. I have seen a camera after it had been subjected to very humid conditions during the rains in Zanzibar, where mould had grown on the lens elements. Since mould will also grow on the film emulsion, films need to be kept as dry as possible before and after exposure as well as after they have been processed. Roll films can be kept in their vacuum-packed foil packaging until use. After exposure, all films should be kept in an airtight box with silica gel crystals until they can be sent off to be processed. As dry silica gel crystals (blue) absorb water moisture they gradually turn pink, but heating in a low heat oven will remove the moisture and change them back to their dry state again.

In south and south-eastern Asia, the summer monsoon brings heavy rain as the cold air from the sea moves in over land, whereas the winter monsoon brings dry weather as cooler air from the land moves out over the warmer sea.

For most of the year, the only green parts of the arid zone in the Galápagos are the cactus pads; the deciduous trees resemble winter skeletons and there is no sign of growth at ground level. But as soon as it rains, a spectacular transformation takes place, as the deciduous trees leaf out and the annuals and perennials burst into life underfoot.

Arid Zone, Conway Bay, Galápagos. Kodachrome II, 35mm lens on Nikon. *Above:* December 1973. *Below:* March 1975.

Water

Although water covers seven tenths of the earth's surface, much of this comprises open oceans—an inaccessible and unphotogenic habitat. It is therefore the coastal waters and the inland wetland sites—streams, rivers, canals, ponds and lakes—which attract the photographer's eye. These liquid landscapes are especially fascinating because water itself has several physical properties which can be used to enhance a landscape photograph. As light strikes still water, it is reflected back from the surface so that mirror-like it adopts the colours of the reflected subject, whether it be the sky, trees, hills or man-made structures. Moving water, on the other hand, brings a dynamic element to a still picture.

Temperature extremes transform water; the normal liquid phase freezes into a solid at sub-zero temperatures and evaporates into a gas when it is boiled. These different phases bring striking variations to the water theme.

I find water has an hypnotic appeal. If I am in a boat or a hide overlooking water waiting for an animal to appear, I am quite content to pass the time studying the changing face of the water surface. When I worked several years ago as a marine biologist, I spent a great deal of time wading in shallow coastal water and diving underwater. In those days I was so preoccupied with life in the sea, that I failed to notice the subtle variations of the interplay of light on water. In between the two extreme moods of water—the tranquil nature of calm water and the turbulent nature of a raging torrent—a range of temperaments can be found. These can be conveyed in a photograph simply by varying the time of day when the film is exposed. Other variable parameters such as the focal length of the lens, the presence or absence of a polarising filter and, if the water is moving, the selected shutter speed will also affect the mood of the scene from an identical viewpoint. Longer term seasonal changes (p132)

also markedly affect both the appearance and colour of a liquid landscape.

Still Water

Water will accumulate in any natural hollow or man-made depression until it reaches the brim of the containing wall and overflows. If no currents flow through the water and wind-free conditions prevail, the surface of calm water functions like a perfect mirror.

Bodies of still water span such a wide size range it is impossible to generalise about photographic techniques. A small pond obviously requires quite a different approach to a large lake. An elevated viewpoint—even if it is only from the top of a small step-ladder—can help to give a wider angle of view for a small natural pond enclosed by scrub or trees.

Garden ponds and pools span even greater variety: they may be informal or formal, flush with their surrounds, sunken or raised. When cascades or fountains are incorporated into pools they bring a dynamic feature to the still water. The architect Edwin Lutyens designed many water gardens adjacent

to houses specifically so that features would be reflected in the still water.

Raised pools are a feature found in both Chinese and Moorish gardens, where they contribute a positive architectural element. In China, the pools are often decorated with potted plants, while the circular Moorish tank, as it is known, is typically unadorned so that the open water simply reflects the sky and trees.

Village ponds in Britain have dwindled in number as they lost the importance they had centuries ago when they were the focal point of the

This is essentially a very simple study in pastel tones with wildfowl silhouetted on an inland sea lit by the afterglow of the setting sun. If the water had been lit in any other light, or the birds moved out of shot, the picture would have been hardly worth considering.

Wildfowl on Salton Sea, California, January 1988. Kodachrome 200, 200mm lens on Nikon Twilight

village. They provided water not only for the local inhabitants and their stock, but also watering places for passing horse-drawn wagons.

If the margins of ponds are not constantly trampled by animals coming to drink, they soon become choked with invasive water plants unless they are cleaned out regularly. Many ponds have therefore either become completely overgrown and dried out or been used as rubbish tips. However, the launching of the Save the Village Pond Campaign in 1974 resulted in the restoration of over a thousand ponds.

Where there is open water, ducks often home in to a village pond which adds interest to the pastoral scene. If possible, these ponds need to be shown in their village context with some of the neighbouring houses or perhaps a church.

All animals require water to drink and a pond (or a water hole in an African game park) will lure in birds and mammals. Commoners' ponies are free to roam throughout much of Hampshire's New Forest where well-worn tracks can often be seen leading to a favourite watering place. A patient wait will usually be rewarded by one or more ponies coming to drink. Even if the animals occupy only a small area of the picture, they will still provide a sense of scale as well as a mobile element to the still water.

A large lake is rarely perfectly calm, but early in the morning a ripple-free surface can often be found before a breeze begins to blow. The shapes of surrounding hills and trees, as well as any emergent reeds, are then repeated as reflections. Mist often lingers at this time of day which gives additional atmosphere to a lakeside landscape.

I find large flat water areas are the most difficult of all wetland sites to photograph imaginatively at any other time of day, for then ways have to be sought of relieving the monotony of a uni-coloured expanse. If you are lucky, a shaft of sunlight can produce a most dramatic effect if it is spotlighting a small area of water. Without such drama, a wide-angle lens can be used to exaggerate the foreground perspective, but without water plants or stones, this will only increase the illusion of a mirror-like sheet. Reflections (see below) of waterside trees or architectural features are a bonus since they introduce colour and shape to a flat surface.

Boats can also add both colour and scale to a large body of still water. A flotilla of brightly coloured canoes or sailing boats will tend to dominate the scene, whereas a single boat gives an

I had spent some time taking photographs of the attractive water crowfoot flowers in this New Forest pond. After I had packed up and begun to head for the car, a New Forest pony and her foal came down to drink. Commoners' ponies roam the New Forest using well-worn tracks to drink at the many ponds.

Pony with foal drink at New Forest pond, Hampshire, May 1985. Kodachrome 25, 35mm lens on Nikon. Oblique backlighting.

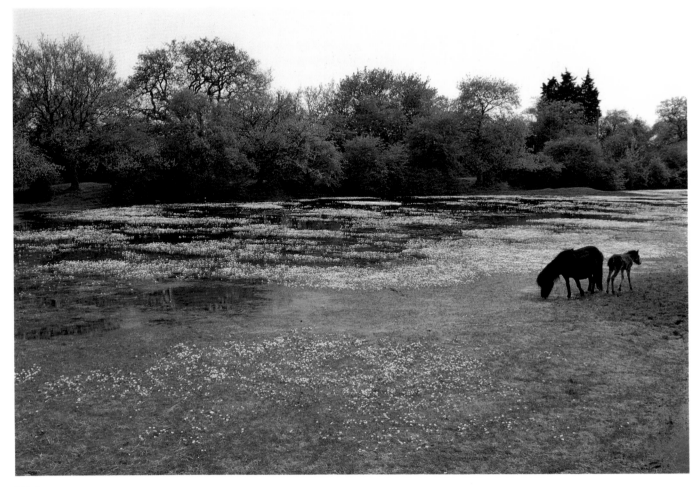

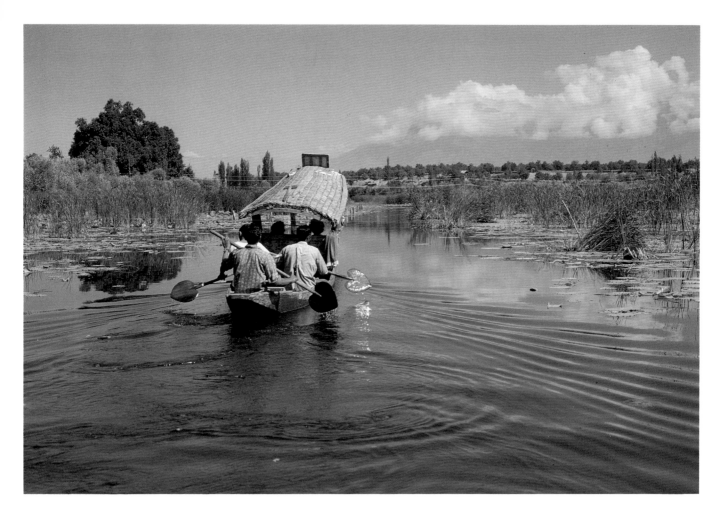

obvious focal point. Dal Lake in Kashmir is a huge lake on which there are many permanently moored houseboats for tourist accommodation. Excursions out on the lake offer opportunities for taking broad vistas backed by a spectacular mountain range, as well as more intimate cameos of the local inhabitants plying to and fro in their crafts. On one occasion we passed a boat propelled by heart-shaped paddles and I was able to get a picture of the rear view showing ripples created by the passing boat and the colourful paddles as they were raised out of the water.

Seeking out and using an elevated viewpoint can be an advantage when confronted with a large area of still water, especially if this will then reveal a convoluted margin to a drowned valley lake. In this sort of situation adjacent hills which are accessible, can be climbed to gain a different perspective. Failing this, I then resort to using the additional two metres gained by climbing on to the specially boarded-in roof-rack of my four-wheel drive estate. Walls, bridges and buildings—especially

church towers—also make useful elevated viewpoints.

In a weed-free lake, waterfowl immediately add interest—especially if they are interacting, feeding or drinking. Likewise, when an isolated clump of water lilies colonises an open expanse of water, this also gives an obvious focal point to a pond or lake. However, when the lily pads or other aquatic plants invade the open water to such an extent they carpet the whole surface, it loses its ability to reflect and so the plants tend to dominate the scene. The size of the lily pads can be exaggerated by photographing them at close range from a boat using a wide-angle lens. When they are viewed against the light they have an obvious silvery sheen as they reflect much of the skylight. Their colour and mood can be altered simply by using a polarising filter to remove the skylight reflection and thereby enrich the green of the lily pads.

Where there are emergent plants—such as reeds or bulrushes—projecting above the water they can provide foreground interest to otherwise flat water.

While out in our own boat on photogenic Dal Lake in Kashmir, we passed a flat-bottomed *shikara* being propelled through the water with red heart-shaped paddles. I did not mind getting the rear view of the boat because the roof at the front slopes down towards the back making one point of a triangular design with the paddles the other two. The ripples created by the paddles provide a texture to the solid expanse of water in the foreground.

Shikara, with heart-shaped paddles on Dal Lake, Kashmir, July 1974. Kodachrome II, 85mm lens on Nikon. Oblique front lighting.

They can look particularly dramatic if they are photographed against the light so they appear silhouetted. If a wind causes a slight rippling of the whole water surface, this in itself may not be enough to make a striking picture, but the combination of the ripples and silhouetted plants produced a striking

end of day picture to a man-made pool in Hampshire's New Forest.

An infuriating problem often arises in wet or swampy areas in summer when shooting into the light with an unlit background behind. Even the smallest of midges shows up with backlighting and a swarm appears as a myriad of bright specks. Using a slow shutter speed exacerbates the problem, since the insects then appear as bright streaks flashing across the field of view. Waving a hand in front of the camera will make them move away for only a short time. Using an insect repellent helps to keep them at bay in the immediate vicinity, but not completely out of the shot.

I spotted this lake with isolated clumps of water-lilies from a train window. On the return journey, I made a mental note of the nearest railway station so I could work out the location of the lake on a detailed map. There were copious private fishing notices around, but as I was not carrying a fishing rod, I pressed on regardless. Without a boat I could not get in close to the water-lilies so I searched for trees to frame the picture. Take away the frame, and there is simply no picture. I knew instinctively that the large area of plain blue sky above and water below the horizon, would be a copy-writer's dream.

Alder and willow trees frame lake with water-lilies, Surrey, July 1982 Ektachrome 64, 250mm lens on Hasselblad. Direct light high in the sky.

Reflections

Flat calm water is enlivened by colourful reflections—whether they be from the sky, landscape features, buildings or other architectural features. The mood and colour of calm water in an open situation changes most noticeably as the sky colour varies from colourless, through blue, stormy black and flush pink or orange with a rising or setting sun. Mountains and hills—as well as waterside trees, plants and buildings—are also mirrored in calm water. Sometimes the reflection appears to be so perfect, it is possible to turn a photograph through 180° and the reflection looks identical to the subject, although since this is a mirror-image, any lettering on signs or buildings will obviously be reversed. Likewise, a hill that slopes obviously up or down from one side of the picture to the other will be reversed in a reflection.

As some light is absorbed by the water, the reflected image will always appear slightly darker than the subject itself above the water. If both are included in the picture, it is therefore impossible to expose correctly for the aerial and the reflected image, but if the reflection fills the frame, it can be correctly exposed simply by opening up by ¹/₂–1 stop. Should distracting skylight reflections appear on the surface in the field of view, a polarising filter will reduce or even eliminate them and thereby enhance the intensity of colours in the mirrored scene.

Since the image of the reflection is formed at the same distance below the water as it appears above, if the reflected image fills the frame, the camera needs to be specifically focused on the reflection and not on the subject.

Where a bridge supported by a series of semi-circular arches is perfectly reflected in calm water, each semi-circle is repeated to form a complete circle. In China, the circle is regarded as a perfect shape and it appears repeatedly both in classical and temple gardens as a variety of forms including window apertures and moon gates (p29).

Perfect reflections are in fact comparatively rare since a rising fish or alligator, birds feeding, falling leaves, wind or rain all send waves of ripples across the surface. But ripples can sometimes be used to advantage as they distort a perfect reflection into an abstract representation. For instance, when the wash from a passing boat laps up against multi-coloured barges or sailing boats tied up to their moorings, this can produce a most attractive abstract picture. Different coloured flowering shrubs—particularly azaleas—planted down to the water's edge can result in an equally effective abstract, while the stark leafless skeletons of trees killed as a result of rising flood water appear as ghostly undulating bifurcating black shapes.

The calm water of Loch Tulla has produced a near perfect reflection of Darach Droire and clouds in the surface; a few small ripples have produced a slight distortion. The saturation of the colours was enhanced by using a polarising filter.

Hills reflected in Loch Tulla, Scotland, September 1984 Kodachrome 25, 35mm lens on Nikon. Direct sunlight

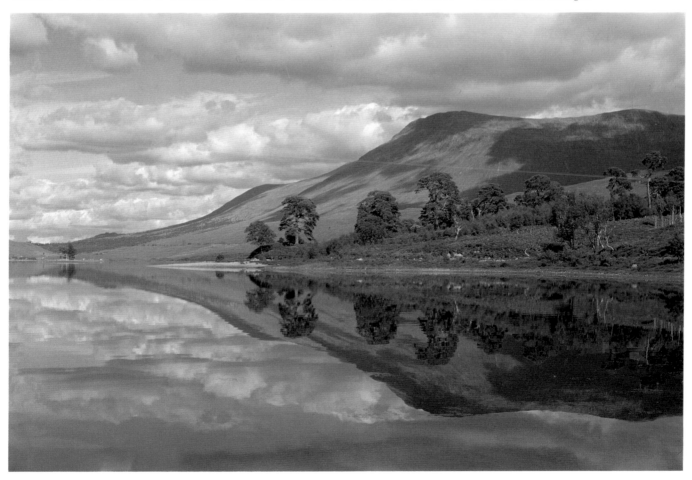

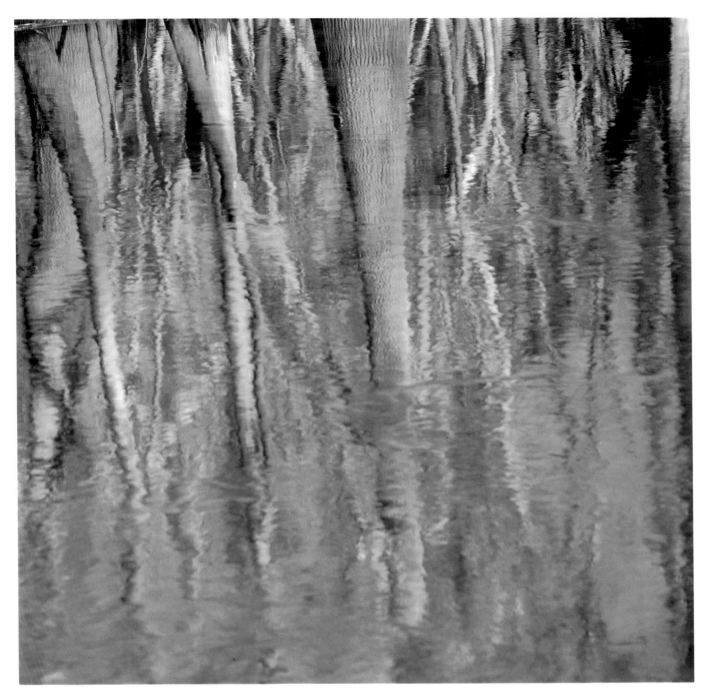

**When I saw swamp cypress trees
bordering a tributary of the
Suwannee River reflected in the
water, I decided to take the
reflections on their own. I was
intrigued by the abstraction of
the trunks formed by gentle
ripples distorting the perfect
reflections.**

Abstract reflections of swamp cypress
trunks near Suwannee River, Georgia,
January 1986. Ektachrome 64,
150mm lens on Hasselblad. Early
morning light.

As the sun rises or sets over water it can produce a few brief magical moments as it is reflected in calm water, wet sand or a road as a fiery ball or on rippled water so that it resembles liquid gold. Determining the correct exposure is not easy when only part of the frame is lit by a golden reflection. By metering off the water to one side of the reflection, the water will appear correctly exposed and the reflection overexposed. On the other hand, by metering directly off the reflection, this will be correctly exposed and the water on either side underexposed. In this situation it is debatable which is the correct exposure, for it is very much a matter of individual preference. However it is a good idea not to be too abstemious about using film and to bracket on either side of a metered exposure. Also, remember never to point the camera directly at a bright sun (p87). In a misty or dusty atmosphere however, when the sun appears as an orange or red ball in a grey sky, it can be included in the field of view without risk of damage to the eye.

As the sun sets on a huge expanse of sea, it is possible to vary the camera position by walking along the shore or cliff top to seek out an attractive silhouette to frame a picture of the sun setting or the afterglow on the sea. If a viewpoint is chosen on the shore next to the sea, a wide-angle lens will be needed to exaggerate the sea in the foreground, otherwise it will appear as a narrow strip across the frame. Using a higher viewpoint such as a cliff top and a long focus lens, it is possible to fill the frame with golden water. Since the sea surface is so often choppy, it rarely functions as a perfect mirror, so that a reflected sunset (or sunrise) appears as wavy orange streaks in dark water. Photographing a sunset reflection from a rocking boat can be very tricky, and it is often easier if the horizon is excluded so that it cannot appear lop-sided in the frame.

The reflection of a full moon on the sea also makes a worthwhile picture, although since there is little colour, it may work better on monochrome film.

When sunlight is reflected from the surface of a river snaking its way through the landscape, the shape of the river can be highlighted by metering directly off the water so that the land features become lost in the deliberate underexposure.

Attempting to photograph a fleeting reflection in water is much more difficult. Among the ideas once sketched for me by an art director was a reflection of

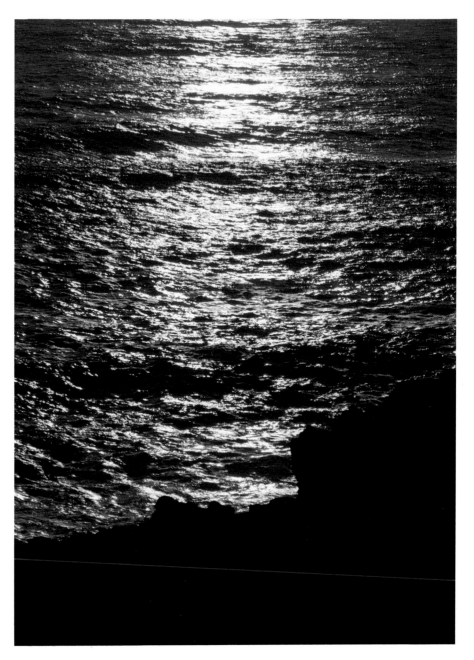

a flock of birds flying above a river. I pointed out it was difficult enough to pan a camera to take the birds flying in the air, but the chance of framing the shot (because their flight path would be unpredictable) *and* focusing on their reflections before the birds moved out of shot would be virtually impossible!

As the sun sets on sea gently lapping against the coast, the motion of the waves transforms the banded reflection into the appearance of liquid gold. For this picture, I decided to fill most of the frame with the reflection itself and to exclude the sun, in contrast to the picture of the sun setting on the Zambesi on page 87, where the reflection is seen in context with the river and the setting sun.

Reflection of sun setting on the sea, Cornwall, July 1977. Kodachrome 25, 135mm lens on Nikon. Reflected sunlight at dusk.

Moving Water

Where water seeps out of the ground, springs gush forth, or snow melts, water flows down the gradient and a stream begins to form. It gradually broadens out as it collects more water until it becomes a river. The colour of water moving overland varies from crystal clear to dark brown peat-stained bog water and tannin-stained tropical waters to rivers laden with silty loads. The relative transparency or turbidity of water clearly affects the type of picture that can be taken. Gin-clear chalk streams such as the Hampshire Itchen enable photographs—especially if a polarising filter is used to remove the skylight reflection—to be taken showing the colour and pattern of the submerged vegetation. If the water is shallow, I wade out into the river; otherwise I look for a bridge to set up my tripod from an elevated viewpoint. Turbid waters, on the other hand, mask everything beneath the surface but they can provide a contrasting colour to the surrounding landscape. An aerial view of such a river at the point where it discharges into the sea can make a striking colour contrast as the silt-laden waters permeate into the sea water. The white curtain of water created as it falls vertically over a dam or

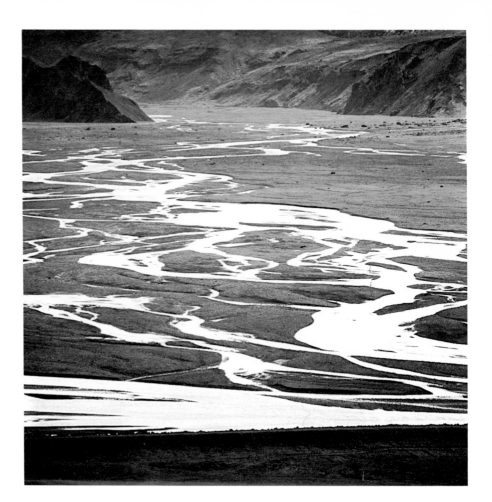

Outwash plains form beyond the snout of a glacier as the debris is carried down by the melt water. This Icelandic plain shows the braided streams typically criss-crossing back and forth. I climbed part way up a hill to get a higher viewpoint of this abstract landscape, which is worth comparing with the creek pattern in Mawddach Estuary (p 36).

Outwash plain with braided streams, Iceland, July 1981. Plus-X Pan, 250mm lens on Hasselblad. Diffused light in morning

The white curtain of outflow water cascading from Craig Goch reservoir is a conspicuous landmark in the Elan Valley. This picture was taken from a nearby hill in winter when the reservoir was full of water. The rate of flow is much less impressive when the water level drops.

Outflow of Craig Goch Reservoir, May 1981. Kodachrome 64, 50mm lens on Nikon. Cloudy but bright

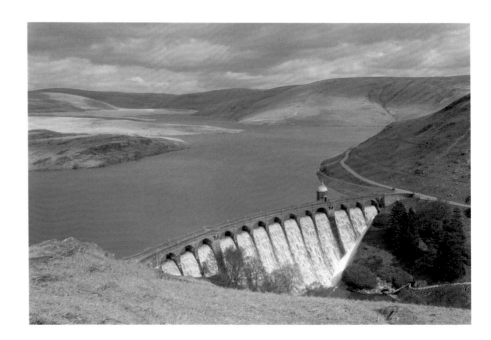

a weir also contrasts well against the darker flat water and the surrounding land.

Moving water can be portrayed in a still picture by means of two quite contrasting approaches. A fast shutter speed will freeze all movement capturing splash from a waterfall as drops in mid-air; while a slow shutter speed makes no attempt to arrest turbulent water, recording it instead as a series of soft lines none the less conveying the direction of movement. The blurred pale water streaks show up particularly well where they flow around dark rocks and boulders.

Turbulent white water reflects much more light than calm dark water, so that either a slow speed film or a neutral density filter will be needed to allow a slow shutter speed to be used to deliberately blur the water.

Man has long been fascinated by the beauty and sound of moving water—fountains being strongly featured in both French and Italian classical gardens. The design of modern fountains incorporates variations on the theme of the simple single jet—such as aerated jets, bubblers and formed nozzles. There are even kinetic fountains that rotate. Unlike static fountains, these should not be taken with a slow shutter speed because the structure itself will then also appear blurred. There is no better way to study the interplay of light on moving water than by walking round a fountain and viewing it from all angles. Coloured lights incorporated into the design bring an exciting dimension to photographing fountains at night.

Waves and Tides

The mood of a coastal landscape is determined by the interaction of the sea with the land. The intimate sandy cove eagerly sought after by summer visitors can be transformed overnight by a winter storm scouring out all trace of sand.

Armed with tide tables, the precise time of high and low water can be calculated in advance of a visit to the coast. The optimum time to aim for arrival at the coast will depend on the type of coastal landscape picture that is required. For shots of surf pounding the coast, high tide is preferable; whereas broad sweeps of sandy bays are exposed only at low tide.

If a pair of comparative pictures is required of a stretch of coast at high and at low tide with both pictures framed in an identical way, careful note needs to be taken of the camera viewpoint and the focal length of lens used, together with a sketch made of the obvious landmarks. A rocky shore will provide a

To take this fountain—one of many outside the People's Palace of Culture in Kunming—I moved in as close as possible with a wide angle lens so as to avoid getting people obscuring the fountain base. The low level of illumination enforced a 1 second shutter speed rendering the water a soft blur.

Fountain playing at night, Kunming, China, March 1986. Kodachrome 64, 35mm lens on Nikon. Fountain lights.

more dramatic contrast than a flat sandy beach; although if you are unfamiliar with the coastline and where the most striking features will be uncovered at low tide, it may be difficult to select the ideal lens to use. In this case, it is sensible to make a preliminary recce before deciding on the camera position and taking the first picture. I have taken several pairs of pictures both of rocky shores and mangrove swamps at high and low water.

At places where the tidal range during the high-ranging spring tides is more than 10 metres in height, and the horizontal distance between high and low water marks is several miles (as at La Rocque on Jersey in the Channel Islands), it is impossible to show the top and bottom of the exposed shore in a single picture taken from land. The only way to show the dramatic visual change of the scene is from the air, when the moving plane makes it difficult to frame an identical view.

In sheltered bays where pastures extend down to the sea, the exposed brown seaweeds make an interesting colour contrast to green fields. A word of warning here though: some colour films may reproduce brown seaweeds as distinctly green. Having tried virtually all the colour transparency films, I find that Agfachrome 50S and Ektachrome 800/1600 give the most authentic brown colour reproduction.

Within enclosed tidal Scottish lochs and Irish loughs, sea water gradually rises and falls with the ebb and flow of the tide with practically no wave action,

On rocky coasts that are not too exposed, a variety of brown seaweeds are revealed during low water of spring tides. These seaweeds were taken on a dull day when subtle variations in the colours are most apparent.

Oarweed and thongweed exposed at low tide on the shore of St Mary's, Isles of Scilly, April 1980. Agfachrome 50S, 60mm lens on Hasselblad. Diffused light.

so that plants such as thrift virtually meet the upper seaweed limit. The brown seaweeds tend to float out over the surface as the tide rises. In the same way as floating plants give interest and contrast to freshwater surfaces, so the seaweeds provide foreground interest. Water in wave-free enclosed lochs has a similar calming effect as a tranquil lake. On the open coast on the other hand—especially one exposed to the ocean—waves constantly buffet the shore which produces a restless feeling.

The height of waves is determined by the force of the wind and the distance across open water the wind has blown (or the fetch). As waves approach the shore and begin to 'feel' the bottom, they steepen and eventually break. The most spectacular waves occur over gently shelving beaches of some oceanic islands, where, after travelling thousands of miles, ocean swells produce the curling breakers so beloved by surfers in locations such as Hawaii. The only way to photograph a surfer inside a wave tunnel is by getting out there with a surf board and an underwater camera.

From the shore, breaking waves show up best when they are backlit, so it is worth studying a map to find a stretch of shoreline which faces into the light—preferably early or late in the day—when the sun is at a low angle. A motor drive is by no means essential for photographing landscapes, but when taking spasmodic action—such as waves breaking—on a day when the clouds are racing against the sky, it can be an advantage to shoot quickly during brief bursts of sunshine.

When working anywhere along the coast it is worth remembering that sea water is highly corrosive and if a variety of interchangeable lenses is not required, one of the weatherproof compact cameras is ideal for working on an exposed coast which is constantly bathed by salt-laden air. A wise precaution when using a non-weatherproof camera is to keep a UV (ultra-violet) or skylight filter on all lenses in use so as to prevent spray getting on the prime lens. The whole camera can easily be protected from spray by covering it with a transparent plastic bag and cutting out a hole for the lens hood to project through. The bag needs to be large enough to enable hands to adjust any camera controls if necessary, although it is possible to focus the camera from outside the bag.

Working directly on the shore involves erecting a tripod on the beach; one with wooden legs will not corrode; whereas a conventional tripod with metallic legs needs to be kept out of contact with sea water. Either tape heavy duty plastic bags around the base of the legs or, when working on wet sand, stand them in plastic cups.

Another way of taking marine landscapes is to use a long lens and work at a safe distance from where the waves crash onto the coast. I often use a 300mm or a 400mm lens to take wave studies. One of the most dramatic ways to record a breaking wave is when the sun backlights it so that every drop of spray becomes highlighted.

On exposed coasts, where the sea forces its way up through a rock fissure

While I was photographing waves breaking on the shore in Sri Lanka with a long lens, I was so intent on looking through the viewfinder, I failed to notice a huge wave breaking on the beach where I was standing. Just at the last moment a sixth sense made me instinctively grab the tripod with the camera and hold it above my shoulder. A second later the wave broke—around my waist!

Wave breaking beneath coconut palms, Koggala Beach, Sri Lanka, May 1983. Kodachrome 64, 400mm lens on Nikon. First dawn light.

in the top of a cave, a blow-hole may form. At high tide—especially in stormy seas—water spurts up through a blow-hole in a similar way to a geyser erupting (p134). Several blow-holes exist on Hood (Española) Island in the Galápagos. An example of blow-holes in Britain is the Flimstone Cauldron in Wales, others can be seen at Flamborough in Yorkshire and at the Lizard in Cornwall. When the sun is shining at right-angles to the white plume with a blue sky behind, the contrast between the two can be increased by using a polarising filter. Alternatively, with the sun behind it, a white blow becomes dramatically rim-lit.

Another more intimate type of coastal landscape is the rock pool. The type of rock, the rate at which it is weathered and the alignment of the strata in relation to the waves all influence the number, shape and size of rock pools. They may be deep narrow slits, broad shallow basins or expansive deep pools low down on the shore. So that life in the pools can be shown in a picture,

they need to be taken when they are uncovered by the tide, preferably with a wide-angle lens so that they are shown in context with the rest of the shore. A polarising filter will eliminate skylight reflections to reveal the colours of the seaweeds and other inhabitants of the pool.

The broad, yet flat expanses of estuaries where rivers meet the sea, require a high viewpoint to do them justice either from a hill or from a plane. Estuaries filled with water at high tide do not make for an exciting composition, but as the tide turns and the water flows out to sea, an intriguing tree-like pattern of creeks and mud banks may be revealed, reminiscent of the braided streams in Iceland (p120).

In funnel-shaped estuaries, the mass of water flowing in during the high-ranging spring tides is so great that it piles up to form a wall of water known as a bore, (from the old Norse *bara*, meaning wave) which progresses up the river. The Severn bore is one of the most famous, but other British rivers

where bores can be seen include the Parrett (Somerset), the Cheshire Dee and the Yorkshire Trent. Bores occur on the Severn twice a day on about 130 days in the year, but spectacular bores will be seen on only some 25 of these days, notably during the spring equinoctial tides.

This picture of the eroded limestone shore of the Burren region in Ireland can be taken only at low tide. The dark circular areas in the foreground pools are sea urchins which dig out individual hollows in the rock where they live. Right at the top of the picture a wave can be seen breaking. I excluded the horizon because the sky was colourless.

Eroded limestone shore, The Burren, Ireland, June 1980. Kodachrome 25, 20mm lens on Nikon. Overcast.

Streams and Rivers

Rivers are the life blood of the land. The water they carry supports a rich and specialised flora and fauna, but ultimately it flows via estuaries to the sea. As fresh and sea water evaporate, clouds form and rain falls to earth thereby completing the water cycle.

Over long periods of time, rivers are responsible for shaping some aspects of the landscape. Fast-flowing waters assisted by boulders and pebbles, cut through bedrock to form characteristic V-shaped valleys in contrast to the U-shaped valleys cut by glaciers. Rivers always take the easiest route they can find, cutting through soft rock in preference to hard rock.

As rivers broaden out and deposit their silt loads, so flood plains are formed. The acute eye of an expert angler will know what kinds of fish appear in a particular stretch of a river simply by looking at the rate of flow, the substrate and the vegetation.

One of the most illuminating ways of appreciating the changing face of the river from source to mouth is by flying above its course as I did years ago over the river Severn. As an upland stream, water gushes down a steep gradient, but by the time the velocity of the river is reduced as it reaches the flood plain above Ironbridge, the route develops conspicuous looped meanders. Indeed, one of the best ways of photographing meanders is from above in a plane (p157) or a hot air balloon. Another dramatic way of taking them is from an overlooking hill against the light, then a drab river in a drab landscape becomes transformed as a silver snake moving down over the land.

Fast-flowing rivers tumbling over rocks and stones also come to life when viewed against direct sunlight from the bankside or by wading out into the river itself. Where the sun is reflected off the bubbling water, a myriad of highlights appear, not unlike the way a gemstone turned in the hand glistens under a bright light.

The interaction of river water on the substrate over which it flows, produces wonderfully varied features, ensuring endless possibilities for varying the photographic approach. For example, where a river cuts through a glacial moraine, as frequently occurs in Iceland and Alaska, the deposits are dumped on a huge plain to form the characteristic criss-crossing braided streams. The dynamic nature of these rivers means that they lack any vegetation and

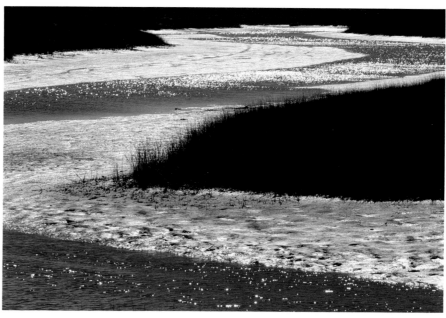

so provide excellent opportunities for taking graphic images in both colour and monochrome (p120). Along some stretches of rivers in the South Island of New Zealand, shingle islands develop and on the most stable islands expansive floral displays can be seen. These may be simply broad splashes of yellow from broom flowers or a multi-coloured patchwork of lupins.

After a long period without rain, the water level in a river may fall low enough to reveal intriguing eroded shapes of the bedrock over which it flows. The interaction of water flowing over the rock provides endless scope at varying magnification scales, using different focal length lenses.

Smaller rivers which have a lush growth of flowering plants and ferns bordering their margins, look especially attractive when framed to include the verdant banks before they become trampled or obviously browsed. Often these sorts of pictures can be taken from one bank looking across to the other; but if the stream is shallow, I may decide to wade up or down it without a camera in search of a better viewpoint. Only when I find one, do I return for the tripod and cameras.

Bridges not only link one side of a river with the other, they also provide a focal point in a photograph, whether they be a rickety cable bridge with a single walking track across a Chinese river or a modern multi-lane motorway spanning a harbour. The choice of viewpoint will depend on the topography of the surrounding land, the size of the bridge and the height of the span.

I abstracted a portion of a snaking river by using a long lens. Looking into the light gave tremendous variation in exposure between the blue water, the silver sand and the grass banks, so I decided to meter off the water. In this way, the banks appear silhouetted and interest focuses on the blue water and the silver sand.

Portion of river in Georgia, January 1986. Kodachrome 25, 300mm lens on Nikon. Strong backlighting.

Viewed from above, a bridge will be defined by a water background; whereas from a low angle looking up to it, the bridge can effectively frame the view using the sky as a background.

Like bridges, boats also make a focal point to a uni-toned stretch of water, even a single boat occupying a small area of the frame can make all the difference between producing a record of a river and a harmonious composition that arrests the eye.

Several years ago when I led a small photographic delegation from Britain to China, we were hosted by the Chinese Photographers' Association. They wanted to take us to the renowned and arguably the most photographed land-scape in China—the Lijiang (Li River) near Guilin backed by spectacular karst scenery. Even from the tourist boats that ply daily along the river, the scenery is breathtaking—although by mid-day the light is far from ideal.

Our Chinese hosts, however, had thought of everything. They arranged for us to stay in a riverside hotel (not normally used by foreign tourists) so we could board a small boat before dawn to get in position on a hill up river for the

The combination of fresh green leaves and bubbling water was irresistible. Before taking a camera with me, I waded out into the river to find the best viewpoint. This one was chosen because of the intriguing pattern of white bubbles in the dark water at the bottom right of the picture.

River Derwent near Allensford, Tyne and Wear, June 1986. Ektachrome 64, 60mm lens on Hasselblad. Oblique backlighting.

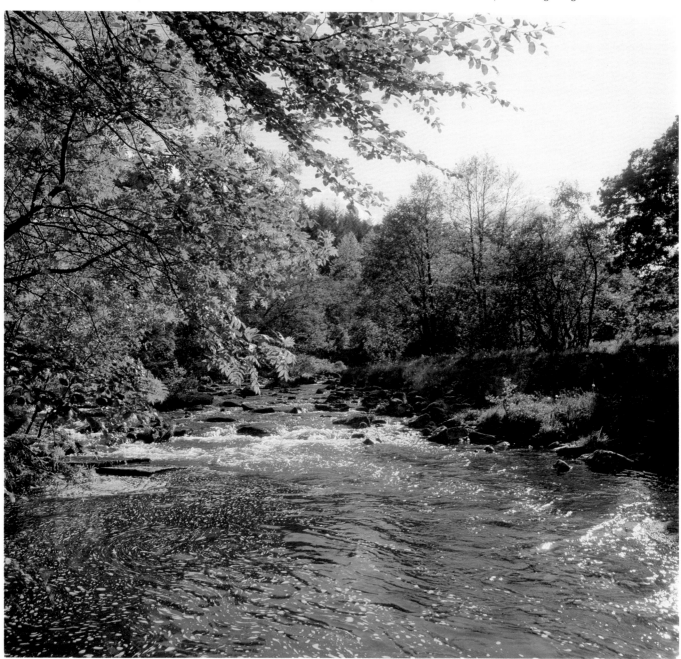

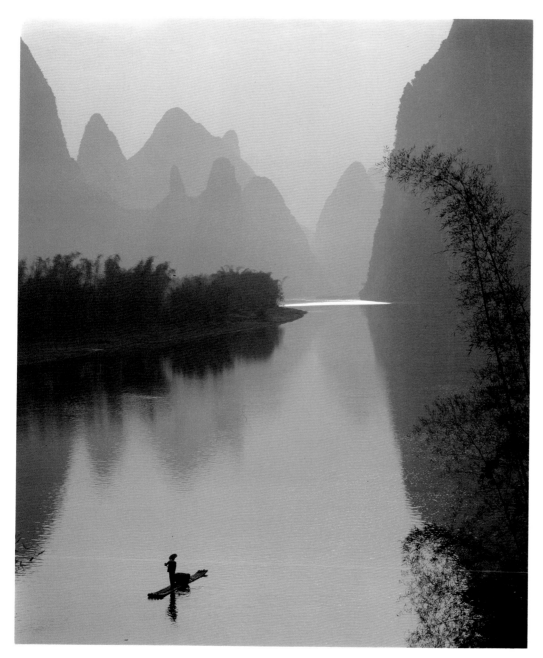

best viewpoint. The dawn turned out to be less spectacular than they had hoped, with no colour in the sky, but a shaft of sunlight did break through to spotlight the distant water at the base of the hills.

While I was focusing the camera, I noticed a bamboo raft moving slowly across the frame and I made some comment about how lucky we were to have the boat crossing the river at that time. Our hosts politely pointed out it was not luck, but good planning on their part, for unknown to us, we had towed the raft behind our boat! We were therefore able to direct the boat back and forth across the picture.

When the elements of the pictures are analysed, they are extremely simple with obvious front, middle and distant zones. However, without either the boat or the strip of bright light on the water, the picture would not have been worth taking. Compare the light here with another dawn picture taken from the same place a few months later on page 61.

Dawn on Lijiang, Guilin, China, May 1985. Ektachrome 64, 150mm lens on Hasselblad. Dawn light.

Waterfalls

Where river water cuts back soft rock beneath hard rock, a waterfall begins to form as water plunges over the overhanging resistant rock. The force of water from the fall often erodes a hole in the rock at the base. Waterfalls tumbling down on each side of a broad valley are typical of alpine areas. They arise as a result of glaciers carving out U-shaped valleys leaving side streams hanging above the main valley. In Britain, the most spectacular waterfalls occur in the Lake District, North Wales and northeast Yorkshire. In northern Britain they are often referred to as a force, hence High Force on the River Tees.

Coastal waterfalls also form in hanging valleys and a plethora of them occur along the north Cornwall/Devon coast between Boscastle and Lynton. In this case, the sea has eroded away the lower parts of the valleys to leave then hanging. A coastal waterfall with a sheer drop from a seaward-facing cliff cannot easily be photographed from land—unless a headland curves round to face it. The best way to appreciate these waterfalls is from a boat at sea.

Cascades and rapids, although falling down modest inclines, can make some spectacular water landscapes. As water tumbles over cascades, the rivulets repeatedly bifurcate as they meet a rocky obstacle. The full effect of such a spectacle needs to be taken face on at right angles or possibly from an oblique angle above. A dramatic way to illustrate rapids is from the river itself, but then a completely waterproof, or preferably an underwater, camera is essential.

Landscaped gardens often incorporate cascades or waterfalls as an eye-catching feature. A technique similar to photographing natural falls can be used for these man-made creations, although the path may lead to only a single viewpoint.

One of the biggest problems of photographing waterfalls in direct sunlight is that colour film does not have the latitude to cope with the extreme contrast between the white water and dark rock. If the water is correctly exposed, then no detail will be shown in the rock. I have found that working on an overcast day is preferable to direct sunlight, but even then I would tend to over-expose the water so as to ensure some rock texture can be seen.

There is no single ideal camera angle for photographing falls—each one has to be appraised *in situ*; although in places where a single viewing platform

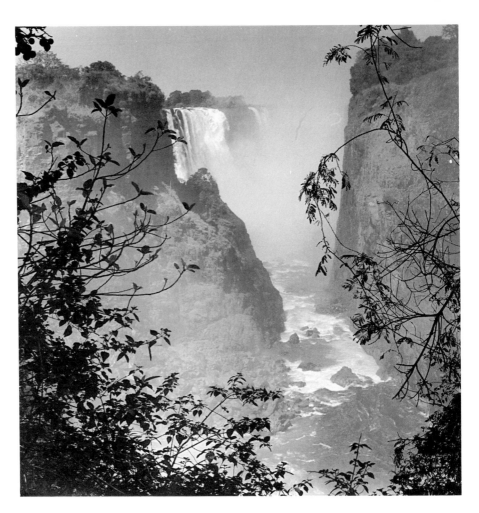

has been built out over a precipitous gorge there may be no choice. In this case, the direction of the light striking the falls at different times of day will need to be noted.

It is often worth looking through a long lens at a narrow-fronted waterfall cascading down a sheer rock unadorned with trees. This may reveal details of the falls—unapparent to the naked eye—showing the interplay of water on the rock.

Like large lakes, record-breaking falls are not always the easiest to photograph. It is difficult to find a new place to view much-photographed spectacles such as the Victoria Falls—named in honour of Queen Victoria by the explorer David Livingstone. I therefore spent two complete days viewing them from both Zimbabwe and Zambia in varied lights from the ground (p89) and the air (p158). From the Zambian side it is possible to see the sun setting in line with the escarpment of the Falls so that the spray appears backlit at the same time as the sun is reflected as a broad ribbon of gold in the

As I walked along a path in Zimbabwe, I came across periodic gaps in the vegetation looking out across to the Victoria Falls. I had to spend some time before I found the best combination of frame and lens to make the picture I wanted. Without the plant framework, the misty rocks would not have been worth taking, with it the picture not only has a strong frame around three sides, but also a feeling of depth. The entire area of the square negative is reproduced here.

Part of Victoria Falls from Zimbabwe, September 1981. Plus-X Pan, 80mm lens on Hasselblad. Side lighting with misty spray from Falls.

Zambesi River. The composition of pictures taken from this fairly restricted viewpoint will change throughout the year as the amount of water in the river as well as the wind force influences the extent of the upward spray. In addition, the arc described by the sun will vary during the year, although not nearly so noticeable as in temperate regions.

From a different view looking along the escarpment, the persistent spray is even more apparent. The spray and mist which swirl around the Falls have given rise to the local name *Mosi oa Tunya*, meaning 'the smoke that thunders'

Mention has already been made of the two approaches to photographing moving water: namely a fast shutter speed versus a slow one. I tend to favour using a slow speed film such as Kodachrome 25 so I can use a long exposure. The shutter speed selected will depend on the volume of water and the amount of rocks that are visible Anything slower than 1/30 second will produce soft white lines conveying the downward motion. If a narrow fall is taken front-on, vegetation framing it on either side will break up the linear streak as well as adding a contrasting colour to the picture. A side view of a water curtain plunging from an overhanging lip can make a striking picture, especially if it is backlit

Additional interest is provided by rainbows (p89) which frequently appear over large waterfalls that produce a persistent, copious spray.

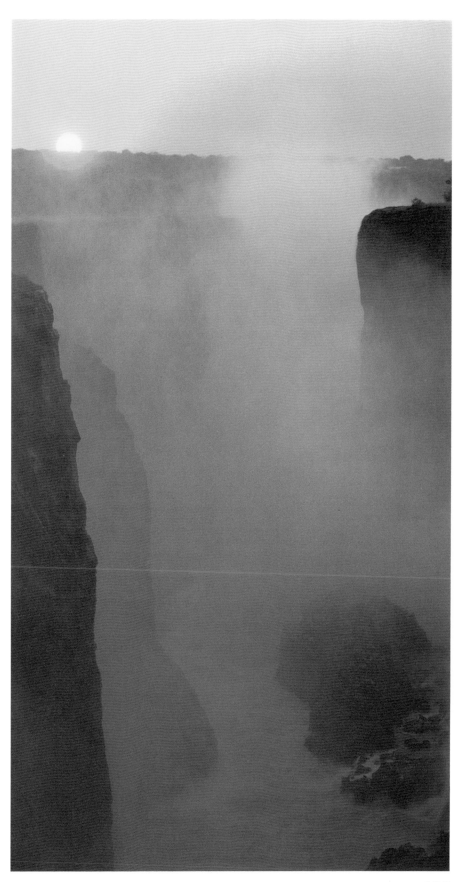

The abundant spray created by the force of water cascading over the Victoria Falls combined with a setting sun, creates for a few brief moments a moody picture. By working fast, I managed to take a whole film of this scene using a variety of different focal length lenses.

Sun setting behind Victoria Falls viewed from Zambian side, September 1981. Kodachrome 25, 105mm lens on Nikon. Afterglow from setting sun.

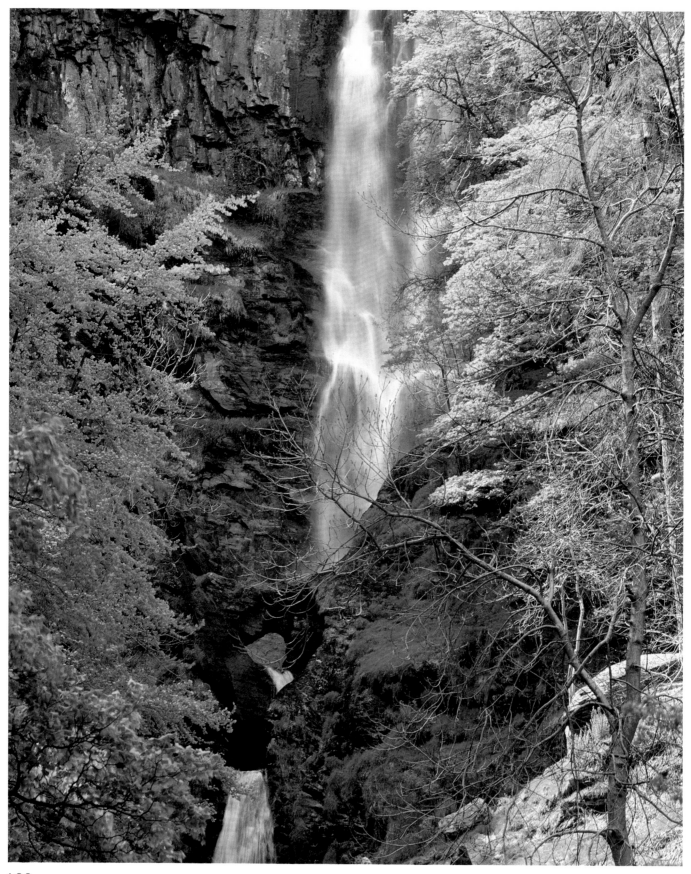

Frozen Water

High latitudes or altitudes where sub-zero temperatures persist for long periods, are the only places where frozen water is guaranteed. Here, not only shallow pools, but also large lakes, rivers and waterfalls freeze solid for months.

It is difficult to make much of a huge ice sheet covering a lake, although like calm water, the afterglow from a setting sun will be reflected on the surface. But natural ice sculptures including icicles, frozen waterfalls and cascades offer tremendous scope for a creative eye. When icicles are backlit, they glow like glass in a chandelier.

Intriguing angular ice patterns appear occasionally when a flooded field freezes over and the water level beneath drops, so that the ice fragments into small portions that tilt at various angles. The combination of ice and water found in rivers which are frozen along their margins while water continues to flow in the centre, make more interesting pictures than rivers that are frozen completely solid. Like waterfalls, ice floes carried down a river can be photographed using two quite distinct approaches: the motion can either be arrested by using a fast shutter speed, or it can be blurred using a long exposure.

In recent years, the ice city of Harbin, north of Beijing, in China has seen a revival of the traditional ice festival. Huge blocks of ice cut from a frozen river are used to create spectacular animate and architectural ice sculptures. Viewed by daylight, they appear glass-like, but at night they are completely transformed as internal coloured lights are switched on and the sculptures glow in a kaleidoscope of colours (p76).

Glaciers are ice rivers that inch their way forward, gouging out the land

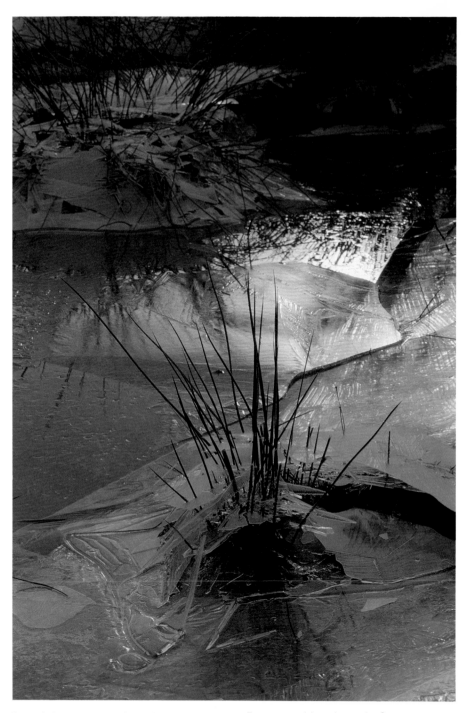

Pistyll Rhaeder—although the highest waterfall in Wales, plunging down 240 feet—has a narrow front. Having looked at other photographs of this fall, I decided the best bet would be to arrive early in the morning at a time of year when the beech trees were just beginning to leaf out so that the waterfall would be framed on either side by green foliage.

Pistyll Rhaeder, the highest waterfall in Wales, June 1986. Ektachrome 64, 150mm lens on Hasselblad. Side light beginning to break over top of rock face.

Low-lying tracts of land which flood during the winter may attract wildfowl and this was my reason for visiting Sussex on a cold winter's day. The area had been flooded and partially frozen, before the water level dropped and refroze. This resulted in curious ice patterns forming around the reeds.

Fragmented ice sheets in Sussex, January 1980. Kodachrome 25, 85mm lens on Nikon. Low angled sunlight late in the day.

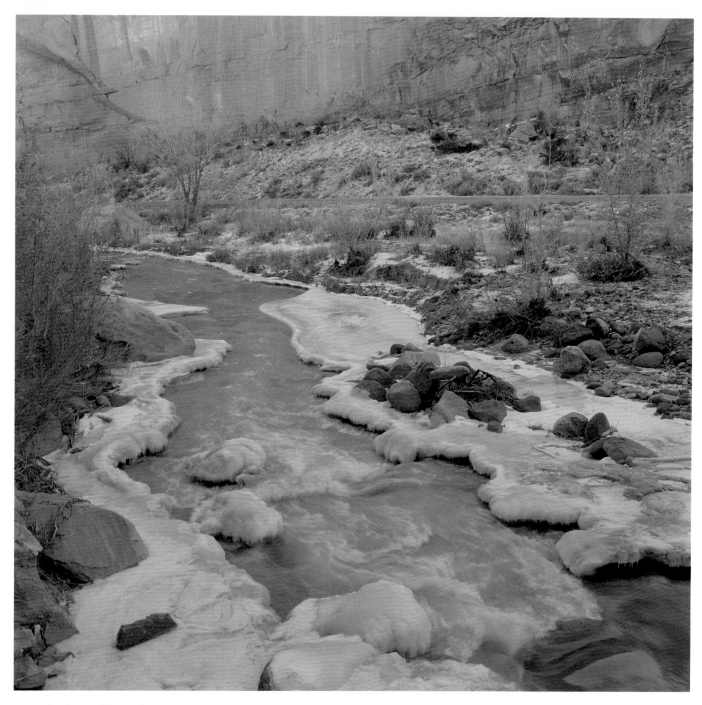

beneath them. When the snout of a glacier ends in a lake, it gradually breaks up to form icebergs. In Iceland, eider duck swim around in glacial lakes dodging the newly formed icebergs as they crash into the water.

The varied approaches to photographing frost and snow are covered in the chapter dealing with weather.

As the temperature drops, the margins of rivers begin to freeze solid making far more striking pictures than when the river is unfrozen or completely frozen over. While the icy margins emphasise the cold weather, the red sandstone wall adds a touch of warmth to the picture.

Frozen margins of Fremont River, Capitol Reef National Park, Utah, January 1988. Ektachrome 64, 60mm lens on Hasselblad. Diffused light.

When the ice sculptures created in a Harbin park in north-east China are lit by direct sunlight from behind, they appear quite magical and glass-like. However, with temperatures around −20°C, photography is hard work and even changing a film becomes an effort.

Pagoda ice sculpture, Harbin, China, February 1987. Ektachrome 64, 80mm lens on Hasselblad. Oblique backlighting

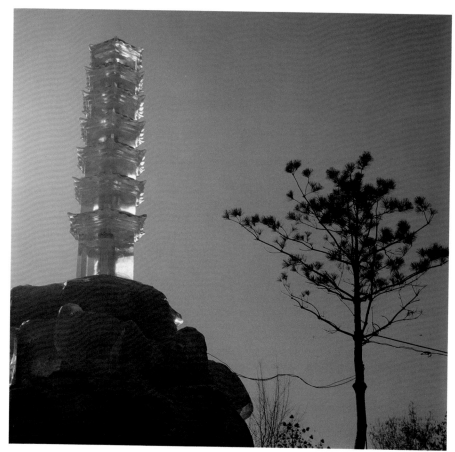

Towering behind icebergs in an Icelandic glacial lake is the snout of a glacier, which constantly breaks up to produce the icebergs; some a delicate pale blue colour, others almost black from debris picked up by the moving glacier. The overcast day was perfect for recording these subtle colours.

Icebergs in glacial lake Fjallsárlon with glacier behind, Iceland, July 1981. Ektachrome 64, 150mm lens on Hasselblad. Diffused light.

133

As we walked down from the rim of Alcedo Crater on the island of Isabela, the white gases emitted from this geyser were clearly picked out in the early morning light against the unlit floor of the crater.

Geyser in Alcedo Crater, Isabela, Galápagos, March 1975. Ektachrome Professional, 80mm lens on Hasselblad. Grazed early morning light.

Fumaroles and Geysers

In active volcanic regions, geysers form when superheated water and steam is ejected from underground. The spouting may be sudden and violent for only a brief period or it may continue to steam for long periods. The best known geyser locations are in Iceland, the North Island of New Zealand and at Yellowstone National Park in the United States, but they can also be seen in the Galápagos where fumaroles occur. A fumarole is a hot spring which emits volatile gases and sometimes the vents are bright yellow from a deposition of sulphur crystals.

To highlight the gaseous plume, a geyser needs to be taken either against the light or with strong side lighting early or late in the day. Some geysers play at regular predetermined intervals, but many others erupt in an irregular pattern which makes it more difficult to anticipate when they will play.

Mount Kilauea on Hawaii is highly active and erupts at regular intervals. As cracks appear in lava flows, linear vents disgorge colourless superheated gases. By the time the tourist buses arrive at mid-morning, the fumaroles are barely discernible, so it is essential to be on site either by dawn or at the end of the day.

In the dawn light copious fumaroles can be seen emitting their gases from a recent lava field on Hawaii, showing some yellow sulphur deposits against the black lava. The contrast was so great between the hill lit by the dawn light and the black lava, that I metered off the hill behind and opened up a stop.

Fumaroles on Hawaii Island, January 1977. Ektachrome 64, 150mm lens on Hasselblad. Dawn light.

134

Varied Landscapes

One of the delights of landscapes is their infinite variety. There is always scope for recording some kind of landscape; although finding a wilderness area without any people may require travelling some distance.

Throughout this book, I have stressed the need for a seeing eye. A point particularly relevant to this chapter, for the varied landscapes I have included are very much in the eye of the beholder. They are not all immediately obvious and they are certainly not all romantic or evocative ones.

Static subjects

Vistas in which every component is static should be among the easiest to take, for there is no sense of urgency to get the picture before a mobile element moves out of shot. There is also time to appraise the lighting; if necessary, to wait for it to improve. Likewise, the composition can be carefully considered and modified either by a slight adjustment to the tripod or by changing the focal length of the lens.

When I go out with a completely open mind as to what will catch my eye, I find it is striking light and shadow, textures, or juxtaposition of colours, which persuades me to take a second look.

Landforms in harsh climates where rainfall is scanty, which experience extreme temperatures or which are constantly eroding away, have no vegetation cover. They appear harsh and naked in comparison with floriferous meadows or verdant rolling hills, but it is the colour, texture and form of the rocks themselves which present such a rich potential for landscape pictures.

Soft sedimentary rocks are much more susceptible to erosion than hard metamorphic rocks, so that uplifted sediments tend to erode into highly textured shapes such as the view from Zabriskie Point in California's Death Valley and the hills in Arizona's Painted Desert. Natural arches and bridges are

described elsewhere (p26) and other examples of geological features from America's canyonlands can be seen on pages 17, 52 and 80.

When photographing a geological landscape such as Bryce Canyon in Utah with similar features but without contrasting colour from a clump of wild flowers, it is all too easy to confuse viewpoints by the time you return home and get the films processed. It is therefore very important to number each film immediately after it is removed from the camera (or else number all the films beforehand and make sure they are exposed in numerical order). If there is a plaque with the name of the viewpoint, I

On my first visit to the Galápagos, I spent several hours walking over an extensive lava field on San Salvador Island. Everywhere I turned there were graphic shapes and designs depicting the way the once molten lava had solidified. This picture looks for all the world as though someone has used an outsized icing bag to create the shapes.

Detail of pahoehoe lava flow on San Salvador Island, Galápagos, December 1973. Professional Ektachrome, 80mm lens on Hasselblad. Oblique lighting.

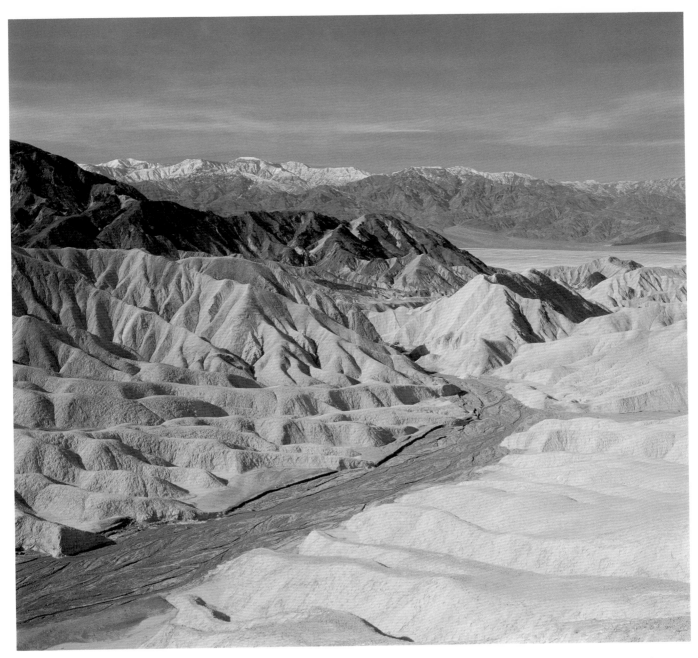

photograph this at the beginning of a sequence as well as making a thumbnail sketch in my field notebook of each framing I use. In this way I can be sure each picture is correctly captioned.

Rock colour varies from white chalk and limestone, red sandstone, grey schists to black basalt. Lava formed as a result of volcanic eruptions may be the rough jagged inhospitable AA lava or the convoluted rope or pahoehoe lava. The latter is formed as the surface cools and begins to form a skin but the warm lava continues to flow beneath it. Extensive rope lava fields can be seen on James Island in the Galápagos, on the

island of Hawaii, and on Réunion in the Indian Ocean, where they provide endless studies of textured surfaces. The arid climate of the Galápagos results in very little weathering of the lava so that few plants have been able to gain a foothold; whereas, on both Réunion and Hawaii, plants quickly begin to invade the lava—lichens and ferns at first, followed by shrubs and trees. Iceland, too, has extensive lava fields, but the high rainfall there means that even the jagged lava becomes smoothed and eventually smothered by invading mosses.

Standing stones and ancient

Zabriskie Point view in Death Valley shows ancient lake beds which have been uplifted and eroded by wind and water to produce a highly three-dimensional feature. Side lighting is essential for revealing detail of the surface structure.

Eroded lake beds, Zabriskie Point, California, February 1979. Ektachrome 64, 60mm lens on Hasselblad. Oblique side lighting with polarising filter

monuments introduce a feeling of antiquity to a landscape. A group of stones can be used to frame a picture or to provide foregound drama. In moorland areas, sheep provide useful scale for monuments. Now that Stonehenge is completely enclosed in barbed wire, it is impossible to walk among the stones to get an unusual viewpoint, although a dramatic silhouette can be taken when the stones are viewed against a setting sun.

Industrial archaeology also provides some graphic static subjects—bridges, viaducts and windmills to name but a few. More recent intrusions into the countryside include cooling towers of power stations and electricity pylons. A line of pylons marching across the countryside can ruin an otherwise idyllic landscape, but they should not be despised out of hand, for they can provide interesting silhouettes when viewed against a rising or a setting sun.

Some photographers actively seek out abandoned cars and discarded junk to photograph in a landscape setting. Such objects long since past their former glory, often convey a sense of poignancy, but, just occasionally, they may take on a humorous slant.

Like buildings and bridges, statues are static subjects which can be appraised in different lights. A statue erected on a plinth in a city square is of interest to tourists as a record of a place visited in their travels, but I need to see statues in a landscape setting to be motivated to photograph them.

The grand French and Italian gardens are well known for their plethora of statues and fountains, all much photographed; but an American garden which deserves to be much better known is Brookgreen Gardens in South Carolina. These were specifically created to display sculptures by American artists in a magnificent outdoor setting. Arthur Huntingdon instigated work on the gardens in 1931 as an outdoor museum both for sculptures of figures and wildlife by American artists—including his wife, Anna Hyatt Huntingdon—and also for preserving the native flora and fauna. The collection continued to grow so that there are now over 450 statues, each judiciously positioned so that it enhances the trees and plants which, in their turn, provide a naturalistic backdrop. One of the most memorable vistas I retain is of a gilded bronze statue of Dionysus at the end of a live oak avenue. As these oaks are evergreen, this vista remains the same throughout the year, but additional

colour comes to other parts of the garden in late March/early April when the native azaleas and dogwoods burst into bloom.

It may not be possible to find an original viewpoint to a familiar natural landscape, but it is well worth studying maps in search of high viewpoints readily accessible from a road for an overview of a meandering river or some other flat landscape below. Even if the quality of the pictures is not good, it may be worth glancing through geography and geology textbooks to glean useful ideas for viewpoints of spectacular landforms and geological features.

The origin of rocks and soil makes their colour highly variable. This, together with the texture and nature of the surface, affects the amount of light which is absorbed or reflected. Pale rocks and soil such as chalk, limestone and coral sand beaches reflect much more light than brown soil and therefore present the same exposure problems as snow-covered ground (p96). Black volcanic soils and beaches, on the other hand, such as occur on the islands of Hawaii, Réunion and Lanzarote, reflect practically no light and therefore tend to

We approached the ornate frontage of the Forestry Research Station at Lourizan from the opposite direction and it was only after I had spent several hours walking round the garden, that I returned to the front. The oblique lighting was perfect for outlining the statues, steps and balustrades leading up to the house.

Architectural features at Forestry Station, Lourizan, Spain, March 1987. Ektachrome 64, 80mm lens on Hasselblad. Oblique side lighting.

appear overexposed in a picture metered using a direct reflected reading.

Soil and rock colour also varies with the weather. Most obviously, rain enriches the colour of soil and rocks. On small man-made surfaces, such as paved courtyards, colours of bricks or tiles can be enriched by wetting with a hose—although in warm weather, on a windy day, it is rather like painting the Forth Bridge in that parts begin to dry out before the job is completed! Wet clay reflects so much light that it appears almost silver at certain times of day.

The first time I visited
Brookgreen Gardens was in
winter when many statues were
unadorned with plants. For
instance, my January picture of
this statue sited in the centre of
a pool has a few tatty brown
pond weeds around the base of
the plinth. In April, backlit
leaves and stems thrusting
upwards complement and add
colour to the statue.

Diana of the Chase (Bronze 1922)
by Anna Hyatt Huntingdon at
Brookgreen Gardens, South Carolina,
April 1987. Ektachrome 64, 150mm
lens on Hasselblad. Oblique
backlighting.

138

A Mobile Element

A person walking or running, a line of animals—whether they be sheep moving over pasture or plains game traversing the African savannah—not only provide scale but also bring life to a landscape. A downhill skier, reindeer running down a snow-clad mountain, or an aeroplane taking off, provide fleeting action and they become a key element in the composition of a landscape. An obvious way to ensure a successful picture under these circumstances would seem to be a rapid sequence of frames taken using a motor drive and a fast shutter speed.

In reality, even with a motor drive it is still possible to miss the optimum moment, since the time interval between each frame exposed at a rate of a mere three or four frames a second, is very much longer than a shutter speed of 1/250 or 1/500 second. Also, a motor drive cannot compose a picture. This has to be done before the action moves into the frame.

Another way of conveying movement, is by using a slow shutter speed to create an impression of movement by recording the motion as a blurred image. A tripod should be used here, since camera shake on top of blur from a moving subject creates a very confusing image. Ernst Haas was a master of the impressionistic approach, notably with his pictures of bull fighting taken in the 1950s. As well as using a slow shutter speed, he might also deliberately jiggle the camera to increase the impression of movement. This technique—which is by no means as simple as it sounds for the subject must be very carefully selected beforehand—is a prime example of how it is worth experimenting to see if a different effect produces an eye-catching picture. This may seem extravagant on film, but it is worth remembering that film is relatively inexpensive.

A single moving object should be positioned at one side of the frame so that it is balanced with a larger area of space on the opposite side, for it to give a feeling of movement continuing over the distance still to be covered.

A puffing steam locomotive needs to be taken during the maximum outburst of steam. Just as our breath shows when we exhale during cold weather, so the head of steam is particularly well defined in cold winter weather. It is small wonder that north China, still with a large number of fully operative steam locomotives and guaranteed sub-zero winter temperatures, attracts many steam buffs.

Driving into the Masai Mara at first light, we came across this line of elephants moving through a shadow area standing out conspicuously against an area bathed in sunlight. Shortly after we stopped the jeep, a hot air balloon drifted across into the field of view, adding a touch of colour as well as a mobile element to the natural scene.

Elephants crossing Masai Mara, Kenya in front of hot air balloon August 1986. Kodachrome 64, 200mm lens on Nikon. Backlit at dawn.

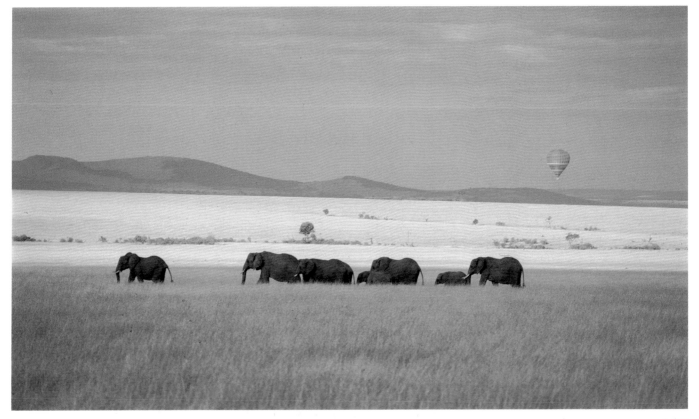

Open Vistas

A clear view across an expansive flat landscape may look breathtaking, but a photograph of such a scene is invariably disappointing if it does not convey something of the mood or atmosphere of the scene. Unless some foreground interest is included to give a feeling of depth, the three-dimensional vista we see becomes compressed into an obviously two dimensional picture. Clouds that contrast well with the sky will also help to convey depth to an expansive sky.

One of the biggest disadvantages of taking a photograph is that it can be accomplished so quickly without any thought being given to the composition or lighting of a landscape. Artists, on the other hand, even if they make only a quick sketch, have to record the direction of the light and shadow as well as the modelling. The average photographer would probably be appalled at the suggestion of spending time sketching a view, but this is an excellent way of appreciating shape and form in relation to the lighting. Another useful exercise for appreciating how the quality and direction of light influences the way we see a landscape, is to study a scene throughout the day by taking a photograph every few hours and recording the time of day. A direct comparison can then be made by laying the series of transparencies out on a light box (preferable to projecting them because only one slide can be viewed at a time). This will illustrate the optimum time of day for taking that particular view at that time of year, for the arc described by the sun in temperate latitudes varies considerably throughout the year. For instance, a picture aligning a bridge crossing the great canal in the Chinese city of Suzhou, complete with setting sun reflected in the water can only be taken in February.

Working early or late in the day will help to produce a better picture since the long shadows cast by direct light falling across hills and valleys will reveal the contours of the land. Also early in the morning any lingering mist will help to add atmosphere.

Although a wide-angle lens will include more in a picture than a standard lens, the image size will be reduced. It is therefore well worth viewing a landscape with different focal length lenses to see the varied angles of view.

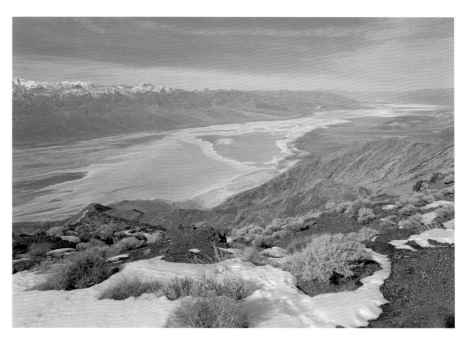

A winter snowfall up on a high viewpoint helps to accentuate the distant vastness of the chemical desert with the white salt beds in the valley floor below. Snow can also be seen on the mountain range which provides the distant zone to this expansive landscape.

Dantes View, Death Valley, California, February 1979. Kodachrome 25, 24mm lens on Nikon. Weak sunlight.

The minute figures fishing amongst the waves breaking on the shore convey the vast area of water in the picture and beyond. The low angled sun has produced a uni-toned picture by throwing the bank of clouds into shadow.

Sunset near Hookipa Park, Maui. Hawaii, January 1977. Kodachrome 64, 50mm lens on Nikon. Backlighting.

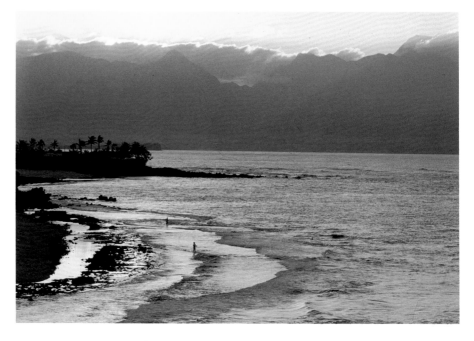

Enclosed Places

The approach to photographing narrow angled viewpoints such as rides in forests, the base of a canyon, an alleyway in a town, a courtyard or a house at the end of an avenue is not so very different from taking a broad vista; for although the scene may be lit for a very limited time, it is still a question of choosing the time for the optimum lighting. The odds of arriving at this time purely by chance are remote and so it may mean noting the position of the sun and returning later that day or even on the following day. The choice of lens will probably be longer for a narrow view and the framing may well be a vertical format.

A natural or man-made narrow passage with a single opening will offer no scope for varying the camera angle; whereas the lighting and composition of a view down a forest ride, a canyon or an avenue can be appraised by viewing it from opposite directions.

One of the delights of walking through minor streets in Far Eastern cities, is the unexpected cameos seen at the ends of alleyways. Here, old people may be taking an airing, children playing or animals foraging for scraps. Tall buildings on either side will automatically frame the view, often as bold silhouettes providing a strong contrast to an open courtyard at the far end. Converging walls or straight-boled trees in a coniferous plantation also help to give a three dimensional feeling to an enclosed place.

Wilderness Areas

Many of my favourite landscape pictures were taken in wilderness areas in remote corners of the world—places such as the Galápagos Islands, Madagascar and off-beat parts of New Zealand. It is in these sorts of places where I prefer to work, well away from people and habitation without any distractions so that it is possible to feel completely at one with the land.

The approach to photographing wilderness areas need not be very different from more rural habitats, but more time does need to be spent on planning and preparation, since as well as cameras and films, food, water and camping gear may also have to be carried. This inevitably means that equipment may have to be pruned down to the bare minimum, since it is pointless to economise on film stock. Plenty of spare batteries are a must, especially with

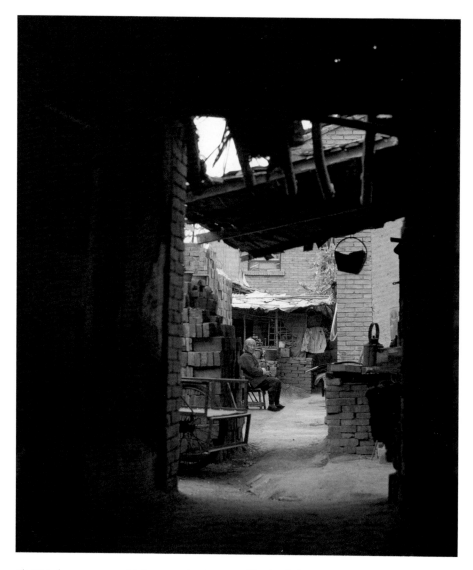

electronic cameras which cease to function without battery power, also a basic repair kit.

Climbing over rough terrain or working in boats means that equipment is subjected to greater risks than sauntering out into a park, so that it is sensible to make sure that everything is properly insured. Even for a day trip, cameras and lenses are best carried in a padded rucksack so that both hands are left free for climbing. Few rucksacks are completely waterproof, so it is wise to use a waterproof liner and to pack all film and equipment in separate waterproof bags.

Some of the problems of working in extreme climatic conditions are covered elsewhere, notably in humid environments (p112) and in cold temperatures (p94). High temperature is detrimental to film; both unexposed and exposed film needs to be kept as cool as possible,

Tucked down an alleyway away from the bustle of the busy city street, I noticed an old Chinese lady sitting out in the open. As I could see she was looking straight at me, I took a few pictures very quickly. It was only after the film was processed that I noticed her tiny feet misformed by binding them as a child. The silhouetted frame of the picture leads the eye past the hanging basket and kettle on a crude stove to the seated woman.

Woman sitting out at end of alleyway, Xi'an, China, May 1984. Kodachrome 25, 135mm lens on Nikon. Indirect top lighting.

so that in tropical climates, camera bags should always be put down under the shade of a tree.

When my husband and I gained permission in 1975 to camp inside the extinct crater of a volcano on the island of Isabela in the Galápagos, we had to carry everything from sea level up to the 3700-foot-high rim. The profile of Alcedo Crater is somewhat like an up-turned soup plate, so that the first part of the climb is up a gradual slope, but the final part—at the end of the climb—presents a much steeper gradient.

Although we set off at first light, it took us most of the day to reach the rim, with little cover along most of the track.

After spending the first night camping on the rim, we climbed down onto the floor of the collapsed crater which we shared with the largest population of giant tortoises in the archipelago. Our visit coincided with the tortoises' mating season and the end of the short rains, so the floor was dotted with mating tortoises and temporary pools—an unforgettable experience which we knew few other people had been fortunate enough

It takes a two day drive from Chengdu in Sichuan to reach a fairytale gorge in north-east China. Here there are cascades that tumble through mixed forests and lakes that are an unbelievable blue colour, yet so clear that trees which have fallen into the water are sharply defined.

Clear blue water in Five Flower Lake, Jiuzhaigou, Sichuan, China, October 1985. Ektachrome 64, 80mm lens on Hasselblad.

to see

We were allowed onto Alcedo only on the condition we took an experienced guide and we certainly would never have found our way up the narrow overgrown track without one. Taking a local guide is not only sensible when exploring territory far away from civilisation, it can also save wasting a lot of time locating a specific goal as well as avoiding falling into all sorts of pitfalls such as touching plants that are likely to cause an allergic reaction or stepping into quicksands.

Even if you cannot speak the local language, it is amazing what miming and sketches can convey. I learnt a tremendous amount from an ex-caiman hunter who christened me 'Angelita' and led me through a tropical rain forest area in Peru, miming the uses of various shrubs and trees.

Without a guide, special note needs to be taken of landmarks *en route* and trails marked, preferably by tying coloured tape to branches. In tropical rain forest, the customary way of marking a track is to slash some of the abundant hardwood saplings; but remember to cut them about half a metre off the ground, otherwise it is all too easy to step on them on your return and thereby spear your foot.

Special precautions are needed to keep gear and film dry when working from boats—especially canoes in whitewater rivers. Watertight cases complete with an O-ring seal, which float even with equipment inside, are a wise investment for more expensive gear. The weatherproof and waterproof compact cameras are ideal for any wet weather work, but the fixed 35mm lens on most models can be a limiting factor. The Minolta Weathermatic has the advantage of a dual choice lens—either a 35mm or a 70mm—not a zoom.

Pony trekking is an ideal way of covering plenty of ground in search of alpine flowers in the wake of the melting snow. In Kashmir, the ponies know the routes well, all you have to do is to sit tight and stop the pony when you spot a vista, which in good light, can be taken from horseback. To take a plant portrait however will require dismounting to work from ground level.

The blooming of deserts during March in southern Arizona and California is linked to the amount of rain which falls during the previous December. As water from flash floods percolates through the soil, it triggers the germination of annual desert flowers and the production of new shoots by perennial plants. Come March, drifts of yellow brittlebush extend between the giant saguaro cacti and orange carpets of Mexican poppies expand their petals in response to the sun. Much less showy are the individual, often quite small plants which appear in the desert wash areas. They may need a very low camera angle to show their desert backdrop.

Without doubt, the toughest trip I have ever made was up Mount Ruwenzori in Uganda, when I was commissioned by an Italian magazine to photograph the bizarre vegetation, including giant lobelias and giant groundsels. Although we had porters to carry all the food, I ended up carrying my equipment because every time I stopped to take a picture I found my Benbo tripod was either a mile in front or a mile behind me!

The high rainfall on Ruwenzori results in the development of extensive bogs at 3000 metres and more up the mountain which are even more tiring to wade through at altitude than climbing up a firm path. Carrying a full size tripod up a mountain is not to be recommended, but I was extremely glad to have my Benbo when the atrocious light meant I often had to use exposures of $^1/_4$, $^1/_2$

A group of giant tortoises wallow in a temporary pool on the floor of a caldera in the Galápagos. The rounded shells are highlighted so well by the back lighting that even the distant tortoises stand out clearly from among the trees.

Giant tortoises *(Geochelone elephantopus vandenburghi)* congregating in temporary pool in Alcedo Crater, Isabela, Galápagos, March 1975. Plus-X Pan, 60mm lens on Hasselblad. Backlighting early in morning.

or even 1 second. When I staggered into the penultimate hut at 4027 metres, I stumbled against something on the floor. At first I thought the altitude was making me see double, but then I realised it was a second Benbo. The owner moved towards me and on seeing my tripod, said 'Heather Angel I presume? I only bought this because you recommended it in one of your books!'

This retired veterinary surgeon then told me a cautionary tale which I feel is worth repeating. He had arranged his own expedition up Ruwenzori—complete with several dozen porters—to produce a photographic record of the plants for a book he proposed to write. After only a few days up the mountain, he dropped and ruined his sole camera, so he had no option but to go back down the mountain, take a plane from Kampala to Nairobi and make the return journey—expensive on both time and money.

In spite of all the rain and soggy ground, I got my pictures and all the gear down Mount Ruwenzori intact—even though I lost a stone in weight in ten days!

Urban Landscapes

Straight lines and angles of roads and buildings tend to predominate in cityscapes, although the winding course of a river and fountain sprays add relaxing curving lines, while city parks add a welcome touch of verdure when street trees are lacking.

The time of day as well as the day of the week both affect the type of picture taken in busy cities and towns. At street level on days when people and traffic predominate, the approach inevitably is more akin to a photojournalist or a reportage photographer; whereas early in the morning on a Sunday, the scene can be transformed with virtually no obvious sign of life.

Working in a confined space from the ground makes it impossible to move further back to gain a greater working distance, so the camera has to be tilted up towards the sky if the tops of high rise buildings are to be included in the frame. Without using the shift facility of a view camera or a perspective correcting lens (p50) this will result in vertical lines converging. However, with careful

A tripod proved essential to take this desolate scene of mist swirling round the snow-covered terrain of the Scott-Elliot Pass on Mt. Ruwenzori. While sliding down snow-covered scree slopes and trudging through bogs, I longed to be working in the tropics, but with hindsight the opportunity for seeing a wealth of unique plants made up for the discomforts.

Scott-Elliott Pass, 14,350 feet, Mt. Ruwenzori, Uganda, September 1984. Kodachrome 64, 50mm lens on Nikon. Overcast.

composition it is possible to exploit this distortion to advantage.

Office blocks constructed of expansive highly reflective windows function as huge mirrors. They introduce plenty of scope for taking creative pictures of other buildings, bridges, trees, clouds or sunsets reflected in the glass. The shape and position of the reflection can be varied by the choice of lens and the elevation of the camera level.

144

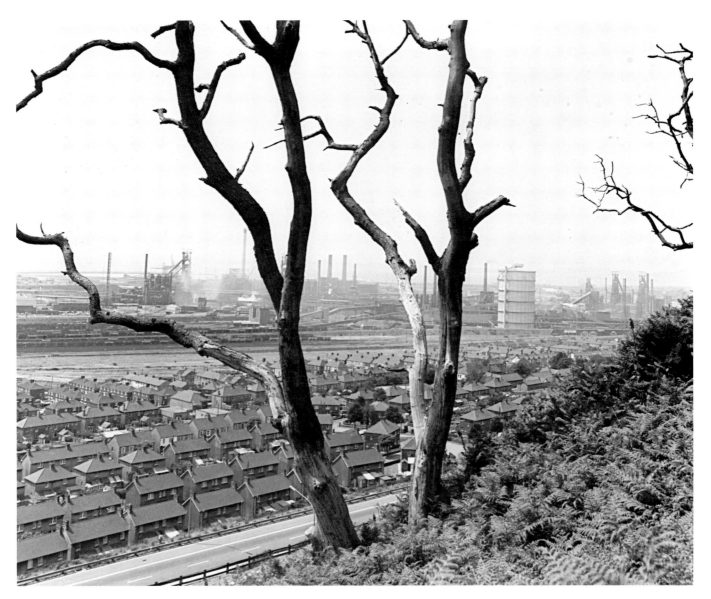

A less cluttered view of a city will be found from a bridge spanning a river, although if the river is too wide the buildings on either side appear rather remote. A boat moving on the river will provide a focal point and, if required, colour near to the foreground.

Taking a boat trip on a river or canal in a city such as London, Paris or Florence will broaden the scope for taking city-scapes looking up or down the water or across to one or other of the banks. Each day, the Port of London Authority (PLA) patrols the tidal part of the river Thames in three sections. The PLA very kindly allowed me to join the patrol boats on the upper and middle reaches so I could do a recce of all the riverside landmarks. I made the trips in January when the weather was dull and overcast, so I was unable to get any worthwhile pictures,

Many times as I drove to the Welsh coast, I had seen these stark dead trees up on the hillside. One day I made a detour and climbed the hill, so I could fill the frame with the leafless skeletons and yet show the reason for their demise—air pollution from Port Talbot steel works—behind.

Oak trees killed by air pollution from Port Talbot steel works, 1973. Plus-X Pan, 60mm lens on Hasselblad. Slightly overcast.

but I learnt a great deal more about the river than would have been possible by making repeated trips from the land.

Famous riverside landmarks—such as Tower Bridge—can be used to pinpoint

a less well known feature in the foreground. A spectacular equatorial sundial is sited on the north bank of the Thames adjacent to the Tower Hotel. By using an extreme wide-angle lens and a low camera angle, I was able to include one of the tower supports in the background of the shot. Even though only a small portion of the bridge appears in the picture, it is enough to convey the location.

Some years earlier, I used Tower Bridge as a backdrop to an imaginative ecological park which, alas, is no longer still in existence. Even with the bridge in the picture, many people could not believe such a wildlife haven existed in the heart of London and were convinced I had made a double exposure or sandwiched two pictures together!

An open-topped double-decker tourist bus is an easy way of getting a mobile elevated view of a city; although the obligatory fast shutter speed will require a fairly fast film to be used on an overcast day.

People and traffic become less significant when seen from the elevated view of a high rise building; instead it is the pattern of roads and streets which are emphasised. A forest of tall buildings will look less confusing when viewed against a misty or a smoky background so that the tone of the buildings gradually recedes into the distance.

Cities at night take on a magical appearance, especially if lights are reflected in the sea or a river. By using an exposure of several seconds, lights on moving cars and boats are recorded as coloured streaks. Before making the exposure, look to see the direction the traffic will move within the frame and whether there will be any attractive curving lines produced as a result of a one-way system of a roundabout or a corner.

Market streets in towns and market stalls tucked away in the off-beat parts of cities always provide colourful scenes of people bustling among the fruit, vegetables, fish and meat. The available light may be so poor in street markets covered with temporary canopies that artificial lights need to be used above the stalls in winter. These will produce a yellow cast on daylight colour film unless a blue 80 series colour conversion filter is used. Markets which have a mixture of daylight and artificial light present even more of a problem, since you have to opt for one or other type of colour film or else resort to taking a closer view with flash—hardly a landscape!

This impressive equatorial sundial can be seen on a walkway beside the river Thames. The dial lies in the same plane as the equator while the gnomon is parallel to the earth's axis and points to true north. I used a low camera angle and a wide angle lens to virtually fill the frame with the sundial and also include part of Tower Bridge behind.

Equatorial sundial designed by Wendy Taylor is sited beside the river Thames, April 1987. Kodachrome 25. 35mm lens on Nikon. Side lighting

For several years, a disused lorry park in the heart of London adjacent to the river Thames, was transformed into an ecological park. It provided opportunities for city-based children to go pond-dipping and learn to recognise many plants and animals that children living in rural areas take for granted.

Pond in William Curtis Ecological Park, London, July 1980. Kodachrome 25, 20mm lens on Nikon. Overcast

This was the view from my hotel room in Kunming—rows upon rows of unimaginatively designed buildings looming out of a smoke haze produced by abundant fires. I had to balance precariously on a stool and lean out of a small window to get the framing I wanted with a 300mm lens.

Misty cityscape, Kunming, China, March 1986. Kodachrome 25, 300mm lens on Nikon. Smoke haze

People and Landscapes

A person, or a group of people, will help to provide scale and, if seen as minute figures, to emphasise the vastness of a landscape. They can also add a splash of colour to a uni-toned landscape. Unlike portrait photography, where the face is all important, figures in landscapes should never be obtrusive and the face does not need to be shown. Silhouettes of people beside water or on high ground work well in colour or black and white.

There are comparatively few pictures with people in this book, since I do not go out of my way to include people in landscapes. However, if a local person happens to appear in the field of view, then I will look for a composition which naturally incorporates the figure. In places where few tourists are seen, local inhabitants are often camera-shy; either turning their back or covering their face with their hands as soon as they see a camera. In this situation, it pays to use a 35mm instead of a medium format or even larger camera, to dispense with a tripod and to keep your distance. People

I went down to this beach in Madagascar looking for ghost crabs to photograph. They proved to be rather elusive but I was rewarded by two figures—one carrying wood on her head and the other wooden baskets on a yoke—walking down the beach. I waited until they had moved into one edge of the frame before taking a few pictures against a very weakly coloured setting sun.

Beach at Fort Dauphin, Madagascar, April 1976. Ektachrome Professional, 150mm lens on Hasselblad. Dusk

When I noticed a slightly misty atmosphere rendering the distant peaks as subtle tones, I knew they would not dominate the view of a man using a water buffalo to pull the harrow through the rice field. I decided against using a longer lens to get the man and the buffalo filling the frame, because the backlighting showed virtually no detail in the faces and coats. In any case, I wanted to convey the location of this primitive agricultural Chinese scene as well as the reflected images in the waterlogged field.

Harrowing with water buffalo near Guilin, China, October 1986. Plus-X Pan, 60mm lens on Hasselblad Against the light.

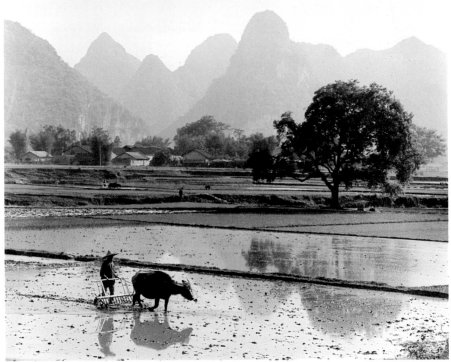

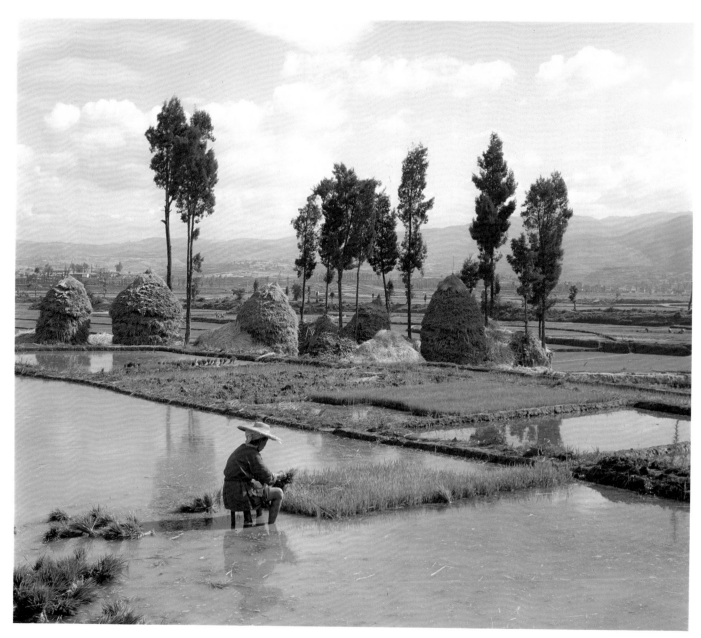

intent on working in fields are always easier to photograph than people strolling down a road with roving eyes.

Adopting a more subtle approach often pays dividends. Pretend to take something else—even expose the odd frame in the opposite direction—before quickly panning the camera to take the landscape with the person. I resorted to this approach in Kenya when I discovered a grassland fire had broken out. I asked permission to photograph the fire fighters at work and was told I could take the fire but not the people!

Friends or models, on the other hand, can be directed to walk into the shot wearing whatever coloured clothes best suit the scene. However, they should

look as though they fit naturally into the landscape, not as if they have just donned a red shirt to provide an obligatory splash of colour to brighten a page in the *National Geographic*.

The technique—often used by television news cameramen—of pushing a camera with a wide-angle lens as close as possible to a person, resulting in exaggerated perspective distortion of the face, is also much favoured by documentary photographers. Personally, I feel no affinity towards these sort of pictures with the exception of Bill Brandt's graphic studies of distorted nudes lying on the beach, looking for all the world like rocks smoothed through the aeons of time by the sea

I saw the line of haystacks from the road before we rounded a bend, and then noticed the old lady working in the rice field. She is very sensibly sitting down to pull up the rice seedlings in the nursery bed. These are tied in bundles for carrying to other flooded fields where they are hand planted. Once seen, this is an easy picture to take, since all the elements—including the person—are static.

Woman pulling up rice seedlings from nursery bed, Yunnan, China, May 1984. Ektachrome 64, 80mm lens on Hasselblad. Side lighting with a polarising filter.

Animals and Landscapes

Keen and often extremely knowledgeable naturalists have a tendency to 'collect' species on film, by photographing individual birds or mammals so that they fill the frame. This approach is an excellent one for producing identification portrait studies, but it gives no information about the habitat in which the animal lives.

My instinct has long been that animals, just as much as trees, need to be considered as an integral component—albeit a moving one—of the landscape as a whole. Since they spend their entire life out in the wilds they have to be well adapted for survival. For instance, animals which spend long periods resting on the ground such as ground-nesting birds and mammals that forage on the ground, have feathers or fur blending in with the ground colour on which they are found. In temperate climates and the summer months of northern latitudes, this tends to be mottled brown, but with the approach of winter, arctic animals develop white winter coats so that they will blend in with the snow and ice.

Flying out to Africa armed with a battery of long focus lenses, there is always a great temptation to fill the frame with one, or a group, of animals. Wildebeest, or gnus, make spectacular annual migrations up from the Serengeti in Tanzania to the Masai Mara in Kenya moving along well worn paths as far as the eye can see. Taking a handful of wildebeest with a long lens cannot possibly convey the sheer numbers of dark animals moving through the parched Masai Mara grassland in the middle of the year. In this instance, a standard or even a wide angle lens is ideal for conveying the dark line, ant-like, following the leader towards the Kenya/Tanzania border, where the wildebeest have to cross the Mara river. Here, hundreds of animals plunge to their death from the stampede that builds up at the rear.

From raised ground, general views looking down onto the African savannah—especially if there is a water hole present in the dry season—will show a variety of plains game grazing or drinking. No-one who has experienced the vista of the water hole complete with mountain backdrop, in front of Kilaguni Lodge in Tsavo Park, will ever forget the spectacle of game constantly arriving to drink throughout the day. The drama continues throughout the night when the water hole is floodlit.

Photographing deer in enclosed deer parks presents little challenge, although it can be a very useful exercise for trying out a new camera before setting off on safari. The only satisfying way to photograph deer and other large mammals that can safely be approached on foot, is by stalking them in the field. Like all mammals, deer have an acute sense of smell so it is important to stalk them from a position where the wind is blowing from them towards you and not vice versa.

Naturally gregarious seabirds and wildfowl can be taken as a group in their coastal or wetland habitat. Knowing the time of year and the time of day when birds assemble to breed or congregate on winter feeding grounds can increase the odds of getting the picture. Before I could be sure it would be worth my while driving up to the Solway Firth on the west coast of Scotland, I made several telephone calls to the local wardens. My objective was to photograph completely wild barnacle geese which overwinter there. I was on site before dawn broke and as I stepped out of my car I could hear the geese chattering on the grassy swards known locally as the merse. By the time I had walked along behind the raised banks to one of the hides, the sun was beginning to rise and the whole area in front of me seemed solid with geese. Photography was difficult at first, since I was looking directly into the low-angled sun, so I had to wait until the sun rose a little higher in the sky to avoid getting flare on the lens, but the black and white birds contrasted well against the green merse.

Brent geese also migrate south from their northern breeding grounds to over-winter in Britain. The best places to see these geese are in the Thames estuary and in the Solent. I spent an October night at Leigh-on-Sea in Essex so that I could be on site before dawn broke. Although a magnificent orange ball gradually appeared in the sky, all the geese remained out of sight intent on feeding, so I was unable to get the planned flight shots against the sun. Disappointed, I went off for a late breakfast and it was almost mid-day by the time I had packed everything up to drive home. Normally, I would never consider taking a picture at this time of day, but as I took the coast road, I instinctively looked seawards. By this time the tide had fallen to reveal the mud flats and there, hundreds of elusive brent geese were feeding.

Starlings congregate at dusk in trees or on buildings in built-up areas before they fly to their night-time roost. Once a starling roost has been located in a town or city, it is easy to get pictures of the birds in an urban setting. These birds are typically very noisy, chattering incessantly, but just before they lift off they

The only way I could convey the long line of wildebeest migrating in single file through the parched savannah was by using a standard lens. At this range, little detail can be made out of individual animals, which is perfectly acceptable for such an ecological picture.

Wildebeest migrating through grassland, Masai Mara, Kenya, August 1986. Kodachrome 64, 50mm lens on Nikon. Overhead lighting.

suddenly become silent, providing a useful cue for anticipating the lift-off when the birds become silhouetted against a twilit sky.

Composing a landscape picture with mobile animals is much more difficult than taking a landscape on its own, since the animals' position constantly changes. Sometimes there is only one ideal position for the animals and in this case I set up the camera on a tripod and either wait until the animals reach this position or, after checking I have plenty of film in the camera, use a motor drive to take several frames so that I have one perfect shot and a few near perfect ones. Flight shots can be obtained of birds which take advantage of the updraught on the seaward side of cliffs by pre-focusing a motor drive and panning the camera as they fly past. In some locations it is then possible to get the bird sharply in focus in the foreground and an impression of the type of coastal scenery behind.

Joining national or regional natural history organisations is an excellent way of gleaning information about where to visit at certain times of year.

Sea lions tend to haul out in the sandy coves of the Galápagos, although some of them are lying here on the hard volcanic rocks. Notice the bull sea lion in a prominent central position with his head held high surveying his territory.

Galápagos sea lions hauled out on Seal Island, Galápagos, December, 1973. Ektachrome Professional, 80mm lens on Hasselblad. Diffused lighting.

At low tide, overwintering Brent geese move in to feed on the exposed mud flats of the Thames estuary. The reflected light reading from the wet mud was several stops higher than from green grass, but I decided to use this so the birds and the stranded boat would appear silhouetted.

Brent geese (*Branta bernicla*) feeding on mud flats in Thames estuary, November 1985. Kodachrome 64, 300mm lens on Nikon. Mid-day light.

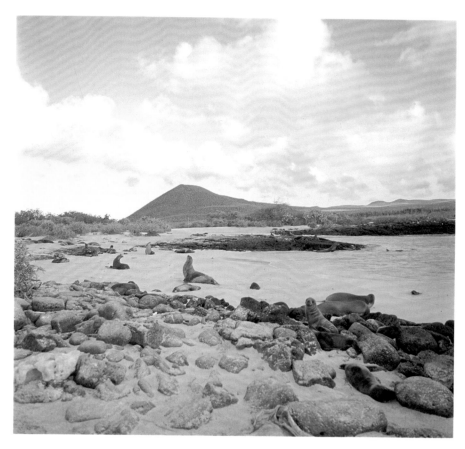

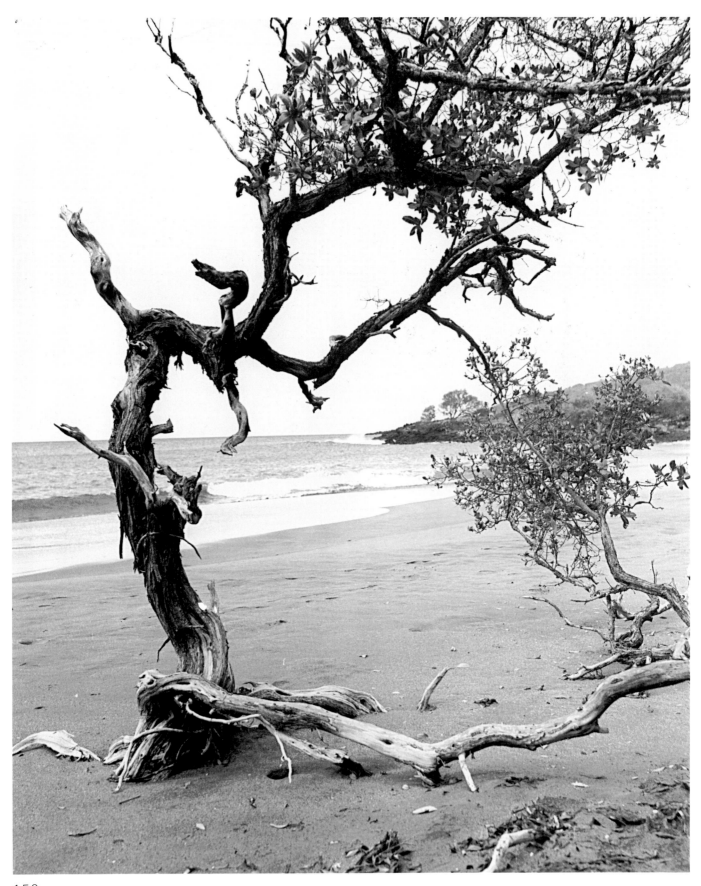

Plants in their Habitat

With the exception of ice-bound polar regions and extremely arid deserts, there are few habitats where plants do not flourish. Trees, shrubs and flowers not only embellish the landscape with their array of leaves and flowers, but also—together with lichens, mosses and ferns—help to prevent erosion of soils. Conservationists now appreciate that a rare animal cannot be preserved unless the complete habitat—plants and all—is conserved as well. Plants provide shelter and homes for many animals as well as food for herbivores.

Photographing plants in their habitat spans subjects as varied as the man-made mosaic of hedgerow field boundaries, a forest glade, desert cacti or a meadowful of flowers. The approach to photographing just one of these subjects—a single tree for example—is equally varied. If a deciduous tree is photographed in each of the four seasons, quite different pictures will result. A lone tree, or a group of trees, growing in an arable field, will be surrounded by varying background colours as the brown earth of the barren field turns to a green sward of young seedlings followed by a golden sea of ripe corn ears, back to bare earth again, with always the possibility of a blanket of white snow in winter.

The feeling conveyed by a picture of a single tree also varies depending on the size and position of the tree in the frame and the type of lighting, a misty background being more 'restful than direct sun with a strong shadow. Trees are more permanent features of a landscape than annual or perennial plants, but even trees do not last for ever. The continuous gradual cycle whereby trees germinate, grow and ultimately decay, becomes telescoped when hurricane force winds fell large trees well before they have completed their natural cycle.

The way that plants are specially adapted to their environment can be illustrated by emphasising part of their structure with the appropriate choice of lens, camera angle or type of lighting. For example, a wide angle lens will accentuate the huge buttress roots of a tropical rain forest tree, a low camera angle looking into the light will silhouette stilt roots of mangroves against sky or water and backlighting will reveal the spiny skin of cacti.

There is no single ideal lens for photographing plants in the landscape. The ones I find most useful however, are a wide angle lens such as a 28mm or a 35mm for taking forest interiors or for showing a conspicuous plant or group of wild flowers with some feature that immediately conveys their habitat behind, and a 135mm or 200mm lens for taking groups of trees on distant hills. On occasions, I have used even wider and longer lenses when needed—including a 400mm for taking water plants growing out in the middle of a lake in a place where no boat was available. This is not to say that a plethora of lenses is essential for photographing plants in landscapes, simply that I was carrying the long lenses for taking wildlife studies and it takes little effort to change a lens.

Flowers of trees are usually taken when they are at their prime on the tree, but when copious flowers fall from trees, especially tropical ones, the ground or water below becomes strewn with an ephemeral coloured sheet. I have seen purple carpets of jacaranda flowers in South Africa and red carpets of sausage tree flowers in Zambia.

These bizarre cabbage-like giant groundsels grow high up on summit ridges in the Aberdares. To get these involved a long drive and a further hike. Taking pictures at altitude is always a chancy affair since the weather can change so rapidly.

Giant groundsels (*Senecio johnstonii*) on summit ridge, 13,000 feet up, Aberdares, Kenya, August 1986. Kodachrome 64, 35mm lens on Nikon. Side lighting.

A gnarled mangrove tree growing on the foreshore of a sandy beach in the Galápagos has only a few living branches. Viewed from the seaward side towards the land, it was not easily distinguished from other trees and scrub on the shore. I therefore walked up the beach and crouched down so the tree stood out against the sand, sea and sky.

Old mangrove tree on beach, San Salvador Island, Galápagos, December 1973. Plus-X Pan, 60mm lens on Hasselblad.

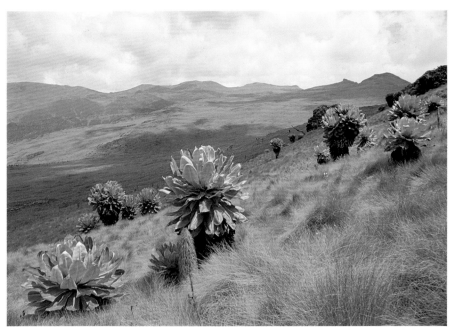

When an oak tree begins to leaf out, the leaves are distinctly acid yellow, but they soon turn a dull green. A lone tree such as this can be positioned in a variety of places in the frame. I decided to off-centre it and include plenty of sky above to give more flexibility for the ways it can be used and cropped. Sheep are taking advantage of the shadow cast by the tree as they pause from grazing.

Oak tree at Hanbury Hall, Hereford and Worcester, May 1988. Ektachrome 64, 150mm lens on Hasselblad. Side lighting with polarising filter.

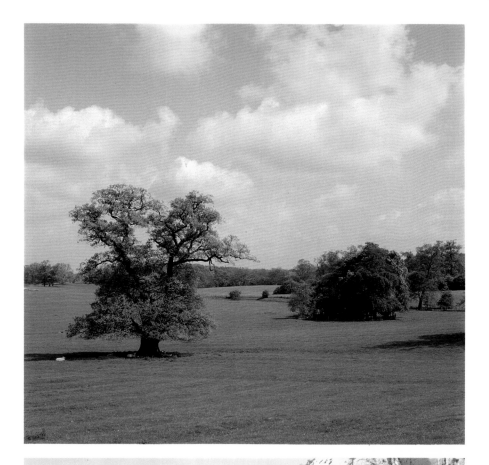

It was the cross-bedded sandstone which caught my eye rather than the pine trees, but I quickly saw that the warm stone perfectly complemented the green needles. As this outcrop was beside a road, very little work was involved in taking the picture and the cross lighting was ideal for emphasising the strata lines.

Ponderosa pines growing on cross-bedded Navajo sandstone, Zion National Park, Utah, February 1982. Ektachrome 64, 150mm lens on Hasselblad. Cross lighting.

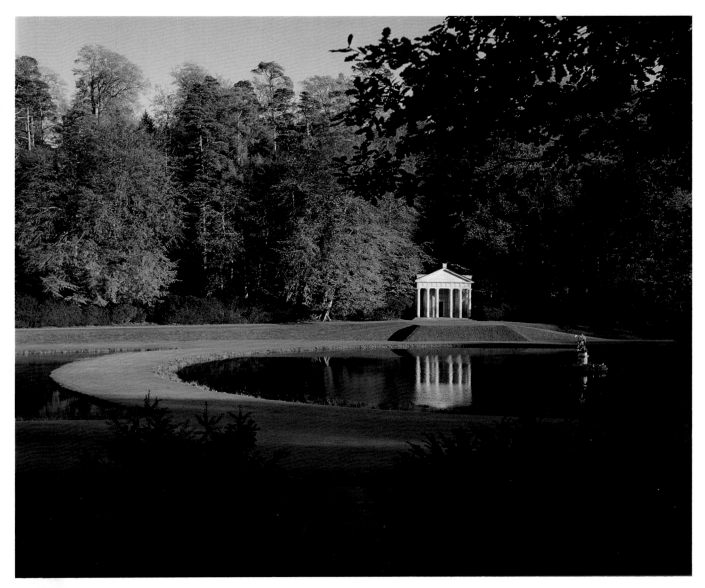

Landscaped Gardens

Expansive landscaped gardens such as Stourhead in Wiltshire, Studley Royal in Yorkshire and Middleton Place in South Carolina which have been laid out so that eyecatching architectural and water features suddenly present themselves at strategic points along the circular route, are in one sense a photographer's paradise. The viewpoints do not have to be found, they are already pre-determined. This can be somewhat frustrating, although admittedly a choice of lens to use has to be made and the time of day for the optimum lighting chosen. But if the viewpoint has a narrow angle, it is extremely difficult to produce an original picture. Gardens in which it is possible to wander at will in any direction offer much more scope for an individualistic approach.

The sweeping curve of green turf leads the eye to the temple spotlit by the evening sun. Although slight ripples on the water distort the temple reflection, the whole scene gives a wonderful feeling of peace and solitude. This picture was taken on my first visit to Studley Royal just before closing time, so I decided to leave my cameras in the car. However, as soon as I saw the potential of this picture, I raced back to the car to re-enter fractionally before the entrance gates closed!

Temple of Piety reflected in Moon Pond, Studley Royal, Yorkshire, September 1985. Ektachrome 64, 150mm lens on Hasselblad. Evening light.

Architectural gardens where statues, balustrades, fountains and lawns predominate can be maintained so that they give the impression of remaining static. In reality, even these gardens would revert to a wilderness if they were not maintained, while gardens with an apparently harmonious mixture of flowers, trees and shrubs constantly change as some plants die and more vigorous ones invade the gaps. A dated photograph of a garden therefore provides important historical evidence of how the garden looked at that time. For the record to be as complete as possible, the garden should be photographed from many different viewpoints, including a bird's eye view from a window in an upper floor room or even from the roof.

The current interest and vogue for restoring old gardens, in some cases where very little evidence remains on the ground, has meant that old photographs have proved invaluable for ensuring the design is as authentic as possible. Many of these originate from illustrated articles of gardens in their heyday in back issues of the British magazine *Country Life*.

Such pictures do not need to be boring records; on the contrary, check there are no eyesores (hose pipes snaking across the lawn, washing on a

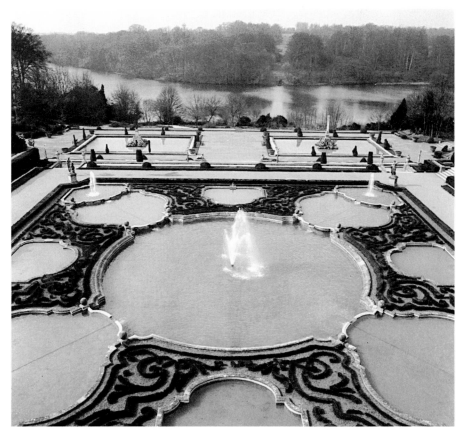

The best way of appreciating the design of Achille Duchêne's water parterre is from high up on Blenheim Palace. This picture was taken immediately after the pools had been cleaned, so that the pale areas show the maximum contrast with the dark configuration of the box parterre surrounding them. Since I particularly wanted to take this view without any visitors, I had to gain special permission.

Water parterre. Blenheim Palace, April 1985. Plus-X Pan, Superwide (38mm) Hasselblad. Diffused light from light cloud cover. By kind permission of His Grace the Duke of Marlborough.

I spent only a short time in this unusual garden before storm clouds rolled up and it began to rain but, as is often the case, the lighting before the storm broke was dramatic. To take this picture I stood on a bridge crossing the moat looking over to the raised walk backed by the long border.

Moat Walk, Loseley Park, Surrey, August 1985. Ektachrome 64, 80mm lens on Hasselblad. Cross lighting.

When I arrived at this garden it was blanketed with mist, but it soon evaporated from the warmth of the sun's rays. Having taken a few pictures with the beds front lit, I decided to move round to the opposite side, so as to get the backlighting to shine through the red tulips with the clipped yews silhouetted behind.

Spring bedding, Lanhydrock, Cornwall, April 1987. Kodachrome 25, 85mm lens on Nikon. Backlighting.

line, coloured toys or garden tools lying around). Look for a foreground plant or statue to give depth or a window, arch or pergola to frame the picture; these can be most effective at tempting people to visit an unknown garden.

Garden vistas taken to include a winding path which leads to a hidden part of the garden automatically invites the eye towards the unknown, impressing a feeling of secrecy. The material used to construct paths brings a unique colour and texture to this part of the garden, whether they be grey flagstones, weathered brick surrounded by moss or cross sections of tree trunks. The colour of paths if enriched by wetting, so that if rain does not fall naturally, the garden hose can be turned on instead. Fallen petals or leaves can provide contrasting colour not only to paths but also tables, seats and low box hedges.

The time of year for photographing evergreen trees and shrubs in gardens is much less critical than deciduous trees, since apart from when they produce flowers or catkins, they change very little with the seasons. However, trees or shrubs which are artificially shaped into topiary forms are best photographed soon after they have been clipped, so that the shapes are crisply defined.

Timing is much more critical for taking trees which produce copious blossom, since they may be at their peak of perfection for one or two days at the most. Early spring flowers such as magnolias and camellias turn brown when frosted, so that it pays to check the weather forecast before driving any distance to see a renowned magnolia or camellia garden. The pendulous yellow flowers produced later in the year by laburnum will escape frosting, but if the weather is hot they look their best for only a matter of days. A view down a laburnum walk at this time is magical, although I find the strong scented flowers somewhat sickly.

Herbaceous borders—surely the quintessence of an English midsummer garden—are not quite so ephemeral if the plants are carefully chosen so that they flower in succession; but heavy rain or strong winds can flatten tall plants that are not adequately supported or staked. So, like all garden pictures, it never pays to postpone taking them when perfect conditions arise.

By the time autumn comes, leaves have turned and fruits ripened, most gardens find it is uneconomical to remain open in winter. Many of the

notable landscape gardens do remain open however, proving that well thought out design coupled with architectural features, ensures such a garden is always worth a visit. One of my favourite pictures, taken in such a garden in the process of being restored to its former glory, has virtually no colour at all. It depicts a white gothic temple taken immediately after a heavy snowfall, each element complementing the other in the cold winter landscape (p96).

None of the garden pictures reproduced here include people. This is no accident, for although people do add scale, I find they are often a distracting element in the appreciation of the design, colour and texture of a garden. I therefore have to gain permission to visit early in the morning or late in the day outside normal visiting times.

Aerial Views

Good visibility is essential for taking clear aerial photographs; more often than not haze spoils the clarity. By choosing a window seat with a view that is not obscured by part of a wing, satisfactory pictures can be taken from a commercial aircraft shortly after take off and before landing. A shutter speed of at least 1/250 and preferably 1/500 second will be needed and the lens should be held as close as possible to the window to avoid reflections appearing in the picture. Old planes which have badly scratched or discoloured panes ruin all chances of getting a reasonable picture, so it is not worth wasting film.

It is much more worthwhile and extremely exhilarating to go up in a small lightweight plane or even a hot air balloon (a helicopter tends to produce too much vibration) because the low altitude enables pictures to be taken throughout the flight. Also working without the restriction of a window helps the definition of the pictures.

Landscapes take on a new perspective when seen from the air. Flat terrain, in particular, becomes much more interesting; colour mosaics appear from the field patterns, and winding creeks can be seen weaving their way through a salt marsh when the tide recedes. The best viewpoint for photographing the outsize horses and humanoid figures cut out of turf on chalk hillsides in south Britain, is from the air, because the perspective is so often distorted from the ground. Indeed, the elongated shape of the White Horse of Uffington in Oxfordshire can be fully appreciated only

from the air above, which makes its early origins a complete mystery.

If you are after specific landmarks, it pays to do your homework beforehand by marking up a map to show the pilot before take off. When I was working on an aerial photo-essay of the river Severn for a book, I went up at three in the afternoon on a perfectly clear day. My pilot was a wizard at interpreting my hand signals so that he manoeuvred the plane exactly where I wanted it. When I needed a repeat shot, he was more than happy to oblige. After I had landed, he confessed he was very relieved I still had all my cameras, since I had been leaning out of my window without any strap on them and he would have been responsible had a camera landed on anyone below!

I was not so impressed with the pilot who took me up in a tourist flight over Victoria Falls. After the obligatory repeated loops over the Falls, he flew low over the Zambesi river and the adjacent plains causing hippo and terrestrial game to charge off at speed.

Unquestionably the most exhilarating flight I ever experienced was in a hot air balloon on a calm October evening. It was a week after the October 1987 hurricane, as I wanted to record wind-blow damage from the air. We unfortunately did not fly over the worst hit areas, but it was nonetheless a magical hour aloft with the shadows, somewhat softened by a very light cloud cover, gradually increasing in length. From the air it was immediately apparent how the salt-laden winds had penetrated far inland killing all the leaves along the southern flanks of the hedgerows which appeared completely brown on this side yet were still green on the northern side. The Great Storm of 1703 also deposited salt well inland. Daniel Defoe records a South Downs shepherd relating how his sheep refused to eat the salty grass until they were desperately hungry.

Aerial pictures can also be taken remotely by strapping a camera to a kite or a model aeroplane. This need not be totally haphazard if a plane is radio-controlled.

Only from the air can the broad front of the huge curtain of water from the Zambesi River crashing over the Victoria Falls be fully appreciated. The copious spray is also apparent along the entire width. This picture will help to orientate the ones of the Falls taken from the ground on pages 89, 128 and 129.

Victoria Falls taken from a light aircraft, September 1981. Kodachrome 64, 50mm lens on Nikon. Direct overhead lighting.

Landscapes in Miniature

When some kinds of rocks are sectioned, their internal markings are reminiscent of a landscape. Throughout Utah, portions of sectioned sandstone are sold in tourist shops, looking remarkably like the recession planes formed when viewing a succession of hills against the light early or late in the day.

The Victorians used the so-called landscape marble as a decorative stone. Quarried in Bristol, it is a type of limestone with curious dark patches (formed by algae) resembling the profile of a hedgerow dotted with trees.

A polished section of a small rock reveals a landscape in miniature. This landscape marble is reminiscent of hedgerow trees silhouetted on a horizon. The small size of the stone meant I had to use a macro lens to get in close.

Section of landscape marble from City of Bristol Museum, October 1976. Tungsten light Ektachrome, 55mm micro-Nikkor lens on Nikon. Diffused studio spotlight.

Wind-blow damage caused by the October 1987 hurricane recorded a week later from a hot-air balloon. The brown hedge has had the leaves killed by salt-burn. I was glad I had chosen to use a medium fast film as a light cloud cover softened the light.

Wind-blow damage in Sussex, viewed from hot-air balloon, October 1987. Kodachrome 200, 50mm lens on Nikon. Hazy but bright low angled light.

In a private Atlanta garden I came across a gazing ball — a highly reflective sphere some 20 centimetres in diameter. It had been precisely positioned on a pedestal so that it reflected the landscape in front of it as a much reduced scene. In this respect it was functioning like a fish-eye lens. The natural world also has its own fish eye lenses in the form of water drops and the enlarged spherical abdomen of the honey ant.

Further Potential

Although I have covered a dozen varied types of landscapes here, there are others which I have not touched upon because the specialised equipment or techniques are beyond the scope of the average photographer. For instance, it is essential to learn the procedures for scuba diving or caving before taking up underwater or cave photography.

As can be seen by the examples in this book, landscape photography spans such a diverse range of subjects and approaches, it can easily be moulded to suit individual taste.

Unlike in Peter H. Emerson's time, the opportunities for taking rural landscapes without any hint of mechanisation, are few and far between in many countries today. Also, even though the extent of true wilderness area is shrinking annually, landscapes persist all round us; it is up to the acute eye to perceive and record them for the appreciation of others.

A highly reflective gazing ball compresses and somewhat distorts the reflection of the landscape in front of it. So that I appeared as inconspicuous as possible, I wore a green sweater and stood beside a green tree. A ball such as this creates year-round interest in a garden.

Gazing ball in Ryan Gainey's garden, Atlanta, Georgia, January 1986. Ektachrome 64, 80mm lens on Hasselblad. Diffused lighting.

Index